VIDEOLOGY AND UTOPIA

VIDEOLOGY AND UTOPIA
Explorations in a new medium

ALFRED WILLENER
Director
Institut de sociologie
des communications de masse,
Université de Lausanne, Switzerland

GUY MILLIARD
Institut de sociologie
des communications de masse,
Université de Lausanne, Switzerland

ALEX GANTY
Institut de sociologie
des communications de masse,
Université de Lausanne, Switzerland

Translated from the French and edited by Diana Burfield

ROUTLEDGE DIRECT EDITIONS

ROUTLEDGE & KEGAN PAUL
London, Henley and Boston

First published in 1976
by Routledge & Kegan Paul Ltd
39 Store Street,
London WC1E 7DD,
Broadway House,
Newtown Road,
Henley-on-Thames,
Oxon RG9 1EN and
9 Park Street,
Boston, Mass. 02108, USA
Manuscript typed by Gaye Hardiman
Printed and bound in Great Britain
by Unwin Brothers Limited,
The Gresham Press, Old Woking, Surrey
A member of the Staples Printing Group
© Tema-Editions, Paris, 1972
Translation © Diana Burfield 1976

ISBN 0 7100 8435 8

CONTENTS

In limiting the meaning of the term 'utopia' to that type of
orientation which transcends reality and which at the same time
breaks the bonds of the existing order, a distinction is set up
between the utopian and the ideological states of mind.
 Karl Mannheim, 'Ideology and Utopia', p. 173

Truth is not only attached to propositions and judgments, it is,
in short, not only an attribute of thought, but of reality in
process. Something is true if it is what it can be, fulfilling
all its objective possibilities. In Hegel's language, it is
then identical with its 'notion'.
 Herbert Marcuse, 'Reason and Revolution', p. 25

PREFACE

The research described in this book was carried out without special financial support in a university situation that certainly offers little encouragement to the spirit in which we work.

The book is first of all the outcome of the confluence of several currents. It is also the product of a small team. It would not be impossible to follow the usual convention and specify the contribution or the particular orientation of the individual authors, but this would be to falsify a praxis growing out of confrontation and fusion, by reconciling differences in a joint project that is itself in a perpetual process of development.

We cannot, of course, mention by name all those who have helped us in one way or another, but we wish to thank them anonymously for their contribution, particularly those videologist colleagues whom we interviewed.

Among the other people whose contribution was especially valuable, we should like to thank: Mmes Girard-Montet, Peter, Rossier; Mlles Keller, Lanini, Meregaglia, Moukhtar, Pelet; MM. Baechler, Belhadjali, Berger, Croquelois, Fantoli, Favre, as well as our friends and colleagues Tripier and Stucky.

The following groups and organizations also helped in various ways to further our explorations: L'Atelier des Techniques de Communication (the ACT group); Le Cycle d'Orientation de Genève; Le Collège Elysée de Lausanne; Les Jeunesses Progressistes Vaudoises; the seminar 'Esthétique et Mass Media', Lausanne, 1970-71.

As before, Monic Gille helped to support our efforts with encouragement and perceptive comments while undertaking the tasks of deciphering and transcribing the material.

INTRODUCTION

It may seem futile to embark on exploratory research in an age of such technical and scientific sophistication that cameras can be radio-controlled between earth and moon; and, though work on the moon is also an exploration, it has the justification of that vast distance, the very space that science is beginning to conquer.

Moreover, we are proposing to explore by means of, and around, the video taperecorder, 'which, after all, is only a gadget', a still imperfect instrument; and, worse still, our goal is the region of utopia located in social reality and sought through the use of that instrument.

So a collapse into irrationality is imminent, and the solemn ritual question, 'Where can objective reality be found in all this?' will soon be asked. Shall we, on that account, involve ourselves in prefactory remarks and defensive statements? In the end, the judgment is left to the reader, anyway.

It seems to us that the most serious question, one that we prefer to touch on lightly, almost playfully, is to decide whether the rationale of a study, the most positive facts (positive = true, but also positive = hopeful), are not precisely those which remain least accessible to measuring instruments; those in the realm of virtuality,(1) of a reality that is no less real - on the contrary - because it is not - yet - established. It is a positive act to play with this sur-reality rather than to stay confined in the sub-reality that is ordinarily presented to us as the sole standard of reference. And the transition from sub- to sur-reality occurs only in action, that is to say during that process which enables it to happen even before it is possible to be certain of its outcome.

It is in this direction, after all, that the greatest objectivity can be achieved through the subjective experience of the enthusiast. Sociologists of the academic seriousness and even the patrician restraint of a Robert King Merton have for a long time been reminding their colleagues of the importance of the self-fulfilling prophecy: the more strongly one believes something will happen, the greater the chance of its actually happening. It is not because this author is thinking above all in terms of the functioning of a process, within the framework of organized forces that can be recognized in advance,(2) that his thesis is not applicable to processes of

renewal and transformation. Utopia can become reality in the course
of establishing itself, or at least of making itself temporarily
believable.

In the long run, if all goes well, even a gadget has features
predisposing it to become a catalyst; on the one hand it may become
a futile diversion, a plaything, or even an item of luxury consump-
tion; on the other hand it may remain in part a powerful mediator
through which the most exciting phenomena of renewal and transform-
ation can be visualized, activated, and disseminated (as models to
follow).

Now, this can be true of videotaping (VT), if we concentrate on
its positive aspects; and this is what we intend to discuss, leaving
aside the wearisome aspects of a medium already partly reduced to
the status of a gadget, or the consideration of national statistics
showing that a particular practice applies to only a derisory pro-
portion of the mass of consumers of this new and still unknown pro-
duct (indeed, for many, the product will all too soon turn into a
'finished' product).

What interests us and, we hope, the reader is a socio-technical
potential. This is why we are passing from the subject of VT to a
videology of utopia and to videological utopias.

What is at stake is everyday life! The sociology that engages us
is situated between the analysis of a practice allied to a technique
and the analysis of the technique of a practice.

In other words, at a time when the market for video cassettes is
opening up, a development that will perhaps define the 'post-
television age', it seems essential to study all the possible appli-
cations of new technologies in the field of the social sciences
themselves, as well as in the fields they study.

First on the market, and already produced on a world scale, the
half-inch video taperecorder (VTR) and the lightweight video camera
with built-in microphone (portapak(3)), seem to call for an exten-
sive series of research projects and experiments to adumbrate the
scope of their possible contributions. Even if current video tech-
nology has to be modified, we should start right away to define the
elements, both structural and potential, inherent in the processes
they stimulate, reinforce, or simply record.

For the sociologist it is a question, more specifically, of try-
ing to understand what conventional research techniques are barely
able to grasp. This implies not only exploring the instrument it-
self, but also developing, or at least outlining, a problematic
related to its use and to its social application. To carry the
analysis a little further, there should be a follow-up of what has
already been started in recording TV programmes and in the work of
certain film-makers; a new medium is grafted onto an old one: VT is
to TV what the taperecorder was to radio in its beginnings before it
achieved an independent existence. So, during the socialization of
this technology, there is a stage of progressive but slow appropria-
tion by the socio-cultural community, of which the sociologist,
whether he likes it or not, is also a member. Trying to derive a
'video-logy' is not only a methodological exercise but also a theor-
etical enterprise, and one of our main concerns is to touch much
more closely than is usually the case on the world of the imaginary -
the imagination of new practices, allied to new perceptions and

processes - which does not rule out an element of plain description of established practices, in television especially.

The new instrument will not assume its full significance until we are able - in the school, the university, the enterprise, in public life or, more particularly, community life - to control the flood of images increasingly unleashed by the media of 'mass' 'communication', and to complement it with independent productions, not of the mass variety but of an order that is neither high culture nor mass culture - what Edgar Morin proposes calling 'third culture'.

THE USE OF VIDEO IN CULTURAL ANIMATION

In France almost all the early experiments with video were carried out between 1969 and 1970 either in the field of political militancy or in connection with 'cultural animation'.(1) In September 1969 the Sony portable video equipment was put on show at the Radio and Television Exhibition and, because of its exceptional ease of handling, it may be said to mark the beginning of the 'revolution' we are discussing here.

Groups of activists who, after May 1968, were looking for ways of providing counter-information, quickly became interested in this new type of equipment, mainly at the instigation of Jean-Luc Godard. Tapes made during demonstrations or during interviews with leaders were shown in bookshops or at political meetings. This trend has never subsequently lapsed in France, and it is true to say that in Paris, at least, a portable video camera will always now be found at any important social, cultural, or political event. The distribution network for the tapes is much more difficult to foresee, and it seems for the moment limited.

As to the role played by portable video in the cultural centres more specifically, it is closely associated with certain people in the theatre and with some of the administrators of Maisons de la Culture,(2) pioneers who recognized in it a means of stimulating creativity and exchanges within and between groups that were too self-enclosed.

In 1969, a company called Serreau-Perinetti (subsequently dissolved) became interested in mobile equipment for cultural animation, among which it included video. It secured a research contract from the research department of the Ministry of Cultural Affairs. A supply of equipment was granted by the director of cultural activities, and the Atelier des Techniques de Communication - the ACT group - was founded in the winter of 1969; it began its first experiments in cultural centres in the autumn. Its first research report was submitted in May 1970 but the cell continued to work until a change of orientation and of team membership took place at the beginning of 1971.

The take-off of video in this quarter occurred at the instigation of Jean-Marie Serreau, supported by M. Augustin Girard, head of research at the Ministry of Cultural Affairs, whose primary interest

was in 'cultural technology' and in developments in electronics between now and the end of the century.

Cultural animation, which was still ill defined and not widely known about, was well suited to play an 'underground' role in the introduction of a new medium such as portable video. Moreover, it stood in a relatively marginal position in relation to the established and recognized genres and fields, for example the theatre, the cinema, music, television, and the plastic arts.

In spite of being sponsored by the administration and integrated with the cultural policies of the state, cultural animation gave the impression of being a shadowy maquis during those years of last-ditch attempts to preserve the grandiose plans conceived by M. Malraux in the 1960s from ending in the shipwreck of those large municipal centres which, despite the label 'Maisons de la Culture', had never presented anything other than traditional entertainment.

Animators were therefore appointed in almost all the cultural centres to complement the work of the theatre people by bringing opportunities for contact as well as cultural services and activities to the local population; their objective was to stimulate the formation of creative groups, which were very thin on the ground, particularly in the provinces. They were attempting to promote the development of the second two vertices of the magic triangle creation—distribution—animation, which tended to be overlooked by professional entertainers.

This policy produced results and attracted some support; for example, in 1968, the philosopher Francis Jeanson(3) decided to launch a cultural animation team at Châlon-sur-Saône. It proved very difficult to find a way between the rigidity of the educational system and the syllabus and the established positions of the entertainment world; reference was often made to the 'narrow path' of cultural animation, suspected of 'co-option'(4) by leftwing groups and of leftism by the political powers-that-be and local worthies.

It was thus in this marginal situation, and in some institutional and financial embarrassment, that the first video experiments described here took place. They were carried out by non-professionals with more enthusiasm than organizational capacity; to certain people their amateur approach seemed sometimes less than serious, to others, more alive to the romanticism of the enterprise or to the value inherent in any early explorations, however imperfect, it wore a wildcat, vagabond, somewhat pirate air.

Because it is no more difficult to operate than an ordinary camera or a sophisticated taperecorder, the new portable video equipment (with synchronized sound) makes it possible to foreshadow not only new types of shooting and of films (which had already been done by 'direct cinema'), but above all participation in the entire process of audio-visual communication, while at the same time offering new possibilities of sociological investigation. In this book we shall try to describe and interpret this direct experience as well as the potential of video as a research tool.

First of all we shall report on the videological experiments made by one of our group, as an introduction to a range of problems connected with the use of this instrument, not only in cultural animation but also in a wider context. The experience of Guy Milliard in the ACT group, though necessarily specific, is interesting as much

for its socio-cultural content as for the technical problems it
raises; it will be presented by way of an introduction to the set
of broadly related preoccupations underlying the present study.
The quoted passages(5) will lend our account something of that
improvised, open-ended style that is the hallmark of working with
video.

TOWARDS COLLECTIVE WRITING

The interrelationship between the operator, the video apparatus, and the subjects treated is such that it is appropriate to start by presenting the participant-observer who is himself the operator. As will appear, the sociological approach we advocate rejects the idea that observers - whoever they may be, including ourselves - can be placed in parentheses. The first steps working with video are marked by the progressive and rather painful discovery of a contradiction: video is a language while not yet being one. We shall frequently have occasion to explore this paradox already signalled in these first chapters.

A transition will take place from the position of participant-observer to that of observer-participant (a significant nuance) in relation to cultural animation at different levels: apartment block, town, region. It may be taken as read that the socio-cultural content of our account of each of these situations is provided only as a sketch to demonstrate how and why video was introduced in them, or how it might have been.

FIRST APPROACHES TO VIDEO

GM had graduated in advanced business studies. He had become intensely interested in what he had been able to glean of the social sciences (Durkheim, Marx, Freud) from the syllabus of the École des Hautes Études Commerciales. In his last year he carried out a study on the perception of life-styles in a suburban neighbourhood, with special reference to leisure-time activities. Later on, a second study led him to the analysis of another district, and his interest in 'cultural technology' was awakened.

> GM: I really found there at last a path that seemed to lead far away from the dusty museums, from that incredible accumulation of books, from the gulf between theory and real cultural life I found so disturbing.
>
> My father has been making amateur films for forty years, and my brother is a film critic and works for religious television. I've always lived in a kind of sea of images. I did photography. Anyhow, for me, photography and the cinema are the same

world. Besides, as I was interested in writing, it seemed neces-
sary to discover a means of writing with pictures.
GM also played the piano and sang, giving fairly regular public per-
formances, sometimes of his own compositions and lyrics, though he
followed this career in a very pragmatic way. While he was a
student he was particularly involved in literary composition, indeed
in cultivating 'writing'.

>AW: You had photographic equipment at home and so you were
> stimulated to take up photography; there was a piano and you
> accompanied your own singing; what about video?

GM: Video came about accidentally. At HEC I was in a small group
of passive film addicts. I was very dissatisfied and even dis-
gusted with this passivity. I'd heard about VT in May 68 at a
department of the Ministry of Cultural Affairs, and about what
Godard had done with it. I met Jean-Marie Serreau, who told me
about the new portable equipment for the theatre, and I began to
work in the group he had organized.

I did one or two things, and I soon became aware that this was
not simply a means of expression for myself but also a medium of
communication. It was a means of getting various processes, a
complete sequence, underway. In particular it seemed to offer
the possibility of depassing the traditional structure of hier-
archical units encountered in film-making. There was no longer
this gulf between a director and a highly differentiated unit.
In the cinema everyone is nagged by the desire to make his own
film, and it takes a long time looking for the money to enable
you to pay the 'slaves' and to produce a film that will be the
film of the auteur, and so on. I saw the possibility of having
much more participation and communication in the creation of an
audio-visual product by means of video.

AW: Wasn't that inconsistent with your writing experiments?
GM: I'd had an idea for a film about Bordeaux. At that time I
sensed the rifts in the production unit, although we had at
least had discussions together. I had already asked myself
whether it wasn't the conditions of the entire instrumental set-
up that falsified the whole project.

With VT I had a revelation of something different. In spite
of my concern with individual expression, I suddenly felt how
much and how inevitably this new medium was involved in a kind
of group dynamics. I also discovered that it is a new form of
expression, a form of writing that can serve individuals in
communicating a personal vision, provided that they are not
trying to make films and that they rethink their style of work
in relation to the equipment. An enormous field of research is
opening up there. For me, this doesn't rule out the need to
develop a special language as well.

>AW: Can you say specifically how large a part of this is
> reporting, simply reflecting, and how much personal expression,
> or style?

GM: To start with we used this medium as a simple recording
instrument, to fix, let's say, a vivid detail.

In the second phase we continued to produce these simple
reflections, but we tried to get together little newsreels,
rather poor imitations of TV news, our editing being rather

cursory. These news bulletins, shot the same day for groups or local bodies, had quite an impact on the people directly concerned. They were staggered by this process, which produced an 'awakening', in contrast with their experience of the kind of television to which they had been conditioned.

In the third phase we began to think more deeply, to work towards a kind of production, to stop operating in terms of a cultural gadget. We put the medium at the service of a spontaneous expression involving a large element of imagination; as the process developed, we reached the stage of elaborating a new language; we certainly had to stop recording mechanically or just imitating TV.

Then, in a further phase, but still within the context of a personal signature, we noticed that setting the group work in motion with a kind of film project changed everything. Relations within the group, the relative absence of specialization according to fixed tasks, led to a process of perpetual and rapid development; people viewed in the evening what they had taped during the day, and this is all very different from shooting a film, which is not seen again until much later and which is fragmented by complex editing, and so on. And the non-division of labour goes quite a long way. At one time or another different people get behind the camera; they can even become members of the technical team for a time - taking charge of the camera or the sound-recording or the lighting - it's obvious, if you just think of this, that a completely different type of internal communication has been initiated.

AW: Is this what you meant when you were talking just now about deep involvement?

GM: At first the material we were acting upon was the relations between members of the group, later it was the relations between the group and the outside world. We were exploring. If there was a setback - if, for example, we felt that the group was going to come a cropper - each individual took the problem to heart.

AW: And if we consider not just the problems experienced inside the group, did this exploration lead to modifications of the images you had of the outside, of society?

GM: Many people in the group came from theatre, from TV, or from cinema. They were interested in a new and manageable instrument, but they weren't much concerned to question their perception of communication. For example, they would have liked to make sorts of parallel circuits that would still be directed, but in line with a perspective inherited from their profession and simply transposed.

AW: Didn't they question this heritage? Which was the strongest heritage: the theatre, TV, or the cinema?

GM: I don't think the cameraman who had worked on shorts properly grasped what it was all about. He had always lived in little 'fraternities', as it were in a closed circuit. He was waiting for instructions from a director. He used to say, 'It's chaos, there aren't any instructions.' He wanted people to specialize and to set up a hierarchy.

AW: In the end, then, has this medium transformed your vision

of the world for some of you?

GM: I can only speak of our own experience. Because of the
influence of Jean-Marie Serreau, the group was connected with
theatrical people. This was a source of opportunities and
obstacles. It was only gradually realized that the whole pro-
cess of animating the production and presentation of a tape was
more important than the finished product itself.

AW: So who really changed as a result of the learning
 process?

GM: The professional theatre people hardly changed, let us say,
their way of looking at society or their profession, or simply
their conception of how this new medium should be utilized.
Only those who were not yet professionalized (students and
others), but were interested in images and in new techniques,
have really changed. Obviously, there were differences, for
example between those who worked permanently with ACT and those
who only participated in certain interventions.

AW: What is an intervention?

GM: What we did in Lorraine, for example;(1) the cultural ani-
mators were preparing the ground; the idea was to make some
tapes about the miner's life, with the miners, in one of their
towns in the course of their daily lives.

AW: Why intervention?

GM: For a small body, this means contributing equipment and
personnel - one or two collaborators who move around with the
video equipment. They explain to people on the spot how to use
the apparatus. Obviously, in spite of everything, they remain
'interveners', hence the term, which conveys the idea of people
parachuted down,(2) directing; personally I prefer the idea of
animation.

AW: 'Atelier de techniques et communications' - no doubt you
 changed the order of the initials on purpose ...?

GM: I wasn't yet in the group when the name was chosen. Certain-
ly, it was intentional. Besides, they were making a play on
words; 'You are a member of ACT', which meant 'do' things don't
just talk about them; do things first, then think about them as
you go, but keep going; and don't submit to codes, to rules, to
grammars. Just jump right in!

AW: Returning to an earlier question; certain people, partic-
 ularly the professionals, hardly changed; were there any who
 did?

GM: For those who had never had access to audio-visual creation,
but who had thought about the phenomena of communication (feed-
back, working in a group and so on), video appeared on the
horizon as a completely new opportunity for expression and
communication. They got involved, and became aware of possible
forms of involvement.

AW: Was their way of seeing themselves in society transformed
 through becoming familiar with different kinds of shot, with
 playback, and so on? Was this a sort of learning experience?

GM: There were a few cases, particularly outside the theatre
world, and especially in Lorraine and at Sceaux (near Paris), in
some work with schoolchildren. Elsewhere, too, people developed
an awareness. We might call it a stronger presence to them-
selves. It's a form of liberation.

This biographical fragment sketches Guy Milliard's personal equa-
tion. The understanding of a technical instrument used in a highly
personalized manner demands a presentation of this kind, although
we must immediately make it clear that we are dealing with a socio-
cultural phenomenon: the 'VT generation'.(3) We are calling atten-
tion to a quite spontaneous interest in the world of the image,
which extends from the active practice of photography and amateur
cinema to cinephilia and to very extensive reading concerned with
the image; to this is attached the contradiction we have mentioned,
which can for the time being be expressed as follows: an opposition
exists, at first sight at any rate, between improvisation and con-
struction, or if one prefers, between a language and the rejection
of all established languages. The contradiction inherent in the
actual emergence of a socio-cultural phenomenon can be expressed,
for the moment, by two curves: a tendency to reject language (in
fact, existing languages, through a taste for truth and spontan-
eity) and a tendency to elaborate a language (through rejection of
the inadequacy perceived in the practice of simple 'reflection').

EXPLORATORY INSTRUMENT AND MEGAPHONE

Everyone now knows the value of an interview recorded on tape. If
the sociologist does not always make use of a tape-recorder, it is
to avoid at the outset the considerable trouble of transcription
and analysis or to save upsetting the respondent with the apparatus.
Obviously, there are similar advantages and disadvantages in recor-
ding people on videotape. Now, what is special about video, apart
from the picture?
 Above all, it is the possibility of playing back the tape
immediately to the people concerned. In a discussion group, for
example, immediate playback not only stimulates or revives a debate,
but also tends to produce a boosting effect; the group becomes
'hyper-reactive'.
 In the course of an opinion survey on the mass media, lively,
even violent, discussions were recorded in this way concerning the
launching of the first Apollo space flights and their presentation
on television. The immediate playback of the discussion following
the initial face-to-face presentation of viewpoints not only re-
vived but reoriented the argument.
 In Lorraine, in quite different circumstances, tapes constituting
a kind of reportage on a mining town were shown to a number of
important local figures (the president of a voluntary organization
and others). They were mainly concerned with interviews between the
mayor and his opponents, and they had such a powerful effect on the
audience that the discussion got under way even before the playback
of the last tapes intended for projection.
 Another example of spontaneous, wildcat utilization of video is
worth mentioning. Two thousand young members of the Fédérations
des Oeuvres Laïques(4) from all parts of France had come to Bourges,
moving from district to district engaged in cultural animation. A
conflict had erupted over the rule requiring the segregation of
girls from boys in the dormitories located in the secondary schools.
After a video presentation, the group suggested taping a confron-

tation on this issue between the animators and the young people, followed by a playback and another debate. The result was extraordinary; the first part of the debate went quite slowly, but during the second part, after the playback, questions broke out on all sides.

AW: How was it possible for the interest of the debate to be increased by video?

GM: At first, because it was in the evening, by a focusing effect: the projector in the middle of a public square creates an attraction and, just like a camera, defines a kind of reserved space; then there's the 'hot' playback, actually in the course of the discussion ...

AW: Who began to speak first, following the playback?

GM: Those who had spoken earlier began by enlarging on the points they had discussed on the tape, but others joined in, and it became clear that there were four or five themes in this debate, not just one ...

The experiment we made in another connection with musical recordings has a bearing on this. After all, a discussion is nothing more than a very free collective improvisation, that is to say it is hardly regulated by debating techniques or the orderly elaboration of arguments. It is not for nothing that the improvisation of 'free jazz' has been likened to 'free speech'. In both cases the participants are not much concerned with letting others express themselves, but each one expresses himself, and with great intensity. Particularly as regards free jazz, it certainly seems that during the playback of a recording everyone is concentrating above all on listening to himself; there's no great interest in the contributions of other people, at the most it's in the atmosphere of the ensemble.

AW: Did this second phase of the debate take you any further?

GM: Not much I think. The essentials had already been said during the end of the first part of the debate. Positions had been stated and rounded out, but they were in some way crystallized. A lot of people came, in fact, to see themselves. They retained a memory of what they had said, but not very much else. The important thing was that they had revealed themselves to themselves.

Another aspect of the phenomenon should be mentioned here, in order to explain the interest of audiences confronted with video, and the nature of their behaviour. This is what we shall term the 'megaphone effect'. It seems that the speeding-up of debate is due not only to the multiplication of images inside a delimited space, but also to the awareness of this multiplication. Indeed, everything happens as if transmission was going to be extended well beyond the immediate circle. Now, this is not normally the case. Video transmission can, of course, reach different audiences, either simultaneously (through apparatus linked to a central source or by means of duplicate tapes) or successively; only in very exceptional circumstances does it achieve the extensive coverage of TV (which is the case when videofilms are shown on television).

Here is an example of this, not from a debate but from an individual interview. The speeding-up occurs inside a person who knows he is going to be recorded so he expresses himself with greater

animation and illustrates his points more forcefully.

 GM: One day we were recording an engineer from the Highways
 Department; he was a bit self-conscious to start with because he
 had been interviewed at first in his office, but when we went
 outside on a hilltop he explained this road he had built, and
 since he had himself chosen to take us there for the taping he
 displayed greater involvement; he revealed himself to himself.
 Standing there, he gained an increased awareness of his respon-
 sibility, of how he had, in short, brought this road into being.
 It was a kind of liberation for him that his work was in this
 way acknowledged and 'publicized'.

In fact it is rare for people to be able spontaneously to avoid the
style of response they have seen on TV. They behave as if they
were being interviewed on TV. Even where the practice and hence
the transmission of video have been properly understood, there is a
kind of pride in addressing a medium of communication. One feels
more important, in some way reinforced, by the prospect of a poten-
tially wide audience.

 The fact of objectification through objectivation intensifies
this tendency. The importance of publication is well known: from
the moment that an idea is not merely written but printed (objec-
tivation), and published, it seems to acquire a higher degree of
truth (objectification). The picture and sound of a tape share in
this objectivistic credibility, perhaps in an exaggerated way.(5)
It isn't surprising that there should be a strong personal involve-
ment in all this, which may indicate inhibition of the critical
spirit as much as heightened susceptibility to the use of an image
with which one identifies, for obvious reasons, when it is the
representation of oneself.

 It is hardly an exaggeration to use the word 'rape' to suggest
the violence of reactions towards 'theft of the image', that is to
say of identity, which can be elicited when a videotape is used out-
side the immediate control of the persons who appear on it in
picture and sound.

 AW: We know that some people refuse to allow themselves to be
 photographed or to have their photo reproduced in a publi-
 cation. What happens with video?

 GM: It is rare for people to refuse to appear on video, for in-
 stance in the street, but it does happen. There was a teacher in
 a secondary school who refused to be taped. He pleaded 'lack of
 time'. Don't forget that for many people being recorded seems a
 bit like an exam. Besides, when they see themselves for the
 first time they are traumatized. They suddenly see themselves
 in a social role from outside. And what is more, a global im-
 pression comes into play; one apprehends oneself as a whole seen
 from outside.

Anticipating the shock, or in any case trying to manage in advance
the impression(6) he will produce on the screen, a person or a
group will sometimes try to construct, consciously or otherwise, the
tape which is to be recorded, in so far as there is time. The
person questioned will try hard to find illustrations that are
favourable to his viewpoints and to himself.

 AW: Have you observed that people, once they are being taped,
 give a different value to what they do habitually, to their

manner of speaking, and so on? For example, by paying greater
attention to their body and their gestures?

GM: A 'cultivated' adult will pay attention first and foremost to
his words; he will want to say something intelligent as his
initial reaction. He will adopt an attitude, a restrained pose,
on both the verbal and the bodily level. A housewife will try
to be comme il faut, to observe the proprieties. There is a kind
of bodily restraint in adults.

AW: Where do they look?

GM: Towards the interviewer, or towards whoever is talking, not
towards the camera.

AW: Will a person agree to be recorded from behind?

GM: After a certain point it is the sound that is the determining
factor. Obviously, this depends largely on the interviewer.
People pay hardly any attention to where the camera is aimed. To
start with, they look at the camera; they tell themselves it's
the same as on telly, but then, if they get caught up in the
game, it's the sound that guides them and they listen in order
to follow, to reply, and so on.

These reflections are offered as an introduction to a particular way
of working with video, granted that other approaches are possible;
however, they constitute a first approach to a living and changing
cultural phenomenon, which we shall now discuss in relation to
ethnographic types of exploration.

THE ETHNO-VIDEOGRAPHY OF A SUBCULTURE

Let us look a little more closely at how the dilemma indicated
above - language (and scenario) a priori/absence of language - runs
right through an experiment designed not only to grasp an adoles-
cent subculture, but also to interpret it, since it starts with the
writer's scenario.

GM: I wrote a scenario for a videofilm about adolescents; I had
them meeting in a café; they didn't know each other; there were
three main characters: a schoolgirl, a schoolboy, and a motor-
cyclist who might be an apprentice; the text was written by me,
a complete story ...

AW: When did you write it?

GM: Two years previously, after my research at Sceaux; then I
revised what was in fact the scenario - and this was my mistake -
I revised the text a month before starting to record.

AW: How did you go about taping the scenario?

GM: There were two characters, centred on a boarding-school,
then a gang of motor-cyclists. In fact, the people who were to
play the parts were unknown to me. So my first idea was to have
them read the scenario, to modify it in the light of discussion,
and also adapt it to the actual characters of the actors as I
got to know them. But I soon realized that this tactic lost
sight of an understanding of the milieu as a whole - that it was
the wrong approach.

AW: So how did you penetrate into this milieu? Is this get-
ting close to ethnography?

GM: I was soon diverted further and further from my scenario, but

I was no longer able to change it completely. However, I had
written a vast number of scenes so as to be able to offer a
choice; they could delete some of them. In short, there were a
number of prepared 'cases'. They said to me, 'No! Come and see
first - the school, the bike club, the café!' I had a lot of
trouble in keeping to my scenario, in directing people where the
text said they should go, and making them appear in the scenes I
wanted. Don't forget I was on my own among the lot of them. If
this situation has anything in common with any other, it's cer-
tainly with that of the ethnographer who approaches a strange
culture (and in this case I was very close to it) with a precon-
ceived schema in his head. It isn't in any way like the situa-
tion of the film-maker; he has a complete unit at his disposal,
which alters everything. My mistake was that I wanted to create
a videofilm based on the scenario I'd set my heart on and at the
same time carry out an inquiry into a specific milieu.

His entry into this subculture, in the course of discussions in the
café, revealed certain obsessions: objects (guitars, bikes, jewel-
lery, pendants, etc.), which were exchanged; a preoccupation that
is difficult to grasp, which could be called the 'planetary horizon';
in fact what is undoubtedly most difficult of all for the 'trad-
itional'(7) adult to understand, the rejection of the 'tunnel' with
two openings - the one the young person wishes to leave by and the
one he has no intention of entering: dependence in family life, and
the dependence anticipated in professional life. And if the import-
ance of these themes cannot be quickly and precisely expressed, even
in free conversations, it is so violently experienced that it can-
not be mistaken in the 'game' provided by video, even with a cumber-
some, but open, scenario. Breaking out by means of psychological
'speed' (drugs) and physical speed (bikes) becomes highly under-
standable.

The acculturation process for the participant-observer occurs
here both with and against his scenario. It will be noted how this
adjustment resembles the classic situation of the researcher in a
foreign society. If not in his notebook or his questionnaire, at
least in his head, the investigator carries a kind of checklist,
and there is movement back and forth between this list or map and
what is observed, with reciprocal adjustment. Of course, the
relation between map and territory is complex, and difficult to
report on later.

GM: First of all I devoted a fortnight to going to their café,
and later the secondary school; I became one of the gang, i.e.
an observing participant. I began to pick out those who were
most representative of the group.

AW: How did you do that, exactly?

GM: Of course, there was a bit, but only a bit, of preconception,
and some personal motives as regards the scenario. For example,
I thought it was important to retain those who frequented a café,
always the same one, and those who played music together. So in
the course of our conversations I realized that, rather than
write some scenario or other, every time there was dialogue, I
should outline the 'dramatic' situation in relation to the gen-
eral idea of a scenario together with some topics for free dis-
cussion. For example, I recall discussions in that café in

which many of these topics appeared (repression at school, the need for a different world), and how some girls invented a sort of child-woman game in a granary, using a lot of old junk, and then another game with a balloon-seller when they were going home from school. I also discovered that on certain days they were bubbling over with ideas and plans, in fact with utopias,(8) while at other times they were depressed. To conceal their instability, for they also changed their plans very readily, and to cement the group together, they met in the same place every day.

Finally we come to the deepest level of the problem of 'writing': the question of 'real reality', customarily relegated to the realm of philosophy, is raised in terms of the paradox of language noted above:

GM: The only way of achieving real pictures and sounds is for me to enter into the milieu, otherwise I'd never make anything but paper.

Once the participant-observer has virtually become a member of the milieu, he will learn directly (from those concerned) and indirectly (from observation) what is most 'real': for him, and for a member of this milieu.

We must make a place for what might be called 'collective writing', and here we touch on that particularity of life in society that positivistic approaches of all schools (including some marxist ones) continue not merely to put in parenthesis but to suppress. This is the 'subjective' level, the imaginative element in all cultures. There is, if we wish to retain this term for the moment, scenario and 'scenario'.(9)

The actors who participate in a situation imagine themselves acting in a particular play.(10) Their own perspective leads to an interpretation of the situation and of behaviour, their own as well as others', which supplies a meaning, a 'scenario', as it were (unanticipated and often unidentified by the observer), a 'reality' (internalized, but all the more real to the actors).

When an exercise like the interpretation of a scenario - taking the term this time in its usual theatrical sense, and therefore in the converse acceptation to that of the preceding paragraphs - requires individuals to conform to an external schema, a complex game begins to intervene between the individual writing desired by the author and the collective writing; video then begins to act as a mediator: reciprocal influences begin to develop between:

- the internal 'scenario' of each individual or of each of the groups present, and
- the scenario of an author, or of an observer, who is more or less participant.

Last but not least - this is the central theme of our problematic - an exchange takes place, for example for one individual, between his submerged scenario and his half-explicit 'scenario'. In other words, two levels of depth are in play.

Our hypothesis asserts that the process initiated by this video practice has the possibility of setting in motion an interaction between scenario and 'scenario' such that the deeper level of the latter reveals all or part of the two aspects of the imaginary: the current social interpretation, what is already established, and the interpretation that is normally repressed: utopia.

Obviously, it is possible to stifle this expression, either with the author's scenario, or with a 'scenario' imposed by a single one of the actors. Individual writing can run counter to collective writing. It is simply that we are directing our attention towards the potential of collective writing. And subsequent chapters will show that, in spite of this, the author, in this case the videographer, is not eliminated from the videographic situation.

VT-TV IN A BLOCK OF FLATS
Maine-Montparnasse

To talk of the post-television age is still not much more than mere
phrase-making, so the experiment described below is all the more
valuable in that it remains a very isolated one for France and
indeed for Europe.

The gigantic property development Maine-Montparnasse was given
its first expression in a residential block on a much larger scale
than others being built in Paris.(1) Very high, and topped by a
swimming-pool in a style consonant with all the luxury of this huge
barracks of well-heeled co-proprietors (executives, cosmopolitans,
or VIPs), the building also sheltered ... J.-M. Serreau.

The founder of the video group we have described above had the
idea of setting up an internal television programme; it would simply
mean connecting up the VT apparatus to the common aerial and relay-
ing to the ordinary TV sets in the flats.

As is well known, universities and schools have private networks
and there is quite a series of circuits in private companies, but
the residential sector seemed to be excluded: ORTF(2) has a power-
ful monopoly, and private TV companies come up against regulations.
Consequently the Montparnasse experiment, carried out by a very
small group of individuals, may be regarded as a venture in
'wildcat TV'.(3)

This experiment will undoubtedly continue to be remembered, even
though the transmission took place on one evening only, and in spite
of quite considerable technical deficiencies.

THE MICROSOCIOLOGICAL LEVEL

Did Serreau and his team succeed in making the programme share in
the 'culture' of this block of flats, or was it a cultural product
imported from outside?

GM: It involved Serreau in the task of approaching and gradually
persuading the Residents' Association. It was obviously neces-
sary for the residents to be able to be themselves. At that time
the Association had a change of president, and the residents
managed to get some space for the children, paid for by the
property company. This gave them the opportunity of opening a

crèche and starting on cultural animation.

 We taped the residents' general meetings, and the Association
decided to give a kind of soirée, during which there would be a
video programme transmitted through one of the communal aerials
as a trial run. It would present the new committee of the Asso-
ciation, the new children's nursery, an art studio, and so on.
We worked on the planning and production of the programme with a
group from the residents' office. So there was no 'parachuting'
of the essential elements.
Of course, there remained a technical problem. The ACT unit, rein-
forced by volunteers, was given assistance by G & Company. Even-
tually a whole Parisian milieu was buzzing round the experiment.
We were opening up a fascinating field. Apart from G & Company -
who install networks in schools and universities - manufacturers of
peripheral radio devices soon became interested in the project, as
did private promoters including property companies.

 Let us remain for a moment on the microsociological level. It
is not by accident that French sociology since about 1965 has tend-
ed to reduce the emphasis placed on problems of work and production
in order to turn to the study of communication and leisure(4) and,
eventually, after May 1968, of everyday life. The case of Maine-
Montparnasse therefore arose in a prepared practical and theoretical
context. J.-M. Serreau, the theatrical producer made responsible
for cultural animation by the Ministry of Cultural Affairs, per-
ceived that the time had come to open up a new cultural field for
the arts and the theatre. If there were TV networks in large blocks
of flats, it would not simply represent one more market, but a new
creative field with hitherto unexplored possibilities of expression
(for example, very skeletal productions), a kind of cultural contact
that would depass the simple provision of entertainment.

 How can one create something that will be really close or relat-
ed to the everyday experience of the inhabitants of these dwellings,
and that will also enable them to turn their gaze to wider horizons?
What does the experiment teach us about this?

 GM: There was a tape about the children's play group; it was
 something more than purely descriptive reportage; the residents
 had the means for explaining future developments and they des-
 cribed them at the same time as they were suggesting them
 There was a tape about a meeting of the Association's committee:
 parking and security problems were discussed; proposals were put
 forward for a roof garden above the station; and finally.rela-
 tions with the local neighbourhood and educational questions
 were raised. This was an authentic portrayal of the day-to-day
 preoccupations of the residents.

The programme actually transmitted one evening - on a special
wavelength - subsequently attracted criticism: 'It is a pity you
showed so many ready-made films; our own problems got too small a
share of the time.' Unfortunately, the experiment was vitiated in
various ways. Those who had volunteered to devise the programme
turned out to be architects, people professionally associated with
the communications world, or amateur photographers and film-makers.
Others, who saw the programme, would have liked to join in, but this
wasn't quite so serious because the programme had involved alike
teachers, women, and young people who were active in the Association.

AW: At what times was the work carried out?

GM: In the evening. There must have been six or seven taping sessions. Each one lasted three hours.

AW: At the flats?

GM: In the assembly hall, and sometimes elsewhere in the flats, which was important. People came down from their floors during the transmission to give their opinions at once: 'It's very interesting, but don't do a sub-ORTF; we need something relevant to our own problems.'

AW: How did they know when a programme was due?

GM: Through the residents' association, which issued a bulletin, and there was a call-sign to announce the programme and its channel. By the way, people could watch either the two ORTF channels or this programme; they weren't deprived of anything ...

AW: How many people were able to follow the experiment?

GM: Almost three hundred, that's to say the residents of staircases A and B, who could receive the programme on their own sets; the others could watch in the assembly hall on a large TV screen.

AW: Why were people insisting on having still more about local affairs, when you had already effectively recorded them?

GM: I didn't want to go into that, but since you ask ... A disagreement blew up in the production unit. It must be said that this buzzing around the team by all sorts of outsiders, some of them with commercial interests, had set up various tensions. Two or three days before the transmission, one of the technicians had pinched the ½-inch tapes,(5) and there was nothing for it, in the ensuing panic, but somehow to cope without the tapes actually recorded at the residents' meeting. In the end we had to show a film borrowed (surreptitiously) from ORTF's research department. Fortunately, we were still able to do some direct taping on the evening of the transmission. The committee of the Association happened to be in the temporary studio at the flats at that time. So the fact that the residents had come to express their opinions at the invitation of the committee given on the screen, to some extent redeemed the situation.

THE MACROSOCIOLOGICAL LEVEL

During the transmission the inevitable clanger was dropped, by a committee member: 'The programme you are receiving now is an example of what will happen in the future, when the state monopoly of ORTF has been broken....'

Now, the breaking of monopolies, a cause readily espoused in the current thinking of all French politicians, is, to say the least, a complex objective. It not only poses the question of finding the material means, but also presupposes technical expertise.

If the experiment acts as an introduction to this strange phenomenon of a new form of community life that is both 'audio-visual' and urban, and drastically reduces the size of the populations involved - at the moment when they are properly and specifically involved - it shows that this form of decentralization has hardly any chance of taking root if it doesn't move on to an 'industrial' level of production. The equipment, the training of technicians, and

even a certain type of production have to be realized on a large scale if one really wants to promote the development of a third force. In other words, and in view of the massive commercialization of video that is imminent, it is still necessary to have recourse to the state.

Already, on financial and technical grounds, internal studios in large residential complexes can no longer function with portable video equipment; it is now a matter of 'serious' studios, which are therefore expensive and necessitate at least one or two full-time trained technicians. To do things properly certainly requires that the programmes should be discussed and the discussions analysed and turned to good account. Experiments should not only be tried, but carried out over quite long periods to a satisfactory conclusion. Expert contributions to programmes will be necessary, and hence the development of networks of production and exchange and so on.

Of course, the political element will soon creep in. Various French political forces are sensitive to the constraints imposed on them by the ORTF monopoly. Although almost illiterate in audio-visual matters, they would obviously like to get a foothold in the new networks.

AW: Can't they resort to specialists?

GM: They could, of course, get the work done by teams of techni-cians, audio-visual specialists, but it's risky. The social problem and the technical aspects of the post-television age hang together. If you bring in outside technicians to 'treat' local situations, they will make mistakes. It is difficult to separate figure from ground.

The intersection of the economic, juridical, and technical dimen-sions of the problem occurs in the context of tension between the micro- and the macrosociological, in an area that is still extremely shadowy.

In analogous, but by no means identical conditions, the press has managed, more or less successfully, to extricate itself from the contradictions with which the political forces have never ceased to be preoccupied. The nature of video as a medium, like the nature of these urban 'communities', still remains largely unknown. For the time being the debate is located at the level of industrial com-panies,(6) and at the horizon of international audio-visual confer-ences; the emergence of the 'third culture' type of phenomenon - participative culture - faces the threat of suffocation, and of distortion.(7)

NEW FRONTIERS IN EDUCATION?

'Residential' VT raises in an interesting way the problem of the contradiction between the necessity and the limits of amateurism, the problem of audio-visual professionalism; and it does so in relation to the established forms of education in 'language'. Indeed, interposed between spontaneity and the elitist attitudes of the literate are the problems and the potential of a technical tool, and equally of an audience to which one cannot, for once, fail to address oneself.

Portable video equipment could serve the purpose, for a certain

time and for some situations. It allows very wide scope to raw
experience; it favours the immediate; and the inadequacies of the
photography are compensated by the sound and the direct interest
of the content.

> AW: What are the differences here between portapak and more
> sophisticated equipment?

> GM: The Montparnasse experiment already had at its disposal a
> control room and two cameras, which made it possible to shoot the
> discussions between residents in alternation; this produces a
> better rhythm and the field of view is more complete.

> With a single camera, the sound becomes more important, and
> since the camera remains in the same place as a rule, it can edit
> the film by its own changes of position, by altering the angle or
> the axis, which gives privileged status to time, to the unfolding
> of events, rather than to space. Aestheticism is avoided and
> everything is concentrated on the unfolding of events, for exam-
> ple on the interaction process in a discussion. So long as some-
> thing is really happening, this is excellent....

In certain circumstances, the technical characteristics of portapak,
which impose direct contact with the essence of the content at the
expense of form, have some affinity with the asceticism found in
'art pauvre'. By forcing the operator to move close to the people
sending the message, the lens emphasizes what most closely touches
those concerned with the problems under discussion, but the limit-
ations of this procedure do not fail to make themselves cruelly felt
by comparison with films or with the productions of highly equipped
TV companies, or when the topics discussed are not directly contro-
versial.

If, as is likely, local resources do indeed remain relatively
modest, the operation of this instrument will in every case have to
be undertaken in full knowledge of the situation; the production of
programmes will require a dual competence: in getting established
locally and in developing audio-visual skills, or even creativity.

> AW: Haven't people remained rather backward on the audio-
> visual level up till now?

> GM: There's a kind of illiteracy in this respect.... Lots of
> people don't understand even now that there can be exigencies of
> audio-visual language, particularly in a situation of widespread
> distribution; we must become aware of various aspects of the
> perception of pictures and sounds. But working out a synopsis or
> a script, or improvising takes when in the thick of things, is
> another matter entirely.

Only a real questioning of the canons of school and university edu-
cation would remedy the present deficiencies of training in the
audio-visual sphere and in the acquisition of active skills.
Learning and creating new languages, working towards the solution
of different kinds of practical problem, through active involvement,
are indispensable, even in a context of spontaneity and authenticity.
Now, people who are sophisticated in literature and the cinema
develop a hypercritical capacity that all too often excludes crea-
tivity, particularly of an 'ordinary', everyday kind. So to exer-
cises in critical analysis and theses must be added really practical
work involving social and technological relations.

It may be found more irritating in France than elsewhere in

Europe that these practices and the difficulties of inventing a
language that can translate more of the inexpressible into an
acceptable form of expression demand the abandonment of clichés -
certain forms of image of society - and cannot be achieved by means
of the customary intellectual techniques.

Is this a field in which less structured, or anyhow less fixed,
images will develop, spread, and finally become embodied?

Video raises a problem of embodiment. If TV sets - receivers -
invite or even compel projection onto already elaborated images,
recourse to VT - which is, above all, a producer system - leads to
projection onto the actual elaboration of images. This is, if
nothing more, a reversal of perspectives, the potential of the
immediate.

A LOCAL VIDEO NEWSREEL
Bourges

In July 1970, the Ligue française de l'enseignement(1) assembled in force at Bourges for its national congress. Its young school-age members and the permanent staff were arriving from all parts of France for four days.

How was this meeting to be organized? Should it be treated as an internal celebration for the association, a get-together of all the regional federations for secular education, or should there be innovation and expansion, with a bid to bring together the town and the supporters of the League? The second solution was chosen.

During the preceding year, each branch undertook to prepare its contribution, in the form of singing, dancing, plays, workshops, various 'happenings', sales of regional produce, and so on.

The whole activity was co-ordinated in Paris according to a master-plan which designated zones and allocated the federations by district, taking in schools, social centres, gymnasiums, theatres, public gardens, and other places where the events would be held. The duration of the congress - four days - was a rather short time in which to bring together these young people and the inhabitants of Bourges (the 'bourgeois'!), so it was necessary to pull out all the stops to stimulate an exchange:

1 a daily newspaper covering the congress was launched;

2 radio links were set up;

3 the League's audio-visual unit (MM. Gautier, Zimmer, and Mazodier) contacted the journalist Bernard Tournois (formerly of ORTF) and ACT in order to organize jointly a mini VT network, with a daily edition of twenty minutes of news, to be broadcast (by means of duplicate tapes) from various strategic points in the city.

Several months before the event, it had been agreed with the media department of the League to make use of video in trying a new experiment in cultural animation: to forge links between the urban areas, the local population, and the congress.

GM: Apart from the limitations imposed by the short duration of the congress, there were material constraints to dampen our enthusiasm. Nevertheless, it was decided to have a VT-TV newspaper, which was in fact produced. A central team based on the Maison de la Culture determined its content with two production teams, the first for editions 1 and 3, and the second for

editions 2 and 4. It was an operation in which you had to do
things at top speed and work unremittingly, and two teams could
just about cope with it.

Making a local VT newsreel come alive is above all a matter
of good journalism, but it can also be something more.

TWO-WAY COMMUNICATION

There were 2,500 participants in the congress. The success of the
VT productions undoubtedly depended on that of the overall event.
The participants were trying to establish contact with the local
population; besides the exhibitions they had organized, they per-
formed folk dances in the streets - towards which people were often
rather resistant. On the other hand, in some of the public squares
and in certain parts of the town, or in the cafés, for example
during the sale of regional produce, real discussions got started,
and even continued, between the 'missionaries' and the 'natives'.

By tackling their own problems, the animators precipitated a kind
of syphonic effect; the local people began to reveal their problems
as tenants and consumers in regard to social issues and social and
cultural needs.

AW: How was it possible to bring video into all this?

GM: In each of the urban zones we had defined, a twenty-minute
VT newsreel was put out every day, at noon and in the evening, in
certain cafés. When the zone was 'cold', the congress members
watched it almost on their own; this was principally the case for
programmes dealing with matters affecting League members. When-
ever the programmes were based on encounters with the people of
Bourges, that's to say after events organized by the animators
the previous day, local interest became apparent.

AW: Why call this a 'newsreel'?

GM: It was, in fact, for two-thirds of the programme a report on
the internal activities and interests of the branches of the
League (exhibitions, discussions and so on), and for one-third a
presentation of local issues picked up in our exchanges with the
people of Bourges.

The newsreel had a double function: it crystallized a particular
state of affairs within the congress; it took stock of the situa-
tion. On the other hand, the contacts with the local population
served to stimulate a mutual awareness between members of the
League and some of the townspeople, to create an interest in com-
municating, to reveal similarities and differences in the preoccu-
pations of different regions or different social categories, and
perhaps to suggest some new solutions.

A forum on problems of employment facing the young people of the
locality may be cited as a positive example. Interviews were taped
with some young people, as well as conversations with local trade-
union officials.

GM: It was rather like a regional TV magazine, but it went deeper
and came closer. A seminar lasting three half days had given
food for thought to some educationists and some of the animators;
then we taped about a dozen young people, and their criticisms
and demands brought a sort of illumination, something that they
rarely risk showing on TV.

Even rarer, a reverse communication (local inhabitants to the news team) proved both possible and successful. A population of between 500 and 1000 people, from all the eight zones, followed the programmes each day. Little by little the news got around of the encounters between the animators and a section of the population. Exchanges took shape. Leaders who had emerged in the zones met each other.

> GM: They already had some idea, thanks to VT or to direct contacts (but they had hardly any time because everyone was very much taken up with his own zone), of what had been done that was of interest to them in the other zones and in the congress. In fact there was a danger that dispersing the congress would sink it.

There was opportunity for criticism, both of the newsreel and of the activities:

> GM: Right at the beginning one of the animators was interviewed. 'It's a bit shapeless,' he said, 'what is to be done to make real contact with the people?' During the programme, the journalist in charge of the video team commented, 'And now the animator you have just heard no longer has any reason for disquiet, the contacts are under way.' After seeing the programme, the animator was annoyed at this 'manipulation', since he wasn't sure he shared this optimism. He was given the right of reply in the third edition: 'True enough, contacts with the locals have been started, but not in a way I'd always answer for, and so on,' and he explained his point of view.

So osmosis took place, not only in relation to the content of an event but also as a result of its creation. If a certain relationship can grow up between zones, or between the organizing activity and the people encountered, it is further completed by a temporal relationship between various moments in the growth of an event, which is not simply reported afterwards or from the outside. The people presenting it, like those interviewed, are participant-observers.

Nevertheless, this temporal dimension is not unrelated to the content and form of video presentation. It raises a problem that is rarely spelled out: film and TV are served up to us like ready-made dishes, and if we are not easily able to understand the 'culinary' stage that comes first, is it not because few of us have the opportunity of seeing the rushes and discussing the montage?

THE PROBLEM OF RHYTHM

The mismatch between duration experienced at the time and duration perceived while watching a film or tape is difficult to eliminate by means of editing alone; the interest of the content and the acceptance of a style in outline are necessary, and the latter has to be suggested; so a certain degree of dramatization soon becomes inevitable.

If there had to be a choice between sequences that were technically successful, though rather uninteresting in content, and others that were interesting but technically weak, it was generally the latter that were retained.

> AW: How was the editing done?
> GM: We had a chief producer, an old hand from television news;

someone from the congress staff; two trainee assistants; and an
operator from our group (ACT).

The use of portapak makes it possible to enter into situations that
are rarely open to a TV unit. Furthermore, ideological consider-
ations tend in the same direction. For instance, a tape was made of
a strange 'ritual dance' by participants in the congress who were
rolling tyres along outside the entrance to the Michelin works,
passing the tyres from hand to hand when the workers were changing
shifts. The light was so poor that the sequence could never have
been shown on TV; in this case it was retained for its intrinsic
interest, and was accompanied by explanations that were all the more
necessary because the dialogue between the students and the workers
had stopped abruptly (the students were talking through megaphones
and failing to make themselves understood by the workers, and so on).

On the other hand, since the production units were short of time
and resources, they sometimes shot frantically and more or less at
random. Some of them therefore recorded little of substance, al-
though the superficial technical quality of what they did might have
been relatively good.

AW: Was the problem of rhythm also a factor of the equipment?
GM: Yes, partly, but not entirely; this congress was on quite a
large scale, and obviously a cameraman using portapak could not
work in the same way as a television unit with several operators,
transport and so on. There was no possibility of changing tac-
tics or technical procedures in order to give some life to a
scene that hadn't much. Portable equipment sometimes offers
interesting advantages, but it often turns out to have limit-
ations. So our operators set out on their own in pursuit of the
picture. They could shoot only once, on the spot. It only
needed the actual rhythm at the time to be slow, or for the
operator to shoot too short sequences, to land us in trouble.

On top of this, electronic montage is far from simple; running the
original tape from a TV monitor to another machine that records the
sequences one wishes to retain or insert in a new tape is an acro-
batic feat that is nothing like editing a film.

All the same, the problems of rhythm go beyond the purely tech-
nical. If the videotape does not always satisfy the actors or the
operators, their disappointment is partly due to the mismatch be-
tween time as experienced and time as re-experienced when the tape
is shown. Judgments of a sequence are even harsher from those who
have not experienced the event on the spot at the time when it was
shot.

GM: In the morning, the production unit on duty were provided
with an outline to follow, but with constant improvisation; in
the evening, the editing unit had a look at the raw tapes before
they all had dinner together, and then followed long editing
sessions. The discussions about the selection of material were
among the liveliest and most interesting that I remember because
they really stemmed from a collective enterprise and they led on
to talk about the technical operations and their pitfalls.

One of the major difficulties lay in the fact that you could not
revoke a decision or an operation carried out at the beginning of
the definitive tape; only corrections to the soundtrack could still
be made.

At the moment of selection it was not just a matter of extracting the wheat from the chaff, but of deciding what would bore the audience: to what extent will the content, and possibly the sound (commentary, music) help to put across a scene that has few variations of rhythm? Will the audience forget the reference to the cinema or to the theatre and think about the fragment of everyday life put before them?

> AW: In what way could the make-up of the bulletin be used to vary the rhythm of the programme?

> GM: First of all there was the problem of transitions, most often made in words, but sometimes in pictures. We went to great lengths to avoid artificiality; the experience, and above all the sense of humour, of the chief editor were a great help here. The main problem was in cutting and assembling the sequences; there were heated discussions about this; it was a means of really getting inside the material, and in such a profound way that no one minded how long the sessions continued. Work used to go on until two o'clock in the morning.

The ultimate objective was to develop a style, an impossible task in the time available, but a start was made. Over and above the technical questions, understanding the problems dealt with by the people and knowing some of their reactions to the programmes - together with the desire of the team to express themselves - brought about a confrontation with a kind of 'total' cultural phenomenon. Many of the projects failed, but others seem to have succeeded. The participants agreed in estimating that two out of four of the bulletins were both lively and interesting. What deserves to be retained from this experiment is its particular 'melting-pot' quality.

> GM: There was a good deal of creativeness, in both the shooting and the editing; some of the operators very quickly and almost instinctively found good angles for their takes and good subjects; ideas bubbled up during editing; lots of alternatives cropped up. This 'hot' style of working has something irreplaceable about it.

Let us consider for a moment the mobilization and fertilization stimulated by working in an improvisatory way. Knowing how to throw into the moment the best of one's accumulated experience, but to throw it into a vast, unknown environment (a town) where something to be grasped is going on continuously, and to improvise solutions that are partly predictable - the script - and partly unexpected, including and transcending a purely reactive adaptation, this is a modern style of creation, close to something that the better jazz musicians have always known.

> GM: The best way of working in video may well be to edit spontaneously while you are shooting; for example, you must find whatever it is in the situation that will gradually bring the viewer to understanding. Over and above a good appreciation of what is going on and of the intended audience, it takes unremitting watchfulness and an absence of hesitation.

We are a long way from understanding all the reasons that make a given operator succeed in distilling the essence of an event (and perhaps these are by no means the same qualities or the same characteristics that make a good ciné cameraman or a good classical

director), or in capturing the life of an event by focusing his
shots on certain aspects of a process. Some cameramen come to feel
this flux in some way; others fail to do so. Could it be that by
going to the heart of the matter one sets up a true communication
with the audience; that this is a necessary, but not a sufficient,
condition?

Similar questions arise in connection with group creativity.
What are the virtues of this 'hot' style of working, in which the
team shares in the excitement of the event, or simply works togeth-
er non-stop to complete a herculean task against the clock, the
state of emergency resulting only from externally imposed delays?

Because it is eminently suited to work done under pressure,
video, and the explorations currently being made with it, seems to
be at the very centre of activities bordering on 'utopia'.

AUDIO-VISUAL X-RAYS

Since they were carried out in a very fluid, or at least in a very
informally structured situation, and one that is highly dynamic from
the outset (with confrontation and opposition), videography and
videology have a good chance of becoming actively revealing and
transforming.

The descriptive, videographic level, which objectivates, trans-
muting the immediate experience into a second-degree experience on
an audio-visual tape, is intercalated at various phases of the life-
cycle of this congress.

GM: Video translated the problems raised at and by this national
congress at Bourges much more effectively than did the press.
Like all congresses, this one led to the kind of extravagant and
inflated ideas that quite naturally possess concentrations of
members of the same profession, so they end up by forgetting that
they aren't the only people on earth. ... The tapes conveyed a
completely different picture of the importance of the congress.
What is a cultural animator? What are the participants talking
about? And what exactly do they want to do? Being able to
record and immediately to re-view people's indifference or ignor-
ance reduces the event to its true proportions. While being
inside the event one is drawn outside it; one surveys its boun-
daries; one's eyes are opened. It's much more raw, much more
powerful, than a newspaper article, or even than chunks of ver-
batim interviews.

The video newsreels brought a number of stages into existence.
Even regarded as a kind of inventory, they had the solidity of a
living object, of which the congress members and the local people
also formed part, whether they wished to or not.

The 'video-logic' of this experience, however, goes far beyond
the mere statement of it.(2) Video is, paradoxically, both nearer
and farther away than a film or TV. The distantiation in relation
to what has been personally experienced that is felt while viewing
the tape readily produces exceptionally stringent criticism.

GM: The impact on the people of Bourges of the role played by the
cultural animators with all the idiosyncrasies of militants and
teachers ... you could not fail to be aware of the limitations of

their cultural action ... fundamental reassessments were
stimulated.
In the case of the teams running the video newsreel, this combin-
ation of collective and creative activity had qualities usually
attributed only to group dynamics sessions.

To begin with, this work helps to bring about decompartmental-
ization and to enhance creativity and expressivity; on account of
precipitation and the need, for example, to shoot on the spur of
the moment, the people involved form a 'precipitate'. But the
chemistry of bonds between the various members of a team is highly
explosive; misunderstandings lead either to outbursts or to a reso-
lution, and if all goes well to the abandonment of prejudices.

GM: I noticed here, as at other times, that video helped people
to recognize and accept the realities of a situation.
It acts also to dedramatize and to reduce tension. People who see
themselves in the videofilm can achieve a distance relative to the
roles they embodied in the recorded action. They are able to stand
aside from their roles.

GM: Drama is reduced ... relations between the video team and
the animator-teachers were rather hypocritical; they didn't
take each other too seriously. Now, this work involved us all
very deeply, we were forced to explain ourselves; in spite of
differences, a mutual respect grew up ... underlying all this
was something much more than discussions. The tapes provided a
continuous opportunity of seeing our reactions, which were often
divergent, as it were concretely illustrated....
Though it cannot be denied that the value of a working-tool mainly
depends on its users and the circumstances in which it is used, it
seems to us that one kind of practice is more logical than another,
given its technical characteristics and, furthermore - and here we
come back to circumstances - in view of the historical moment and
the situations in which it arises.(3)

REGIONAL VIDEO
St Cyprien

Whereas the experiments so far reported emphasize reciprocity in communication, the cultural action we are about to describe is a set of activities connected primarily with distribution, and secondarily with sociological research. The notion of parachuting is used in a number of senses, notably in relation to centralization: it is said in the local branch of an industrial concern whose headquarters are in Paris on the arrival of a graduate engineer appointed by them, that the man has been parachuted. It may be a commonplace that many such parachute descents, including cultural ones, are made from the metropolis to the provinces, yet they are hardly ever analysed. In the present case, culture-shock is occurring simultaneously between urban and rural, ancient and modern, young and old, with the vertical parachuting from metropolis to province taking place against a background of horizontal para-parachutings. Now, the connections between these, so to say, political and cultural encounters are complex. In the present state of knowledge it is as difficult to talk about these relations as it is to practise video effectively without reducing its potential. Here again, we make no claim to do more than sketch an outline as an introduction to the problematics of videology.

SAINT-CYPRIEN-PLAGE

This completely new seaside resort comes into the category of regional amenities for Languedoc-Roussillon. Within the next few years, the resort will reach a population of about 50,000, according to the development plan; a management company is responsible for this, and more specifically for the new building plots, which were proving hard to sell at that time (August 1970). An association (Animation 70) set up by the company had the task of organizing the seasonal cultural life, which was based on such activities as cinema clubs, concerts, theatre, children's playgrounds, and exhibitions. Another organization was to be responsible for gala variety shows and suchlike.

GM: The ACT group was to collaborate with Animation 70, who had very limited funds. We could have two or three people working

with portable video equipment, but we hadn't much idea of what we were supposed to do. ACT, myself in particular, had taken on this job with a view to sociological research. How could video be used in the setting of a summer resort?

In a general way, this all fitted naturally into the regional administrative policy of tourist operations concentrated on five or six new resorts. Perhaps the summer exodus to Spain would be halted or checked. Leading citizens in the locality therefore supported the various companies and associations, if only to safeguard their own interests. It is not at all certain whether the local population really wanted this type of growth. It seems that these resorts, whose frenetic activity is strictly seasonal, are regarded unfavourably by the 'natives', who often see them as parachuted.

The cultural animation was therefore intended to help to distinguish St Cyprien from other places and to make it saleable at least to tourists coming from elsewhere.

VIDEO WITH CHILDREN AND TEENAGERS

Holidaymakers of all ages crowded in their hundreds round the 'caravans' of Radio Monte-Carlo or Radio Andorra. Showbiz stars like Dassin and Hallyday attracted even the inhabitants of the region, who came from ten to fifteen miles around.

The video activities represented a kind of counterpart to these phenomena; instead of bringing distant things nearer, that is to say, giving concrete appearance to the idols for whom the public had long been prepared by the mass media, video aimed to make near things distant, to cause immediate realities to reappear by introducing distantiation through pictures. But show business naturally had an easier job than the video team, which, on top of everything, was working with Animation 70, whose whole idea was to turn video into a mobile mini-TV of restricted range, in other words a subtelevision.

The first difficulty facing the project stemmed from the need for the video activity to take account of the large cultural differences between the various populations, particularly in terms of generations.

Some children's outdoor workshops, for painting, drama, and so on, had been set up on the beach. If the video venture was relatively successful with regard to these workshops, it was largely due to their excellent organization, which was in the hands of the Catherine Dasté Company. Among others, the team of animators included some actors, who were very successful in encouraging the children in such activities as expressive movement, puppets, and musique concrète. From the start it was full of life and greatly superior to the usual beach playgrounds; parents had no hesitation in leaving their children in the care of the team. Indeed, the children were often happier in these workshops than they were with their parents, since their creativity was able to blossom away from family restraints.

What could the video team do in this framework, within the limitations imposed by the material resources?

GM: We were able to produce forty-minute programmes about these

workshops every week. For example, the children made up a story
to present at the puppet theatre festival. We taped the process
of creating this story, following its progress over a fortnight.
The kids participated so fully that I wondered whether video was
really necessary. They cheerfully left the beach in the after-
noons to work on the preparation of the play. However, they were
very much taken with video.

When the video team taped and played back some scenes for the chil-
dren during a work session, it became evident how much it was the
creative activity that interested them, rather than the story. They
soon came to 'embroider' on it, and to set off on new paths.

GM: Everything went with a swing, and the story in question was
quite typical: there was a circus, and a clown who was sacked by
the ringmaster because he had stopped making the audience laugh;
he had swallowed a sadness bug, and had run away to an island;
here he met the 'pioux', little creatures held in captivity by an
oppressive master;(1) the pioux had stolen a magic potion from
their master, who was also a magician,(2) so the clown was cured
of his affliction and showed his gratitude by freeing the little
pioux from their bad master, the magician.

Several groups were taped while playing their scenes. The
animators outlined the themes they were to enact and then let
them improvise. Then the group that had acted best gave its
version, the choice being made with the help of the video play-
back.

The children appreciated these feedbacks, but were by no means over-
involved in them, even when the operation amused them. Here again,
they were very quickly detached, even from the image of themselves.
For a moment they would be amazed, 'Look, it's you!' (laughter).
But the desire for action returned: playing, rather than watching
play.

Besides these rehearsals, among which the one for the performance
of musique concrète probably conveyed the creative excitement most
vividly, the video team went on to record the puppet show, and the
resulting videofilm was subsequently shown several times all over
the resort and even in the village. The audience of village chil-
dren was recorded in its turn while watching the show.

GM: Before the fortnight's work with the puppets, the animators
and about sixty children had thrown themselves into intensive
and many-sided preparations for a beach show (with another story
devised by the children). At the children's festival, starting
on the evening of 12 August, the performance was given along the
three miles of beach, at night, around bonfires, at one beach
club after another.

Although it was far from being indispensable to the preparation of
the show, video provided a means of re-viewing important scenes
from the performance.

GM: The videofilm helped the animators to become aware of what
they had succeeded in doing and what was lacking. The company
complained because they had been compelled to produce a show;
they would rather have worked on developing physical expression
and imagination in the creation of new stories and music. They
were afraid that producing a show, with a large audience and all
the rest of it, would only give rise to confusion, and that the

children would forget this awakening of their creative faculties, which would not be sufficiently established by the experience, since the show itself was becoming a much too significant external object. However, they had an opportunity for discussion with the children while they were watching the videofilm, and they tried to explain to them what it was they needed to go on with. Since the children and the animators were completely involved in what they were doing, as much during rehearsals as during the show, video would have given them subsequent opportunities for reflection; nevertheless, the intervention of video remained of minor importance in a setting that was so lively, creative,and effectively communicating as to have almost no need of outside contributions.

The child remains centred on himself, which does not obviate the need for a congenial setting for his play, but he is much easier to please than the adolescent. Teenagers are beginning to experience unhappiness, and they are trying desperately to put some distance between themselves and their families: to replace Pa by peers! It seems impossible to explain a lot of their behaviour except in terms of the desire to escape; for example, the fact that they are not at all addicted to television (escape from the family telly sessions). The St Cyprien experience showed that, if one wishes to develop the relations of teenagers with each other and with the VT-TV complex, sociological understanding of these two milieux, on its own (although indispensable and far from being achieved), will hardly be enough. The differences between the teenage holiday-makers and the teenage villagers are enormous, and meetings between them are rare and almost impossible. Special conditions would have to be set up if one wanted to encourage meetings and break down barriers to communication.(3)

AW: What can be done with video among teenagers?

GM: The young holidaymakers between 15 and 24 years of age sought out cafés, pin-tables, music-halls, and night-clubs. They were hardly to be found in the new district we were supposed to be concerned with, or even on the beach. And this was even more the case for teenagers from the region. Young people from the country, working on the land, could be met, if at all, in the dancehalls on Saturday night or at the local village fêtes. The problem of these two categories of teenagers - the young country people often representing themselves as emigrants under compulsion, attracted but ulcerated by the superiority of the capital, and the young holidaymakers behaving like 'Parisians', both happy and unhappy to be in the South - could have given rise to a comparison, or even to a confrontation, which would have been both socially desirable and sociologically interesting. It was impossible to bring it about.

AW: What comes between the states of childhood and adolescence, how does the transition occur?

GM: It isn't easy to define this 'between-two-worlds' situation, but we were impelled to think about it after seeing the contrast between the children, who were so intent on their creative activity, and the teenagers, who were linked together in pairs. As well as a much more rapid entry into adolescence, there is probably a prolongation of that state, particularly among students, in whom the impulsive side remains to the fore for a long

time. It seems that in the intermediate state between childhood
and adolescence models provided by the media play a very promin-
ent role.
This is an area that has received very little attention in France,
but our examination must be carried a little further in order to
suggest the part video might play, at least hypothetically.

During the first stage, after the rejection of the father and
before the peer group assumes such great importance, television and
certain models of life are available to fill the void. It is the
factor of age that explains the extraordinary success of programmes
specially designed for 'the gang'. Towards the end of this stage,
because of the rigidity of the regular broadcasts which pour out
enormous quantities of this mass youth subculture, satiety and
impatience supervene; what they want is action. The next stage is
characterized by a desire for emancipation from a level that is far
too exclusively symbolic of participation in a subculture; social
participation, belonging to gangs and peer groups, going out togeth-
er, takes over, again in relation to models largely learnt during
the preceding stage (clothes, language, musical taste). The isola-
tionism of a subgroup, a kind of autonomy, is established, but it
is mainly prefabricated, and is mingled with dissatisfaction. This
concentration isn't creative, as it is with the younger ones in the
workshop, and it isn't play; what they feel involved with is a style
and their own problems. Adolescents at this stage wander about the
old beaches, which are more urbanized than the village or the fun-
fairs and cafés, hoping they will meet someone. There is very
little chance of their getting together with the young people from
the region.

> AW: Were there never any contacts between the summer visitors
> and the young people of the region, in the dancehalls, for
> instance?
>
> GM: I saw a few, but they went off rather badly. Some hippy-type
> visitors ventured to go to a village dance. Some hefty youths
> soon got interested in their girls, who came from Toulouse. It
> should be explained that the country boys admire rugby stars,
> there's a cult here of physical strength. They come from a cul-
> ture that still recognizes male pride and all that. The meeting
> never took place; it finished before it began - with a fist-
> fight - and the visitors made themselves scarce.

The impulsive side of the rural teenagers expresses itself in quite
another way. There is still the dream of another society, but it
still has a regional location: they would find it by emigrating to
the North. Sometimes their isolationism takes a regional form: 'We
are Catalans.' In their music, dancehall pop, foreign models count
for very little. Their interest in technology does not go much
beyond the modernization of agriculture and transport. The agri-
cultural crisis and the specific problems created here by military
service are subjects whose hard reality scarcely conduces to a
dialogue with university students, even from the same region. For
them, and above all for the village girls, family and church are
still the heavy hand that weighs on them far more than the models
purveyed by the mass media. From their point of view the construc-
tion of new beaches is an entirely external phenomenon. If they do
not often go so far as to speak of colonization, some of them, the

Catalans in particular, certainly experience it. Their problem, or
part of it, is to create a new culture adapted to the changes they
are aware of, in spite of everything. For the time being, very
often, they are bored.

 AW: What could be done with video?

 GM: We could have taped the urban and rural teenagers, and their
 occasional meetings. We might have arranged things so that the
 visitors went to dances, and taped them there, and above all we
 might have shown them the videofilms and encouraged discussions
 to develop among them, even between gangs. But this wasn't
 possible.

The necessity and the possibility of achieving collaboration between
sociological research and a certain style of video practice are
quite evident. But they are unlikely to be realized within the
framework of a policy of regional development such as that at
St-Cyprien-Plage, or of a policy like that of Animation 70.

 As regards the adults, the logic of their situation could have
been approached primarily by means of detailed reporting on the
summer life of a few families. How did they organize their house-
keeping and shopping; did they establish neighbourly relations
(with other visitors or with village people); what did they do with
the children? By following families to the beach, and during the
evening, it would have been possible without undue difficulty to
examine the relative gulf between holidaymakers and villagers, to
show the problems caused by the appearance of the new beach and the
paradoxes between the life of the visitors and the life of the
market gardeners, fishermen, and others.

 None of this could be attempted. The video magazine was reduced
eventually to purveying superficial chit-chat from the empty shop
that housed the video studio to the exhibition hall of Animation 70
and sometimes to cafés near the beach or in the village, and to
starting up conversations about the equipment, which was too un-
familiar not to have some of the attraction of 'magic casements'.

THE CONTRADICTIONS OF MINI-TV

Most of the summer visitors are televiewers, devotees of watching
with the family, with the exception, needless to say, of the
intellectuals.

 Now, for the summer visitors, TV is hardly available at all
except in public places, which is different from what they are
used to at home. It is to be found in hotel lounges or in cafés,
even in those where the patrons still lean their elbows on the bar
while others are playing cards (in this case TV becomes aural wall-
paper). The set remains switched on for hours as a matter of
course, and is watched only intermittently except during football
matches and, especially in this region, rugby matches.

 Although the influence of mass communications is hardly in doubt
as regards the stars of pop music - judging by the behaviour of what
can only be described as crowds when a contingent of stars 'des-
cends' after the shows traditionally broadcast from the resorts(4) -
it seems most unlikely that TV offers any opportunity here for act-
ive participation.(5)

However, quite a rapid development is under way in the Catalan
region. A kind of ferment seems to have been stirred up there,
chiefly by the regional TV transmissions, whose programmes have
been progressively increased. But it seems to us that the cultural
potentialities contained in encounters between 'natives' and 'visi-
tors', via the TV medium, are considerable. All the technological
potential of TV needs to be brought into play in order to break
down the isolation of the local communities, which are wrapped up in
themselves, and likewise with the uprootedness of the aggregations
of summer visitors. Breaking with the classical tradition of
regional broadcasting, a closer TV, based on the logic of the 'dir-
ect', would forge less artificial links between the two categories,
and stronger ones within the regional community, even though it
would still be tele-vision.

Of course, neither the visitors nor the villagers would manage to
express themselves freely about their real needs since these have
never, as it were, had the opportunity of emerging through the mass
media. All that can be predicted with confidence is an enormous
discrepancy between their respective expectations.

A research team carried out a sociological study (financed by the
Ministry of Cultural Affairs) on cultural animation in four new
resorts. Had the video team been able to collaborate it might have
proved possible to set on foot a process whereby the needs of both
visitors and villagers were brought to light, particularly if inter-
est had been focused on potential needs rather than concentrating on
the animation that had already been achieved.

GM: We were able to do something with the children's workshop, but
 that's about all. Apart from problems of resources and time,
 what might be called strategic difficulties had intervened, since
 the various teams doing research, or video, or animation were
 parachuted from headquarters and most of the time suffered from
 internal divisions based on highly divergent political orient-
 ations. All the same, it was possible to use video to lance the
 abscess, to use the pictures for discussion, but in actuality
 the differences of opinion never broke out except between indiv-
 iduals. As soon as groups were present there was the most ela-
 borate hypocrisy.

The objective of the video team should have been to contribute to a
sociological understanding of the region through action research
bearing on the contacts between different populations and on their
problems. Producing a magazine reviewing the previous week's
events and promoting the activities of Animation 70 was too limited
an objective, though in material terms it was very ambitious.

Carried out with sufficient skill, this really could have been
action research. By examining a selected milieu each time (visi-
tors' families and rural families, young people from the village and
from the beach, fishermen and sportsmen, and so on), the research
could have supported a weekly magazine with precisely the kind of
'vision' that would not be too 'tele' (distant and alienated) from
the important realities of its surroundings.

Of course, this would have monopolized the team's time and would
not have commanded large audiences; it would have had to be done for
just one sort of sub-population, which would have been contrary to
the intentions of the Animation 70 group. So there was nothing for

it but to beat a retreat and do mini-TV in mobile caravans. This
was concerned above all with broadcasting information about the
activities and budget of Animation 70, with 'hailing the conquering
(local) hero'. From there it was only a step to subserving the pur-
poses of what was really publicity in the commercial sense. To
crown it all there were demonstrations on the technical aspects of
video.

Corresponding to this bar imposed on 'vidéo-vérité' or 'partici-
pant video' by local interests(6) was another, this time connected
with the regional administration.

GM: Everyone in this region knows that the farmers, the market
 gardeners, and even the fishermen are in serious difficulties,
 and that there is quite severe underdevelopment. The heavy
 investment in tourist amenities that remain unused for three-
 quarters of the year is not regarded favourably by locals from
 the undercapitalized part of the region, particularly because
 they are inclined to believe that the wealthy shopkeepers of
 Perpignan are the only people who make profits out of tourism.
Discussion about such problems as these was automatically suppres-
sed because no contact occurred between the various cultures. To
put video on the track of socio-cultural exchanges of this kind was
even more unrealistic than to bring the two types of teenager
together: utopian maybe, but necessary and technically feasible.

The only aspect of this mini-TV that was relatively more creative
than its role of herald came from the idea, which was given equally
little effect, of making it into an alternative TV, and showing what
a team unconnected with ORTF could do. But there was a lack of the
experience necessary to make it into a real video style of work,
with the direct participation of amateurs.

A regional development programme and a plan for administering a
seaside resort are launched, and different teams try to implement,
study, and accelerate cultural animation on the spot. To the first
level of organizational or institutional parachuting is added a
second: cultural parachuting. In fact, even in the absence of
adequate empirical data, evidence of considerable cultural differ-
ences is obvious to reflection. Any unified programme or practice
cannot fail to be exogenous to each of these subcultures.(7)

In a book concerned with socio-videographic and socio-videological
exploration, illustration of the obstacles and dangers of a praxis
based purely on distribution - the creation of a sub-television -
puts us on guard against hopes of a transformation that video
cannot introduce or encompass except where the situation and the
social forces have already brought them at least to a state of
germination. And the obstacles are also, some of them, powerful
and well-supported strategies.

FILMS OF UTOPIA AND UTOPIAS OF FILM

WAITERS
Migration from the role?

We need not watch long before we can explain it: he is playing
at <u>being</u> a waiter in a café. ... The child plays with his body
in order to explore it, to take inventory of it; the waiter in
the café plays with his condition in order to realize it.

> J.-P. Sartre, 'Being and Nothingness'

In this famous passage about the waiter, the emphasis is placed on
role-taking. The analysis stresses the 'too great' eagerness and
the 'too keen' solicitude that the waiter shows the customer; the
waiter's 'movement is quick and forward, a little too precise, a
little too rapid'.

Erving Goffman (1961: 85-152) has pursued the same type of ana-
lysis in stressing the other aspect of the dialectical relationship
between the individual and his role. In fact, the individual does
'too much' or 'not enough' alternately, in order more fully to
endorse or more easily to support his role. Visibly to express
distance from the role one is supposed to be playing can (partly)
enable one to accept it. It is to the extent to which I succeed in
showing that I am not solely defined by the position I seem to be in
at the moment, that I can accept the assumption of a given role. To
put it another way: 'other' behaviours that have nothing to do with
an activity we are (partly) endorsing can be exploited in the inter-
ests of a system of roles, and in the interests of the individual
who has to get away from, or with, it.

We have chosen the relationship between waiter and customer for
our first video observation: the fields of observation are rela-
tively convenient, in any case they are public and there are plenty
of them, and this theme does not rule out going beyond simple des-
cription, as the considerations mentioned above already indicate.

Can video contribute to the description and understanding of a
micro-situation? What is the work of a waiter? Is it possible to
pick out these moments of 'play', of 'distance', that allow the
individual to take on the role and commit himself to it 'too much'
or 'not completely'? Finally, is it possible to go beyond analyses
made in terms of a system of established roles? In other words,
when is there distance disintegrative of the role rather than dis-
tance integrative to the role? Can it be said that the waiter also
plays a part in utopia, and if so, how does he try to migrate from
his role?

The first part of our experiment consisted in making non-systematic, paper-and-pencil observations 'with the unaided eye'.(1) We next made three twenty-minute video tapes in cafés of markedly different types; then came a partly collective, partly individual, analysis which was the outcome of numerous viewings accompanied by discussion.

OBSERVATION WITH THE UNAIDED EYE

It was not our ambition to innovate at any price, nor to compete with the well-known authors cited, on the basis of these very limited observations; however, we had to start somewhere. It is not an impossible task to contribute to the progress of thought, even in a field like that of roles, and in our university situation running a parallel series of direct observations and observations assisted by video involved accepting a degree of primitiveness: we could only envisage extremely simple experiments.

Our first step, rapid and unprepared observations of the café scene, made it clear that the unaided eye of the individual is by no means unadjusted in advance: as we have just noted in relation to the technology of the video camera lens and the operator's decisions, preconceptions guide both observation and interpretation, and these operations are successive only in theory.

Reading through the observers' protocols,(2) which in other respects are very varied in style, one immediately notes that with one exception they are all written from the outside. One writes and one observes - as if the author of the account could make an abstraction of what he is, and of what he is in the observing situation.

'I sat down automatically in a corner of the café,' writes one girl observer, without asking herself about this automatism: 'No one pays any attention to me, although I have taken out a pen and notebook.' The customers certainly cannot guess that someone is noting down observations; the eye that acts as a camera is not distinguished as such, whereas the camera acting as an eye will be spotted all too easily, as we shall see later. But people know or feel when they are being observed, the more so because they themselves never stop observing.(3) It takes very little to awaken their curiosity, if nothing more:

'You are working too hard,' someone says to a second girl observer, 'you are certainly writing a long letter.'

Some customers come in, and an observer notes that 'one of them has a parting in his long hair; he irresistibly (sic) recalls one of the Three Musketeers.' Literary preconceptions. Other observers let social preconceptions intrude, which coloured their observations with disappointment (as regards expectations) or reproach (as regards norms):

The waitress puts my order in front of me quite gracefully, but without a word.
She fills my glass, but goes off without saying a word; the other waitress is more friendly.
She seems nice, but completely professional.
She makes too much noise with the dishes.
She's unprepossessing, not at ease, ... and so on.

Descriptions are sometimes given in very concrete terms, minutely
analysing whatever draws the attention. The following extract
shows how photographic observation with the unaided eye can be:

> There are two boys not far from me. The older one has long
> black hair, an embryonic beard, a silver chain bracelet on his
> left wrist and a black band round his right, and a ring with a
> red stone. He is sitting in a corner with his feet on the seat,
> and an embroidered sheepskin coat beside him. The other seems
> much younger ... etc.

This passage, and all the description provided by this girl student,
do not refer to the waitress ('I was so interested in my neighbours
that I forgot to observe the waitress'). It is a useful reminder
that the relation between waiter and customer is so well 'known'
that it easily becomes part of the décor and one forgets about it
in one's absorption in other matters. It also shows the subtle
influence of the cinema on perception - familiarity with close-ups -
even among those who do not yet belong to the TV generation (the
student in question does not have a television set at home).

Be that as it may, the significance of the waiter-customer rela-
tionship itself varies in a given situation. From another account:
'The waitress is unobtrusive; hardly anyone pays any attention to
her ... apart from two girls who really look like her in every
respect.'

Ethnic or class factors were obviously invoked as explanations
of the different kinds of interaction observed between waiters and
customers. They serve to show how groundless were the fears of the
student who refused to take part in the exercise on the pretext
that it would not get to grips with social relations. And the
importance of sex is readily perceived; for example: 'A group of
young men are chatting up the wine waitress and she seems to be
enjoying it....' Culture and nature at the same time, no doubt, but
the analysis hardly goes deeper. At the most one might hazard the
hypothesis that the intrusion of nature into the café situation
might be an element prejudicial to strict observance of the profes-
sional role.

From another account: 'A customer has wandered right round the
café with his dog; the animal puts its front paws on all the tables
and begs for lumps of sugar; the customers and the waitress talk to
it, and to its owner.' Intrusion of the domestic into a non-private
setting. We will return later to various ways of stepping out of
role. One good thing about this non-systematic neo-reportage is
that it reveals as much, if not more, about the observer as about
the observed. In trying to be objective, the student has made an
effort to put himself in parenthesis, relegating his own ways of
seeing, and his very presence almost, to the domain of things that
ought to be concealed. His selection and interpretations are not
made explicit and are therefore difficult to identify and discuss.

We may note that this mechanistic conception of objectivity
derives from the 'neutrality' characteristic of individualistic
liberalism. As an exception to this, one observer, who was for-
tunately in a bad mood on that particular day, describes the rela-
tions between waiter and customer and customer and café quite
explicitly from her own point of view. She recounts a process of
frustration, complaint, and interaction with the service. Her

account also shows how interesting it would have been to analyse the
situation at the actual moment of an incident. Some other protocols
also tend in this direction. The realities of hierarchy become
apparent as soon as a waiter, passing too close to a table, spills
coffee on a customer's dress; excuses, irritation, remonstrances, and
so on.

Will video be in the right place at the right time? Will it be
a disturbance in the situation under observation and itself create
an interesting 'event'?

VIDEOGRAPHY IN THREE CAFÉS

It is not our intention to play off one method of observation
against another; the only objective is to advance understanding of
the latent potential of video. For example, it is possible that
the video observer will forget to train his camera on the notice
informing customers about the rules with regard to tipping. In this
case visual observation repairs the omission.(4) On the other hand,
the tape may include a sequence showing the payment of a bill; it
will constitute the document upon which repeated efforts at analysis
and interpretation will be brought to bear, providing a much-needed
basis that had previously been lacking.

Café A, visited between 1.00 and 2.00 p.m., like cafés B and C, is
small and serves meals. In order to have room to manoeuvre - for
technical reasons, in this instance - and also because all the other
tables are occupied, the observation team settle in a corner of the
establishment. It is just on one o'clock. In the front part of the
café there is one waiter, overburdened with work; the only help he
gets is from the cook, who brings some of the dishes to the tables.

It is a working-class café, also used by students. The tables
are crowded together, leaving little room for circulation, and even
less when the customers move their chairs.

The waiter works very slowly at such operations as making up the
bills, since there is great pressure on him and he has to run be-
tween the tables and the counter; he is tense and compresses his
lips when he serves the dishes. He has something rather unpolished
about him, though he makes occasional professional gestures like
taking an empty bottle or carafe by the neck and tossing it into
his other hand; he isn't a beginner, but a sort of self-taught
craftsman who organizes his work by himself. He represents the
craft stage in the evolution of labour.(5)

If he takes time to do something carefully, it is the actual
performance of a manual task he is concerned with, not the customer.
He also checks his bills several times at the cashdesk or at the
table in front of the customer. He carefully tears the bills across
with four slow little movements when paying in the money. He does
not try to maintain distance but strongly implies it, to the extent
that he is compensating physically for the lack of time and organ-
ization. For example, he sweeps off all the débris from the surface
of a table he is clearing with his bare hand, along with the con-
tents of the ashtray. When he rings up the till he has none of the
bravura of a cashier, only an inherent skill.

It is true that the diners, crammed together, leave him hardly
any space for keeping his distance. People catch at him as he
passes; one customer goes so far as to tug at his flying white coat
to remind him of his order; how could he manage to preserve personal
dignity?

He is forced - or at least he thinks he is forced - to carry out
several operations simultaneously. He takes an order while clearing
another table, then turns his head, but a second customer tries to
give his order (which is wanted immediately).

Weariness, too much work, but also a lack of organization -
plates of food lie waiting, he has to write on the bills, people
give their orders piecemeal - the waiter is driven to run about in
a disordered way attending to all the customers at once, forgetting
things, and making time-consuming mistakes. The video team wanted
white wine, he brings red, and then has to take back the carafe and
alter the checks. He taps nervously with his pencil while waiting
his turn at the bar.

Quite a few customers seem dissatisfied. The pressure comes from
a variety of factors: the amount of manual and organizational work
to be done, and being under the eye of the customers and also of the
proprietress. One can see that the camera adds extra pressure.

Café B is a vast hall with long rows of tables placed end to end,
so the waiters can move directly back and forth to the counter along
broad corridors without hindrance: we are in the Station Buffet,
second class. The clientèle is, as the local expression has it,
popular; it is even 'proletarian' (railwaymen and manual workers in
blue overalls), which is relatively rare in Switzerland and con-
trasts with the atmosphere of the adjoining first-class buffet with
its heavy linen tablecloths. The workforce here is masculine, with
the exception of a single heavyweight waitress; most of the waiters
are foreign. 'Fifteen per cent service is included' in the price of
all items.

The student-observers and the video team install themselves in
the middle of the dining-room and order drinks.

Each waiter looks after quite a large sector of the buffet.
Wearing worn white coats and threadbare black trousers, the older
waiters have haggard features. There is a brisk turnover of custo-
mers, with some regulars, but very few of them can stay long. The
waiter begins one cycle here (takes an order), continues another
there (brings the dishes), finishes another (takes the money), and
then prepares the next one somewhere else (clears the table).

The waiter keeps an eye on his whole collection of customers
during his comings and goings and while he is at the till;
there is continuous, but surreptitious surveillance; he does
not insist on having the bill settled at once, although we are
in a station (a student).

He is a 'professional' waiter, whose movements are made with a
functional sweep that is materially and socially equilibrating.
For example, he does not throw the round carton of beers on the
wooden table just anyhow, but with a special drive that is both
accurate and elegant.

The buffet is large and there are quite a number of waiters, even

though they are very busy at rush hours. So they are constantly
meeting each other at the cashdesk or in a group facing the crowd
of customers.

The operations of ordering from the counter or paying in at the
cashdesk no longer seem to give rise to the least hesitation or
initiative, apart from the choice of route. It's work on a conveyor-
belt: 'The best-planned organization is the one that is least in
evidence', as the saying goes; it all looks natural; we are aware
that these well-worn routinized mechanisms have become second nat-
ure. If the waiter aggregates his tasks, it isn't from necessity,
or by piling them up as in the previous example. On the contrary,
he is accustomed to completing one part of the work cycle before
starting the next. Given the layout and the division of labour, it
is quite easy for him to plan his work and to cope with it in
stages. He anticipates the best possible sequencing of operations,
and this perception enables him to internalize and control the set
of operations and to aggregate those which are directly functional
with those which are indirectly so. He chats while clearing the
tables; serves some drinks and spots a colleague to talk to; watches
people for his own amusement, aside from the line of duty, while
waiting beside the counter for the hotplate or for drinks; cracks
jokes while paying in at the cashdesk, and so on. His mastery of
these varied operations can even leave time during relatively slack
periods for a brief daydream or a little walk by way of respite.

The repetitive nature of this 'mechanized' labour is more or less
endurable depending on the rhythm imposed by the relative pressure
of customers and by the total length of the shift. The degree of
tiredness can easily be seen in the face of a waiter going off duty,
in striking contrast with the appearance of the colleague who is
coming to relieve him.

Café C, 'Snack Moderne', is very different, with airport-style atmo-
sphere and décor - a very soft voice calls customers to the tele-
phone. The elegant clientèle is middle class and cosmopolitan VIP.

The cloakroom has an attendant, and there is an immediate recep-
tion procedure: one of the managers screens the arrivals according
to social status, encouraging some of them - executives and the fur-
coated brigade - to enter the superior section, which has full
restaurant service. Most of the customers gravitate towards the
snack section.

The organization is very noticeable. Both functionally and
socially everything seems to have been planned by a firm of manage-
ment consultants (brilliant ones, admittedly). Attention has
undoubtedly been paid to the minutest details (there is an à la
carte menu and a table d'hôte menu, changed daily, with dishes from
various countries at different prices). The hierarchization of the
staff is complete, complex,and 'comme il faut' (a pyramid of per-
sonnel for a stratified society): the head manager in a custom-built
civilian suit, managers, head waiters with epaulettes, but the lower
grade of waiter is missing. However, for the sake of simplicity, we
shall refer to 'waiters' (no waitresses, for prestige reasons).

Swift, stylish service, with exchanges reduced to a few words and
relatively little chat. (We shall see that the waiter goes much
further when the videofilm is being made.)

Roles are clearly defined, but relate mainly to the overall organizational system. The managers are omnipresent, supervising, sometimes directing with an imperious hand, ensuring that orders are filled, intervening in crises and whenever actual decisions have to be made. The order pads have been rationalized, and so on.

The waiters exchange a few quick words among themselves when at the cashdesk, but very unobtrusively. Whatever they do is concealed, whether plus or minus. The service is designed to be attentive, polite, distinguished, and free from familiarity. One of the girl students called it neutral and soulless. The waiters can sometimes be less than polite and attentive; they take a rest and withdraw from circulation for a while. The brake goes on occasionally, but they can also fool around a bit with the customers, as happened with a rather chatty elderly middle-class lady. The videofilm captured the scene when she settled her bill. A little dialectical dance around the idea of property. The waiter, instead of counting out the change, holds out his wallet - very lordly. The lady drops in the money for her refreshments with one sweeping gesture. Big smiles. All this is hardly classicial, but, as one of the students notes, 'The waiters behave differently according to the social standing of the customer; they are almost obsequious with some', with others they have a game.

The padded atmosphere of the establishment is in keeping with the luxurious appointments but also with the stylish gestures, which are technically precise and socially attentive (serving from the correct side, not passing in front of people, putting things down gently, and so on). The waiters walk quickly, but they dance rather than run,(6) and they rarely lose the air of high-class hair stylists, with their heads held high.

Work-cycles are rigorously adhered to. There is no aggregation, or very little. Systematically, and in accordance with the system, the waiter sequences his operations. For example he comes to the table occupied by the students carrying their drinks and plates of food; he puts everything on the serving-table for the moment and quickly serves the drinks, pouring them himself. Then comes a sequence of arranging, an aesthetic rather than a functional necessity for lack of space; he picks up the menu cards, turns them all in the same direction, places them in the metal holder provided for the purpose, and puts all the other things on the table in order. Only then, though all this is done very rapidly, does he serve the dishes.

A waiter passes by too quickly, too close to a cup, which he upsets. A little girl starts to cry. One of the managers rushes up, partly angry, partly protective. The abashed waiter covers himself in excuses, after running - for once - to fetch a damp cloth. The customers at neighbouring tables exchange glances. One notices the presence of an 'audience', normally forgotten in the false notion of an insensible environment. The eyes of the manager indicate even more explicitly the hierarchical nature of the system.

A few chosen customers of a particular age or status are escorted as far as the entrance by the head waiter, or even one of the managers.

If the waiter in Café A is still a craftsman and labourer at a low
level of work organization, the waiter in Café B is a bit like the
skilled worker in a mechanized workshop with individual specializ-
ation; it is left to him to do some of the work of organization.

In the circumstances of Café C, the waiter is no longer a work-
man, but a minor executive, a host to the hosts,(7) a practitioner
of human relations, but he has very little scope for autonomy on
the organizational level. The decisions have been taken at the top,
in advance, by the organizers (i.e. the proprietors), or are made
on the spot by the managers.

It now remains to present the process of introducing video which
led to this description.

THE EFFECT OF OBSERVATION

Whereas our study had been announced and authorized in Café C, the
video team was working without introduction in Cafés A and B, al-
though they could obviously not pass unnoticed with the mobile
camera and VTR.

Tape A, the one of the working-class, student café, shows two
indications of disturbance: 'Have you asked permission?' says a lady
customer. 'It isn't good manners, what you are doing.' 'That's
enough now,' says a man we are recording, raising his hand as if to
block the view.(8) As for the waiter, he is too engrossed in his
work to worry much about the camera, except when he is serving the
video team themselves, who are taping during their own meal. The
tape shows a mistake in the order, which the waiter would hardly
have made at another table. Likewise analysis of the tape reveals
an additional element of tension and above all a special carefulness
and hesitation on the part of the waiter. Everything happens as if,
being so close to the camera, he puts himself out to observe the
formal rules of his profession which he normally hardly has either
the time or the need to follow. He moves some glasses, then hesi-
tates; exactly where should he place them? He carefully checks
the exact position of the cutlery. When he is making out the bill,
he will do it more slowly than for the adjacent tables and will
scrupulously double-check it for fear of being recorded making a
flagrant error. Tension is further increased by the fact that the
customers are annoyed with us. 'I don't give a damn, you know; it's
only because of the customers,' says the waiter.

At a distance of a few yards the camera is not always really
noticed any more in a situation like that of the waiter, and if he
behaved differently at our table it was no loss to the investiga-
tion; the camera produced the atmosphere of an examination, unpleas-
ant but revealing, during which the subject tried to play his
socially prescribed role, whereas elsewhere in the café he desper-
ately but gamely struggled as best he could with a physical job.
At all events, the waiter did not 'play' with his role, not even
in response to our presence.

The waiter in the railway buffet (tape B) had given his consent;
he agreed to be taped and promised to come and watch the videofilm
and discuss it with us.(9) Although generally calm and at ease, he
had nevertheless made an abrupt movement away from the camera as

soon as he heard the sound. After a moment of disturbance or
'shame', he soon resumed his routinized behaviour without having
deliberately to construct a character. He played his role and
distanced himself from his role just as he usually did; the effect
of being observed by a camera was considerably lessened by the fact
that he was able to comment on the situation while continuing to
work. This kind of behaviour was quite familiar to him: he exchan-
ged remarks with his customers in a social game that was far remov-
ed from a formal role that is predetermined, functional, and social.

People who make a habit of role distance, or, more precisely,
those for whom distance frequently implies joking about their own
role, are able to take the presence of the camera much more comfor-
tably because they can give free rein to their reactions, including
open comments, during the operation, if only by making asides.

The situation was very different at the 'Snack Moderne' (tape C).
We had gone through the hierarchy and got the green light from
several of the waiters: one of them said, 'I should like to have a
go.' He was quite enchanted and soon felt the urge to become a
metteur-en-scène, being endowed with a streak of initiative, even
in this over-organized establishment. 'Stay where you are, I'll
ask the customers to move. It will be better for these gentlemen
(the camera crew) at the next table.' He was aware of the tech-
nical considerations involved in placing and moving the camera.

During the recording the waiter had a half-ritual, half-ironic
bow. He intended to play, to become an actor. He wavered between
a model performance of his role as a waiter, in a conscious and
amused style, and a cinematic performance with the air of 'I am the
juvenile lead acting the part of a waiter in a café.' When he was
giving the second version, the waiter played the actor and the
actor played the waiter: his gestures were more expansive, his eye-
brows more expressive.

What makes this exercise interesting is that it reveals a degree
of virtuosity at acting that the waiter could hardly have improvised
out of nothing. Constantly under the eye of the managers, although
inclined to play a game with the customers, particularly the women,
the waiter has developed techniques of multiple performance. So if
he now plays at being someone who is not playing, or at someone who
is, he is behaving in a very accustomed way, though he may go a
little bit further in response to the complexities of the present
situation.

Analysis of the tape revealed that the waiter had added a fourth
dimension to the triple game: the role, the game with the role for
the benefit of the camera, and the game with the role for the bene-
fit of the camera in front of the girl student-customers. While
playing around with the first three perspectives, he distanced him-
self by a further step: he was winking at himself. Tricking the
work organization, the camera, and the female student-customers -
one of whom, however, spotted the chicanery - he took down the
orders on the printed slip with extravagant gestures in cabalistic
symbols; in fact, these were makebelieve symbols and he memorized
the whole order - he was constructing his personal dignity out of
this behaviour.

Though in general he behaved as if he had risen in rank during
our experiment, for all that the waiter never lost a single oppor-

tunity of displaying his professional standing: by polishing the
glasses before putting them on the table, and so on.

The other waiters and the managers pretended not to pay overmuch
attention to our activities. They are very modern in this esta-
blishment.

TIME AND DURATION

It is said that 'live' video records 'real time'. Now, since, for
a number of reasons, economizing on tapes involves using the fewest
possible, this is only rarely the case. Apart from the angle and
direction of the takes, the operator selects specific periods of
time - he tapes, stops, and starts again. Taping in extenso seems
unconvincing from the outset. It is desirable to capture duration,
time charged with meaning. Hence the mismatch between time as
experienced (duration) in the situation and time as experienced
during playback gives rise to a problem that is often complex,
particularly when a number of people are involved.(10)

It must be noted that real time deserves this name only in the
sense of a mechanical transcription - a simplistic operative defini-
tion of objectivity. During playback, this time is very likely to
be perceived as of longer duration than what was experienced on the
spot.

The café experiment enables us to re-examine a subsidiary pro-
blem. Once it is admitted that taping won't be done without a
break, the sequences shot present, though they isolate it by cut-
ting, a fragment of time whose duration depends on the real context
as well as on the context provided by the videofilm. The example
of the rate at which the waiters worked illustrates several aspects
of this problem.

The tape of Café A is composed of sequences that almost add up
to a little story. There is the waiter with his coat being tugged,
or doing umpteen things at once, or running back and forth; there
are peevish customers; the incident at the cash desk, and so on.
And there is the episode when a mistake was made at our table, and
the waiter had to return the red wine to the bar and then bring the
white we had ordered - a complete scene. All this forms a whole
composed of fragments of real time. The breaks enable one to exper-
ience, during playback, the duration of the actual incidents, or at
least the duration perceived by an observer.(11) At all events, it
seems quite natural.

Now, though the incident of the mixed-up order takes three min-
utes on the tape, the time that elapsed in the café was all of
thirty-five minutes (from the arrival of the red wine to its
replacement by the white). There is a teaching-point here. What
is seen in the videofilm appears plausible. The waiting-time that
has been suppressed is not apparent and there is nothing to indicate
it. There is consequently a mismatch between duration in the café
and duration during playback, in spite of the fact that the second
duration seems quite normal.

The tape also reveals a contrast in real time that is not so
easily noticed in the actual situation: the waiter is quick in his
movements and manual performance but slow in his mental operations.
This duration is seen and experienced only during playback.

In other words, what appears in the videofilm can hinder or
assist accurate perception,(12) according to circumstances.

The tape of Café C discloses an additional complexity. Cutting
down the real time on the spot while taping does not automatically
lead to shortening the time experienced during playback. It must
not be forgotten that the spectator assesses the length of a sequ-
ence, for instance the circuit from the cash-desk to the table,
against the rate of work of the waiter. If you make a tape of
fragments, of short takes, in order to document the waiter's tasks
on this circuit, during playback the spectator will fill in the
missing sections. Imagination will help to extend the duration
during playback. A fixed scale of real time, from the cash-desk
to the table, would have resulted in a duration, during playback,
of the kind: 'It isn't far; he moves quickly.'(13)

Perception and representation, which are of a different nature,
are difficult to separate. For example, it is likely that the back-
ground noise provides a framework for visual perception that tends
to produce differences between duration in the situation and dura-
tion during playback (transformed sound). As was noted by an obser-
ver during playback:

> One wonders whether the waiters in Café C weren't trying to give
> the impression of being very brisk, whether they weren't putting
> on this alacrity a bit.

If this is so, the potential of video is twofold: it can measure
time and duration simultaneously; in other words, unmask this im-
pression of briskness,(14) which is at once true and false, without
dispelling it. This attentiveness plays an important part in the
logic of 'service to the customer', as was noted in many of the
students' observations. The following extract from a researcher's
protocol, in throwing light on other facets of this problem and of
observation, shows the ambivalence of the briskness which is at one
and the same time attentiveness (giving the impression of subser-
vience) and mastery (demonstrating one's superiority and autonomy).

> The customers were still half asleep, or at all events very
> sluggish; it was breakfast time, just before the office.
> Italian waiters. Mine served me quickly, turning round adroitly
> to take my order. He put everything in its place like a vir-
> tuoso - cutlery, plates, and so on. His expertise contrasted
> with the inert appearance of the customers; there was no trace
> of subservience in the waiter, who looked completely master of
> himself and wore a satisfied expression. Even when awake,
> although they are relatively skillful and involved, Swiss
> waiters would never manage to equal this Italian flair.

In Café B the camera remained much longer in one position, and the
videofilm revealed very few problems of speed. It was probably the
section of tape on the station buffet that came closest to docu-
mentary in the purely mechanical sense. The waiter's working
conditions, with the diversity, separation, and rhythmical repeti-
tion of tasks, lent themselves to being grasped 'directly'.

THE SPECIFICITY OF VIDEO

Feedback for analysis. The waiters did not come to see themselves
on screen. The main use for our instrument, therefore, lay in the
possibility of recording, rapidly and without great technical diffi-
culties, a certain amount of information that could then be repro-
duced at leisure. The advantage of reproducing relatively raw
material is that it permits comparison of the analyses of several
observers with one another. There is an opportunity for intersub-
jective cross-checking and for the building-up of evidence.

Observation with the unaided eye has to be based on the moment,
whereas, on the tape, this moment can be reproduced,(15) which is
even more important when the material is nonverbal and when it
provokes further attempts at interpretation.

In exploratory research, when the objective of the study is not
precisely formulated, an instrument that predisposes to an unador-
ned account, as in the improvisation of a quasi-scenario, is well
adapted to collecting information that will be useful for a more
systematic study.(16)

It is true that the operator does not improvise without having
any preconceived ideas, but in favourable circumstances he is acting
as a participant-observer. The document he produces, particularly
if it is rounded out by the observers' protocols, makes it possible
to disentangle at least part of his personal equation. So a com-
plete experiment would include a process of takes, feedback, discus-
sion, new takes and so on.

This experiment opened our eyes to the socio-centrism of the
customer.(17) Watching the videofilm compels one to abandon the
customer's viewpoint. For example, one notices how the waiter must
constantly attend to the relative progress of his work with a whole
series of customers, whereas the customer sees only one cycle. Of
course, the various perspectives - the waiter's or the customers'
points of view - could be visualized on the basis of a tape made
either by the interested parties or for them.

However that may be, the element of raw data - alive and beyond
all intentionality - in the operator's quasi-mise-en-scène remains
significant. It is enough to experience the stimulating effect of
a videofilm oneself, or to sense it in an audience during playback,
to become aware of another specific advantage of this instrument:
the aspect of life transmitted by the audio-visual operates as an
active mediator between information and reflection; it is not yet
on the conceptual level but one nevertheless becomes conscious from
the outset of significations that demand to be discussed, explicated,
and if possible formulated.

MIGRATION FROM THE ROLE?

The classic studies carried out in terms of role oscillate between
inventories of actual behaviour made in the course of quite long
periods of observation of large samples of cases, on the one hand,
and the elaboration of principles forming a model of behaviour, on
the other, regardless of whether the model is frequently and com-
pletely followed or not. And a good deal could be said about the

fatal attraction of frequencies.(18) Be that as it may, the first
type of analysis is concerned with the actual role system, at best
with its current functioning, but not at all with the meaning of
behaviour nor with the evolution of the system.

Now, our little exploration illustrates how much of the waiters'
behaviour cannot be understood except in relation to a more compre-
hensive totality than the role: themselves. And certain behaviours
are intersecting. The distance taken by the individual from his
role helps him as much to carry out and endorse the role as to trans-
form the role in the light of another system. In the second inst-
ance we are certainly in the realm of virtuality. For the time
being the actual system of roles will be perpetuated and will 'work',
but we know that functioning that derives from observance of a rule
cannot be assimilated to apparently similar functioning that results
from taking liberties with the rule. This is the field of socio-
logic that has been covered in various ways in the course of this
experiment.

To summarize: a waiter can (a) play his role; (b) play with his
role; (c) play at his role. And the major difficulty of the analy-
sis arises from having to unravel the skein of multiplex behaviour.

It is not enough to interpret migration from the role - playing
at one's role, for oneself - as a form of distance destined to bene-
fit role-taking. An enormous potential for transforming behaviour
and consequently the system of organization is recharged at the
moment when the actor satisfies his own autonomy. For example:
playing at being an actor; playing at being a virtuoso, for the
mental and physical pleasure involved, but also for the feeling of
superiority in relation to other people; playing at being a resource-
ful organizer; and so on.

It is even less adequate to interpret migration from the role -
playing with one's role to the point of doing the opposite of what
is expected - as a form of momentary distance, a respite conducive
to maintaining the accustomed system. A waiter's familiarity with
some of the clientèle, the fact, for example, of going so far as to
be very personal in conversation or to drink with them, cannot fail
to transform the whole climate of the social context.

A parallel may be drawn here between the effect of video and that
of the mode of analysis. The commonplace event represented, for
example, by the relation between waiter and customers at the station
buffet appears as something theatrical when projected on the screen
and the same goes for some of the scenes from Café A. From the
moment these sequences appear on the screen, it's like watching a
show. There is spectacularization at the perceptual level resulting
from a complex process of references (films, reportage, TV).

On the other hand, the presence of the video camera leads to the
spectacularization of the commonplace even in the field, as in Café
C. Video and the observers induce behaviour that is not comprehen-
sible except in terms of the references it arouses in various actors
in the situation. And this spectacularization will be yet further
amplified on screen; the habitual game of waiter C was in this way
twice enlarged through these two stages; analysis benefits from this
loop effect, which enlarges and reveals, provided it is recognized.

WOMEN
Political migrations

Today, everyone born and bred before World War II is such an
immigrant in time - as his forebears were in space - struggling
to grapple with the unfamiliar conditions of life in a new era.
Like all immigrants and pioneers, these immigrants in time are
the bearers of older cultures.

Margaret Mead, 'Culture and Commitment', p. 72

Why are we now taking an event - the referendum of 1971 concerning
the right of women to vote in federal elections in Switzerland - and
why are we laying stress on the campaigns, the crises, and the ex-
ceptional circumstances?

When the projectors of reality are suddenly turned on such-and-
such a problem, or group, or person, these become for a time the
poles, the focus, of attraction and of the surge of collective life,
where conflicts and aspirations previously hidden can burst forth
and sometimes find expression. So it would also be interesting to
approach this campaign not so much for the sake of the event itself
as for what it will cause to erupt.

INCLUSION IN AND EXCLUSION FROM THE EVENT

By means of experiments and reading, a group of students approach
the problematics of woman's condition by placing the part-problem of
civil rights in a more general context, taking account of various
female subcultures (feminist, sexist, liberationist, and so on).

It must be said that preparation for the ballot does not give
rise to a very lively campaign; it seems won in advance by the
supporters of women's rights, but it provides occasions for dis-
cussions, meetings, broadcasts, and articles, which are also oppor-
tunities for exploration and intervention:
- a debate with journalists ('Feuille d'Avis de Lausanne')(1)
- meetings of a militant women's liberation group(2)
- discussions with writers on the question of women
- debates with apprentices and students
Obviously, all this brings to light a very sharp diversity of opin-
ions and positions; involvement in the event was also variously
experienced by different groups and individuals. There was, as

well, a very clear differentiation between social images: images of
woman as she is and as she might be, images of her role, images of
woman in society.

This phase made it possible to distinguish more accurately which
groups were most deeply involved in the event or in relation to the
event or outside the event.

The women who were most involved, whether on the level of assoc-
iations, parties, or revolutionary groups, imitated and invented
roles in relation to politics or policies, as the case might be.(3)
It must be said that this invention was grafted on the imitation of
various existing roles: 'responsible citizen', 'active participant',
'leader', 'militant'.

Some of them demanded equality of rights for women in the name of
justice, equity, and dignity, invoking the 'equality of rights for
all citizens' prescribed in the constitution. It was a demand for
complementarity, for co-responsibility, and for participation. One
reference became central for this feminist-reformist movement sup-
ported by the parties in power: that of the 'suffragist', of the
responsible citizen who deserves the vote, and is entitled to it.

This will indicate the tone and the style that dominated the
event and the people who were caught up in it. At the other ex-
treme, among those who stood aside from it, there was frequently an
involvement that was related to the event yet outside it: the entire
society of father-employer-administrator was put in question in
order to encourage the migration of exploited womanhood towards
political consciousness, towards an awareness of a state of exist-
ence, with the former fostering the possible depassing of the latter.

FOUR PORTRAITS: TV ANALYSED BY VT

During the campaign, 'Temps Présent', a current-affairs programme
put out by the Suisse Romande TV network, presents four portraits
designed to cover the situation of women in French-speaking Swit-
zerland: the mother of a working-class family, aged about forty-
five; an 'executive wife' in her thirties, with no occupation of her
own; a woman business executive; and a divorcée with two children,
a stenographer also aged thirty.

After watching the TV programme, the students had a preliminary
group discussion. The programme was recorded on videotape to give
the seminar the opportunity of a second video-reading, with repeats
of earlier passages, re-readings, and discussion.

In this way an initial comparison can be made between two types
of 'seeing-and-hearing': one in a mass situation and the other in a
group. Changing the conditions of reception changes reception it-
self: the video-reading creates a centring, a focusing, a crystal-
lization; the audience is taking part in an extractive process: one
part of the programme becomes a video-text abstracted from a tele-
vision context; in parallel, the televiewers become video-analysers,
and seeing-and-hearing is transformed into audio-visual reading.

The video-recording thus serves as a frame of reference, even as
a link with reality, in order to focus, or stimulate, or crystallize
the effects of reception. A 'video milieu' is created and generates
new experimental conditions. The medium of mass communication is
metamorphosed into a medium of group communication.

The group reacts very strongly: those who have seen the pro-
gramme before spark off the discussion, expressing themselves
rapidly and initiating and guiding opinion; the others give their
more immediate impressions with the spontaneous reactions of those
who are viewing the material for the first time.

In this way a first confrontation is already brought about be-
tween those who have 'experienced' the programme before, who have
begun to form an opinion and have participated in the two-step flow
of communication, and those who are discovering it for the first
time in the present situation. A confrontation also occurs between:
what is patent and what is latent but becoming manifest; the poten-
tial and the actual; and that which arises from the programme and
that which conditions its reception. It is in some sort a scaled-
down experiential model of the phenomenon of communication, a human
miniature of reception in which the mental and social perceptions
and representations differentiate themselves, reinforce each other,
and confront each other, and in which the subjectivity of each per-
son can objectivate itself in a group awareness of the phenomenon
itself.

Let us try to break down this game of confrontation. There is
first of all what has been seen and heard: consideration of the
pictures, the sound, and the format of the programme:

VIEWER A: The first two portraits relied on detail, they were
caricatures. There's too much commentary and it's too well
engineered, and this influences one's feelings. The executive
wife and the general manager woman struck us as antipathetic and
the others as quite sympathetic. I don't agree with this kind of
presentation.

There is also what each person saw independently:

VIEWER B: I was struck by the short untidy hair of the divorcée.
And I'm sure the executive wife had chosen her hairstyle against
the advice of her husband.

And also what was seen by someone else, which one takes note of. By
this gain in universality reception becomes multidimensional:

VIEWER C: At the beginning Guy Milliard said that this portrait
'rang false', and that oriented my perception.

VIEWER D: Reception in any case assumes emotional involvement.
With the family or elsewhere, you turn towards the small screen
and comment, approve, or joke in front of it.

And what is revealed between those who are involved or distantiated
in relation to the content of the message:

VIEWER E: The executive wife is dressed like a starlet, whereas
it's different with the divorcée; you can go beyond her appear-
ance.

A WOMAN STUDENT: Yes, that's right; I could easily see her (the
executive wife) as a starlet; on the other hand the divorcée had
to look after her kids, and that's another story...

What is accepted or rejected in the message discloses a personal
position in relation to the programme:

A WOMAN STUDENT: Younger women were passed over in silence. Why
were they all between thirty and forty?

A MAN STUDENT: That reflects an ideology; they should have pre-
sented something different.

The totality of the programme is thus put in question, as well as the
universalizing aspect of its reception:

ANOTHER MAN STUDENT: It's a human comedy that is being played before us and between those of us who are watching it. I'm convinced that if I'd seen this programme on my own I would still have felt what was unsaid, non-manifest, but ...

VIEWER F: It's interesting to have a discussion during the programme ... but perhaps on one's own one would have had other ideas about these portraits.

There is obviously reinforcement or domination of opinions during reception, but in these conditions there also develops an awareness of these phenomena, which relativizes them in an intersubjective context:

VIEWER G: It's impossible to believe that our perception is free from influence, even if you watch in silence... on a second viewing you can become aware how fascinated and identified you have been, and who received our projections the first time round.

So what potentialities are released through the group?

A MAN STUDENT: They ought to have shown something more in discussing certain women ... for example, the executive wife is only flirting with the idea of emancipation, it's pseudo-emancipation. The real reasons for their situations remain hidden from us, and it's precisely these which need to be dug out.

A questionnaire enabled us to examine these themes more thoroughly and to develop others on the basis of interpretations of the programme; in this way will appear distinctions experienced between images of images of reality (interpretations), images of reality (the programme), and reality experienced during the video-reading process. By a reverse movement, these distinctions cause the emergence of social images, images of society, in those who reply to the questionnaire.

There is evidence of multiple projection in the responses: 'She is sublimating. What has to be hidden is shown in shadow.' And identification is difficult: 'What a lot of middle-aged women!'

Undoubtedly, written responses, particularly from intellectuals, do not encourage the appearance of identification. No one recognizes his or her present problems, or even future or possible ones, in the problems of these women. One comment was widely expressed: it concerned the responsibility of the TV producers and the implicit hierarchization they had slipped into the portraits; in other words, the meaning they wanted to give to the programme.

The overall meaning, if one is evoked, is first of all grasped in sequences and fragments:

VIEWER H: The first woman is presented as a standard of reference; the second as an ideal in process of formation; the third as an exemplary ideal; and the fourth as a reality to which these ideal-types must be related.

VIEWER I: This video-reading enabled me to compare one woman with another.

In this way, by means of objectivation, that is to say concretization, the realization of a portrait, an objectification, an additional analytical distance can be established in order to compare, to analyse, and to synthesize the portraits with each other.

VIEWER J: You can see here in a particularly acute way the development of a recognition of the other, in her full and complete alterity.

VIEWER K: You are exaggerating there, because I think there is a
discovery of the other - I'd agree with you on that - but as a
thing in pictures, which is quite another matter!
VIEWER L: In any case, this programme reflects an ideology, par-
ticularly as regards the 'well-adjusted' married woman. Real
liberation is not even suggested.

TOWARDS A CREATIVE READING

The video-reading introduced into a social situation permits real
experimentation with reception by opening up the unlimited field of
diverse conditions into which it fits. Furthermore, this reading
can be creative and can influence the production of another pro-
gramme, if only by modifying the recorded (but erasable) commentary
on the magnetic tape.
 This provides a valuable opportunity: deconstruction and recon-
struction can contribute to a continuous critique, which is not con-
fined to the external, specialized viewpoint of a critic, but which
leads to a critical production and a productive critique, to rever-
sible modification, which we might therefore term a 'creative read-
ing'.
 Here, already, the new medium (VT) contains its predecessor (TV),
but it does not restore the TV message; it is a recorded message,
perceived by another audience in other conditions, which can become
the potential basis for a different message: 'New messages for a new
medium.'
 The milieu in which the video audience encounters the message of
recorded television provides a very different situation from that
surrounding the TV producers who made the portraits; the audience is
already confronted with an objectivated image of a situation, which
puts it in a position to depass that situation.

INTERVIEWS: MODIFICATION BY VIDEO

Accounts given 'hot' on the scene of some event gain in authenticity,
but generally they cannot be captured by cinema or television be-
cause the requisite equipment is cumbersome and the work is regula-
ted by time-schedules.
 A meeting on women's suffrage is drawing to a close. The man who
has made a video recording of it wants to get reactions after the
session. Since there is a microphone built in to the camera, he is
able to question a woman himself, while he is filming her. The
intimidation normal to any interview is here reduced to a minimum,
since conversation can develop between two interlocutors without a
third party; an intimate atmosphere can grow spontaneously. The
cameraman talks while he is shooting, which causes surprise and
indicates that this is not so 'serious' as cinema; here, at once,
there is evidence of an attraction towards the unexpected.
 But, as in any other interview, the person questioned can feel
that his communication will reach a destination, that it will be
heard by an audience whose composition he knows very little about.
The person replies, but the interviewer becomes the loudspeaker

relaying responses to an unknown audience. In this unknown quantity lies the attraction or repulsion of the loudspeaker.

Here, at any event, the woman felt intrigued; she at once adopted an emphatic attitude, and was very attentive, almost on her guard, but this block was soon demolished by the urge to express herself. One is aware of this during the playback of the videotape carrying this interview: one is facing her, one asks her questions by proxy through the intermediary of the cameraman; she replies to us 'directly'. It's a face-to-face situation in which one re-experiences her presence at a distance, for her the mediation of the interviewer corresponds directly to the mediatization of video, and this permits a double focusing: from the interviewer to the interviewee, and the other way round. There is reciprocity of perspectives.

Outside a polling station, two people (one with a portable microphone and the other with a camera) are questioning people who have just voted or are about to do so. They are caught in a context that predisposes them to tackle this subject, but that also conditions their responses; it is as 'voters' that they are speaking, and they have already rationalized the subject, for the most part. The interviewer holds the microphone; he is accompanied by a cameraman, who keeps a little distant in order to pick up the dialogue and the context in which it is occurring. The presence of a camera changes the situation: the interviewee cannot back out; even his silences will be registered and he must surrender himself in one piece, here and now; what he does not say will count just as much as what he does say in verbalizing his attitude, as he is secretly aware; and his gestures will complement or contradict his words.

Moreover, and this applies to all interviews, the interpersonal communication set up is intended to inform a third party. Hence the need to commit this communication to memory, for example by written notes. In our case, videotape will provide the memory for this communication, but the recording at once takes on a further meaning: it symbolizes, by making concrete, the presence of this third party - the public or the researchers - who will receive, through the intervention of video, the messages this communication enfolds.

In a little town in German-speaking Switzerland, one of us, microphone in hand, tries to establish quick, simple, direct contact by edging into private and public conversations (in this case also we are outside the polling stations). Here, very plainly, the person with the microphone will guide the cameraman accompanying him (who is connected to him by a cable). This is 'mike-piloting', that is to say sound-into-image becomes the primary image, while the cameraman illustrates the sound image by shots that reconstruct the totality of the situation as experienced by developing a sort of instant ecology.

By means of video, the interview is captured in the round, and it gains in universality on account of this style of punctuation. It is understood by the viewer as a directed intervention.

A video interview can stimulate or provoke authentic speech, just as it can inhibit or reduce it. It can provide the opportunity of 'holding forth'(4) by creating the 'loudspeaker effect', the amplifying effect that is emphasized by the presence of a microphone and a camera.

Their presence modifies the interview situation, but it can also transform it much more fundamentally, for instance by inducing the interviewee to break into gestures. Let us imagine a person in an interview who wants to demonstrate something he has experienced by means of gestures. Then the mountain of verbalization he is already ascending, as we have seen, is depassed; why does this person, who is breaking into gestures, not take possession of the recording apparatus in order to transform the interview into a game of action and expression in which the people doing the filming exchange roles with those being filmed, and vice versa?

This avenue, which will be explored later on, gives a new meaning to 'holding forth' and to 'breaking into gestures'.

THE EXERCISE, THE IMAGE, AND AWARENESS OF ROLE

As we have seen, the event that provides the starting-point for this chapter has been approached by various mediations (interviews and discussions) and mediatizations (principally TV and VT).

At this point, by focusing on one of the leaders of the campaign, we can distinguish the elements of a style. This focus will enable us to bring together the immediate (action) with the mediate (image) as they are presented on the inside of the event, for this particular actor and her audience.

Here again, the multidimensional approach will not facilitate the development of an outcome, because this is only one of the possible fruits ripened in the encounter between a group of students (the seminar) and 'Mrs Woman's Suffrage' (Mme Girard-Montet, president of the association for votes for women), in which both parties were brought face to face with television programmes (recorded by video) and with the video presentations in which the latter appeared. The encounter was therefore between an 'actor', the mediatizations, and the researcher-interveners, but also between social praxis (politics), instruction (the seminar), and videology (yet to be defined).

As an active worker in this association for the past ten years, in a country where women play a restricted part in political activity, Mme G-M found herself in the position of establishing a role (that of woman political leader) both for herself and for others in the political world, in a situation and a society in which a particular image of woman has been perpetuated.

This 'role-taking' is what attracted our attention.

But let us return to the beginning of the process: a variety of observations have been made during her campaign, in the course of two meetings and the television programmes concerned with them. Among these observations are a video feature and a televised recording, in both of which Mme Girard-Montet appears. These documents provide numerous indices of her role-taking: her tone, her appear-

ance, her presentation of self, and her presentation of her material
can be compared with those of the other leaders appearing with her.
From this, a style of intervention can be identified:
- she fully accepts rules and forms in order to change them from
 within
- having demonstrated her allegiance and respect, she advances
 her political thesis, unmasking the internal contradictions of
 politics
- in this context she asserts herself 'naturally', as a woman
 employing charm and a feeling for relationships
- she adopts a personal rather than a formal style, which en-
 ables her to adjust to different audiences
- she plays her role skilfully, interweaving the natural and the
 cultural with politics and policy.
But a study of the documents and the first conversations on their
own would not have permitted what was made possible by the confron-
tation of the actor with her image in the specific conditions.

Mme Girard-Montet, invited to talk about herself, her TV image,
and her VT image before a student audience who did not represent her
milieu or her usual public, was in a position to make reflexions
from the inside on the role of her image, the image of her role, and
lastly her image of the role. The usual shock of seeing one's image
on the video screen was in this case balanced by Mme Girard-Montet's
familiarity with making television appearances. On the contrary,
the real shock lay in the simultaneous presence of Mme G-M, in her
presence in pictures in front of the public (at the meetings) and in
front of the viewers (on the TV programmes), among the students who
had met that day in the seminar to analyse these pictures.

G-M: This kind of experience enables me to make a critique of
 myself. There, on the screen, I see defects that are magnified
 by the microphone, including errors of pronunciation, which are
 a serious handicap to me. I still have to work very hard at
 public speaking. If you want to make an impression on your
 audience, you have to be able to hold them the whole time, and
 hold them by your look and by your words at the same time. On
 committees I am often the woman 'witness', the 'token woman',
 for there are still very few of us. Young people are also some-
 what stifled in political parties. You have to adopt the langu-
 age of male politicians....
We are not concerned here to interpret the lengthy conversation in
which numerous problems were raised, and still less to interpret
the campaign in terms of one of its leaders. All the same, it is
quite clear that a certain potential, for politics, was being trans-
formed by Mme G-M, and through her by a large number of women, into
a policy, with all that this implies for the defence of the dominant
interests: there was, in fact, a migration from politics towards
policy.

In this age of the media, an event is constituted as much by actions
as by images; it is constituted through a complex process in which
these two terms intervene dialectically, images modifying action and
vice versa.

And, analogically, a coherent approach to the event will owe as

much to intervention as to interpretation; it will operate on both levels in an attempt to discern the significant features. But this is a complex process of approach, which here we have done no more than to intimate.

SCHOOLCHILDREN
Immigration of the Trojan horse

In the entrance hall of the high school I noticed a Trojan horse
studded with nails, a work of art made by the pupils of another
school and ceremonially delivered when the closed-circuit tele-
vision system was installed.

One could not imagine a better symbol to express in a humorous
way the revolutionary potential of closed-circuit television in a
school. However, there has to be something inside the horse's
belly.

A. Depeursinge, 'Gazette de Lausanne'

The conclusion reached by a journalist after visiting the school,
which is undoubtedly one of the best equipped in Europe with audio-
visual aids, gives a good indication of the problem to be treated
in connection with 'Major Davel'. The hero and central character of
one of the first educational TV broadcasts produced by and for the
'Cycle d'Orientation',(1) this William Tell of regional history
clearly raises, in his own way, problems of authority, and we shall
see how our experiment, which was carried out by students,(2) did
not itself fail to throw up problems of a similar kind.

Does educational TV make it possible to import something into the
school that other, too familiar, means can nowadays no longer manage
to introduce? What is the specific gravity of the new medium? Does
it operate entirely on its own? Should it be supported by monitors?
These are some of the questions one might ask about the programme
which we will now describe in outline as an introduction to the cir-
cumstances of the field experiment.

This time the video exploration deals with the reception of a
schools programme that was itself produced by video; it is not an
analysis of feedback, but of problems sharply raised by 'back-
feed'.(3)

THE FIELD EXPERIMENT, AND THE PROGRAMME

In search of a seminar topic relevant to the sociology of mass com-
munications and to education, we contacted the Cycle d'Orientation,
which possesses not only its own educational broadcasting depart-
ment, but also comprehensive facilities for experimental programmes.

All this is brand new - sophisticated equipment but naïve utiliz-
ation. Three programmes were ready for transmission at that time
and none had yet been made the subject of study. At the appropriate
time (determined by the syllabus) they would each be shown in the
classrooms, many of which have TV receivers: the films, transmitted
from a central control room, can be shown simultaneously in all the
classrooms, one of which is designed for observation.

It was tempting to choose the programme on 'Memory' for our
study, since it deals with laboratory work in experimental psych-
ology. But perhaps the pupils would be a bit like guinea-pigs. In
the experimental classroom equipped with two TV screens, on which
the educational programme took the place of the teacher, an invis-
ible observer was hidden behind three cameras and microphones placed
in three corners of the room, which was in other respects a typical
classroom (blackboard, rows of desks for the pupils, teacher's
desk). The operator, adjusting the lenses and the microphones by
remote control, could choose the angle of observation by following
what was happening in the classroom on three monitors in continuous
operation, the pictures and sound being recorded by videotape.

We had opted for a historical programme about Major Davel,(4)
which was closer than the others to ordinary TV and also more socio-
logical because of its connections with everyday life (in using the
themes of order, authority, a historical character from the region,
and so on).

One of the first findings of the study is undoubtedly the fact
that the pupils were not so greatly affected as we were by the
experimental situation. Perhaps the horror of being a guinea-pig
has now been relegated to the past; even in Switzerland, a TV-gener-
ation has been born and will eventually be discovered. Instead of
feeling like rats - i.e. essentially objects of study - they can
feel like subjects, stars, in other words their worth is enhanced!

The programme begins to the sound of the national anthem of the
region (Vaud), with a shot of the Château Saint-Maire outlined
against a sky with circling pigeons. The camera zooms to the
window of a dungeon, inside which Davel is found, his hands ban-
daged.

On this evening of 23 April 1723 Davel is thinking of the
morrow, the day of his execution, which will also be, he says,
the day of his triumph. He looks back over his life. .

He was born at Morrens, where his father was a pastor, in the
heart of a country 'that is no longer ours', where robbery and
immorality are rampant. Then he studied at Lausanne, his father
died, and when he was eighteen he moved to Cully with his mother.
There he meets the 'Beautiful Unknown' who helps at the wine
harvest and who predicts that he will fulfil a high mission.
First of all he follows the profession of notary, and then be-
comes a soldier. He serves with the Bernese in the second cam-
paign of Villmergen,(5) and returns to Cully with the rank of
major. The people of Vaud have only one right: to obey and keep
silent. Davel watches and prays and meanwhile nurtures 'the plan
that God dictates'. In the spring of 1723, when the bailliffs
leave Vaud to gather in Berne, Davel raises his troops on the
pretext of an inspection, and marches on Lausanne. On arriving
in the city he meets Major de Crousaz, his former companion in

arms, and discloses his plan to him. This traitor persuades the
members of the Council not to oppose Davel, who reads them his
manifesto; he invites Davel to stay the night at his home and
hastens to warn the Bernese. In the course of the evening Davel
reveals all the details of his plan.

There is a conversation between the Major and Mme de Crousaz
while her husband is writing a detailed report on Davel on the
orders of 'Their Excellencies'. The wife tries in vain to soften
his judgment, to remind him that he did not regard Davel as a
crank when they were fellow-soldiers; she tries to justify Davel,
who is, she says, a good Christian. Her husband tells her brus-
quely that this is not the point; that Davel will not be tried
for witchcraft, but is condemned because he is a threat to law
and order, and 'God desires order'. Moreover, she would be quite
mistaken to complain of Bernese domination, without which the
situation of both of them would be very different from what it
was. However, Mme de Crousaz believes that they are nothing but
the lackeys of Berne.

Davel takes up his story again: his arrest, symbol of the ser-
vile obedience of the Vaudois to Berne; the interrogation, the
torture to which he is submitted in order to make him denounce
the accomplices he did not have, since he acted alone.

A dialogue at an inn between two wine-growers, who are talking
about the execution on the following day. One of them is savage-
ly opposed to Major Davel, an arrogant troublemaker, possessed by
the devil, who has not acted for the good of the people but is
simply pursuing personal advantage. The other man, Cullieran,
who is always ready to help other people, defends Davel; he is
convinced that the Vaudois are quite capable of governing them-
selves and have no need of the Bernese 'bear' for their protec-
tion. A bystander maintains that it is no business of people
like them, wine-growers and common people, that 'this is poli-
tics'.

Back to his dungeon, where Davel proclaims that he is 'condem-
ned for revolt and rebellion against a ruler who has no legiti-
mate power over us'.

Short conclusion (voice off) saying that Davel was not the
only person to revolt against an established order and reciting
a list of other names.

THE COURSE OF THE EXPERIMENT

Should people who listen to records or read books be informed about
the vicissitudes of making the finished 'product'? We think they
ought to be, in so far as the production process of a product that
is never 'finished' is a revelation - which may not be the case for
a disc, but is for a research study, and emphatically so for an
exploration. Everything without exception can be considered rele-
vant. Instead of 'putting personal equations in parenthesis', it is
far better to indicate what they are.

Since we knew very little indeed about the 'Cycle d'Orientation',
we began the study with a short visit to the institution, later
followed by talks with the producers of the film. It appears that

some earlier studies had come up against a characteristic resistance on the part of the teachers. It seemed to us that what was happening was similar to the mass erection of defences in industry at the moment when automation threatens to invade. On top of this the administrative hierarchy, though interested in the idea of a study, seemed sceptical in advance; the technicians were even more reserved because they feared a disturbance to their tranquility, and their air of effortless technical superiority was chilling.

To put the lid on these preliminaries, there were various changes in the date of the experiment, which didn't fit easily into the school or university timetable; initially difficult contacts with the history teacher; my absence on D-Day, when it was eventually fixed; some anxiety among the students whose task would be to explore the pupils' reactions to the film, while maintaining good diplomatic relations with everyone concerned.

There was a brief introduction from the history teacher; two young students sat at the back of the class as observers, silent, with pencil and paper; two older students sat facing the class to carry out the interviewing. Then came the projection of the programme on the TV screens facing the twenty or so fourteen-to-fifteen year-old pupils, whose progressive and relative absorption was observed and filmed from the 'control room'. None of the technicians entered the experimental classroom, but one of the students was with them in the control room. There was one source of irritation, the sound of the observation-cameras. The remote-controlled cameras (technical miracle) were not adequately lubricated and distracted the attention of the subjects by sharp little noises at every change of angle.

After the showing of the film and our first video-recording of the class in process of watching it, a second tape was devoted to an interview with the children in which the history teacher appeared. The discussion was dominated by the two students, who intervened vigorously and at length, although they should in theory have let the pupils do the talking.

We thought that the 'field' phase would finish at that point. Quite wrong! During the playback of our videotape we were treated to our first socio-electronic shock; the girl students who had the task of recording the pupils' emotional responses during the programme had practised what current jargon would only describe as 'repression'; the interview with the pupils came much nearer to being a 'lesson', or even a lecture (sometimes in favour of the film or educational TV, sometimes in favour of traditional methods of instruction), than a study of the reactions and the experiential world of the pupils.

Instead of beginning by letting the discussion build up around the film and allowing several pupils to have their say at some length, and then to move on to more general questions and less immediate reactions, the discussion proceeded in precisely the opposite direction; by launching forth into general considerations, reactions to the film could not be expressed until too late and after undergoing the distortions of repression. They consequently lost in truth and directness.

Having overcome an initial feeling of irritation, we realized that we must, in fact, extend the fieldwork phase to cover a study

of the reactions of our own students. The post-film stage would be
at least as much a video phenomenon as the video transmission it-
self. The veiled authoritarianism of the style of presentation of
self and of the experimental situation constituted a particularly
interesting sociological complement to a film that, on reflection,
and bearing in mind the socio-cultural environment, was not far from
being a critical document, at least as regards its central message.

We therefore interviewed the two girl students before and after
showing them for the first time the tape of their monitoring work,
ad well as the part of the 'live broadcast' showing the pupils
watching the screens.

So the fieldwork phase ended with two mistakes on our part and with
conflict-ridden encounters with the student team. Having expressed
my annoyance in front of the students, talking in a no doubt intem-
perate manner about 'typically repressive attitudes' in relation to
the interview,(6) I then showed the videotape to a friend, a local
history teacher, and his fifteen and sixteen year-old pupils, with-
out reference to the students who appeared on the tape. This did
not fail to precipitate a conflict, in the heat of which quite
searching explanations were forthcoming to complete the record.

The analysis made by the students, and above all the transcrip-
tion of the data (unbelievably detailed), obviously showed the
effects of all these stages on the course of the experiment, which
wound up with an interview with the woman producer and the history
teacher from the Geneva class following a showing of the videotape.

THE AUTHORITARIAN SYNDROME

After looking at the tape and reading the transcripts a dozen times,
one becomes more and more aware that a veil tends to be thrown over
a sort of authoritarian syndrome. Let us go back to the film, which
itself has the character of a Trojan horse. The Swiss, and above
all the people of Vaud, are renowned for their cagey equivocal res-
ponses, 'maybe yes, maybe no'. The themes of order and authority,
and even that of domination (of one nation by another), are both
omnipresent and barely acknowledged. It is true that it all starts
with the choice of the major as a subject. The treatment given him
in the film reveals the whole syndrome if you are prepared to use a
magnifying glass (in this instance video) to see it: the national
anthem of Vaud; the hero's deprivation of liberty; the pigeons at
liberty; the formula 'This land which was not our own' (external
authorities, which one finds in various reference to 'Their Excell-
encies' of Berne). There is talk of religious wars (conflict of
authority between catholics and protestants), and it goes as far as
playing a double game with the authority of God himself. Davel: 'A
plan dictated to me by God'; de Crousaz: 'God desires order'; 'God
has given some men the mission of governing'. In this way various
phrases and comments suggest an atmosphere: treason, on the one hand,
towards Berne; traitor, on the other, in relation to Davel; shaking
off the yoke/their preference for servile obedience to Berne; tor-
ture, chains/privilege, reasons of state.

The final commentary in the film draws attention to the extensive contemporary relevance of the problems it deals with.

However, references of this kind are always hidden below the surface. By making them explicit, and even more by enumerating them, we reveal the extent to which this syndrome permeates the whole programme. Even in the scenes where the actors express themselves more in words than in gestures, the film is never a discourse. Unlike an oral exposition, it does not qualify what it is presenting. It does not unfold its meaning; at the very most the viewer is aware that he is reflecting while he is experiencing the film, but that is something quite different; there is no one equivalent to the teacher who puts himself both in and above (outside) the account that he is presenting and at the same time commenting on (hot). In the film even the oral linking passages seem to be an integral part (cool) of the programme.

The producers would in this way have swung the balance decisively in favour of Davel. This is the conclusion of the analysis, but the film makes liberal use of the balance between 'on the one hand' and 'on the other hand': Davel the visionary, Davel the utopian, Davel the broken champion of the people, Davel the recluse and so on.

So, though leaning towards one side, the film seems to have exploited detail and atmosphere more successfully than argument; similarly, though an attempt is made in the commentary to relate history to contemporary life, nothing is done to translate these modern parallels into images.

Furthermore, emphasis on the monologue - the hero on his own talking at length about his adventures - allies the film with the magisterial pronouncement or with the formal lesson (centralization). This is at variance with the theme of emancipation (decentralization) but congruent with 'heroic' historiography. One might hazard a guess that this programme on emancipation might never have seen the light of day if it had presented a more advanced conception of the 'hero', of history, and of scenario-writing. Balance must be preserved: new wine, old bottles!

A NEW VIEW OF THE PUPILS

Although the experiment yields only fragmentary information about the interpretative worlds of the pupils,(7) the two parts of the videotape point to observations that could only be made because of the video situation thus created.

Video recording undoubtedly gives a limited operational definition of experienced reality, and these limitations could be stressed (the angle at which shots are made leaves several pupils out of view at a given moment; the relative amplification of sound depends on the proximity of the microphone, and so on). Nevertheless, it provides a valuable opportunity for second-level observation: after and during the re-viewing, a degree of intersubjective verification is possible, notably through the repeated viewing of the people who have been recorded; evidence of polysemia eventually leaps to the eye of even the most hidebound positivist. The decisive point, however, is perhaps the possibility of grasping, or at least of studying, relationships: transmission/reception, inner world (of the

individual or group)/outer world (for the adults, for the school, for the experiment). Though teachers or observers are normally immersed in the situation when in the presence of a class, they can now confront their own reactions 'in' and 'out' and, ultimately, observe themselves observing. But let us dwell on some details related to the syndrome described above.

First of all, it is hardly possible not to notice that the dress of some of the pupils expresses an anti-academic or even non-academic attitude. The hippified Indian with a band round his forehead; the jeans which, for girls of this age, still represent a heroic feat in a Swiss school. The briefcase left negligently on the desk of the 'chief' - the leader who has more to say than the others - he has departed with a girl rather before time, having no intention of letting himself be pushed around. The judo fan, silent throughout the entire session, yawning as he raises his arms and flexes his back muscles every five minutes.

One must certainly be wary of interpretation. The paper the pupils were passing round at the beginning of the programme was not a funny drawing, despite the laughs, but a straightforward list of names that they handed on while chatting about something else. The other outburst of hilarity, towards the end of the programme, was not a response to something said in the dialogue, but to the sound of splitting jeans (according to the observer, an essential adjunct here).

The programme slowly captured their interest. We noted the progressive abandonment of parallel activities like chatting and day-dreaming. Varying degrees of attention were manifest at moments that were neither predictable nor programmed. It was never when the producers wanted to 'make a point' in a commentary that attention was at its height. The message never has any reality except in the context of an interpretative universe. If one child seems to spend the programme mimicking what is being broadcast, this is nevertheless his way of seeing and hearing, in harmony with what he can mimic, which is the determining factor; and he continues, for much of the time, to mime an internal film that bears no relation to the film on the screen. So many other pupils remain impassive and hence unfathomable.

There is laughter when the hero's execution is mentioned, but it is the idiom (the accent and the local peasant dialect) which has taken precedence over the content of the tragic message. There is amusement when the glug-glug of a drink poured into glasses produces - a highlight because it rarely occurs in this programme - an illustration in sound: a perceptible materialization that makes an impression, because it recalls sounds directly experienced - in cafés, for instance - and also shocks here, in the schoolroom, by contrast; but once again, as in the case of the idiom, we are in the realm of peripheral phenomena.

We now come to the discussion, which shows above all the pupils' determination to behave as subjects. The pupils: we were consulted about an educational broadcast, then we gave our views, even about technical points, and even about the 'mentality' of schoolchildren; such-and-such a scene should have been put at the beginning rather than the end because it expressed public opinion; there were too many monologues (antiheroism).

Here is an excerpt from the transcript:
P(8): ... it made us laugh, that film.
M: It made you laugh?
P: Yes, you couldn't say you were enthralled ...
M: Can you explain what made you laugh?
P: No ... it's well done, but it's ... it's sweet *(laughter)*
M: Did you know about Major Davel before?
P: A little bit, and we know that what he did was important,
 but the film was rather novelettish *(with a knowing look)*.
Some other remarks from the children: the film treated us as if we
were younger than we are. All the same, we know we've got to learn.
'When something doesn't interest us, we don't study it so much.'
If it were interesting, we'd get on with it (learning as enjoyment).
 The rejection of everything suggesting a 'lesson' is very far-
reaching; in fact, it goes as far as blinding some of the children
to the anti-authoritarian content of a film that is too strongly
perceived as instructional:
 M: The question raised by Davel's situation can be related to a
 number of contemporary problems....
 P: Yes, but there is more mysticism in Davel than there is nowa-
 days (in the rebels of our own time). He thought he was div-
 inely inspired *(laughter)*.
 P: The poor chap was the one who was betrayed *(disillusioned ex-
 pression on pupil's face)*, the poor martyr *(weary shrug)*, and
 there were these wicked Excellencies in Berne ... at least,
 that was my impression.
There is such a blockage to understanding the message that even the
question of torture - the very controversial central theme - is
barely touched on. The history teacher (T) tries to remedy this:
 T: Good, what needles you most are the static scenes, the ones
 when the character is soliloquizing, but it is also what he
 is saying. Are there any symbols?
 P: His hands.
 T: Yes, and what about his hands?
 P: They are both bandaged.
 T: Yes, and what does that mean?
 P: Every time anyone says anything about Davel, you know he's
 been tortured - that old story.
 T: Yes, but it isn't just a story.
 P: It's only folklore *(laughter)*.
 T: It isn't just folklore; the folklore is more like an embellish-
 ment. It actually happened; at that time torture existed.
 Davel was tortured to obtain information, to find out if he
 was the ringleader of a plot. Besides, historians have inves-
 tigated the question of whether he really was held in chains.
 There have been some very serious studies on this subject.
 Here it strikes us because the part is played by an actor.
Many of the children's comments show how the attitude 'If it were
me, I'd do so-and-so' is accompanied by identification: they would
like to be producers, and to be with the producers, hence innumer-
able questions to the student-monitors, whom they believed to be
specialists. Reflecting on these issues brought the children to the
point of asking questions about their own milieu (pupils discussing
pupils!).

M: Do you think TV is useful in supplementing a history lesson?

P: Useful and interesting, yes, but I'm sure that at the end of about three years of such experiments the pupil will be just as weary as he is of other things....

BACKFEED

In order to understand what an explosive problem backfeed can be, we must retrace our steps a little way.

Some of us have become accustomed to being recorded (by photographs and taperecorders). For most of those who are involved in video experiments this is rarely the case. Photographs and taperecordings are only taken intermittently and for a moment, and above all in the presence of friends and family. Video achieves a much more complete recording.

A strange paradox must be mentioned in this connection. In talking about the videorecording of the discussion, our students emphasize everything that the tape does not display; precisely because the tape returns a more complete image of themselves than any they have been able to encounter before, they are even more strongly impelled now to point out the respects in which this reflection is incomplete.

It must be stressed that in the institutional setting, objective dangers (other people's judgments) are added to subjective dangers (fear of one's own judgment or that of one's neighbours).

Conflict will always break out whenever films are made and shown without adequate safeguards and in an institutional framework. Without going into details here of the conflict between the students and the teachers that erupted during our experiment, we may note the following observations:

 - as soon as a person who is unused to it sees himself on film (i) he is liable to feel put to the test, both at a deeper level (subjectively) and socially (objectively, e.g. in his school or university or professional career); (ii) he tends to seize on the negative aspects of what is reflected of his own person and the positive aspects of what he sees in others.

This hypothesis about polarization-culpabilization probably holds good in the socio-cultural field influenced by the protestant ethic (more than in any other).

 - awareness of this threat, accompanied by an upsurge of anxiety, quite naturally leads (i) to apprehension that the tape will be used against the interests of the people filmed, and even (ii) to fear that it will simply be shown to other people (a fear independent of any effect it might produce on others or, by ricochet, on oneself). Anxiety drives one towards rationality, magic towards calculation.

These are phenomena that refer particularly to social manipulation, but they also touch on the still little explored region of identity. The first analogy that comes to mind is that of copyright; the desire to be known as the proprietor of one's own work depasses the problems of economic or hierarchical interests.(9) In the present case, we are at the stage of production of oneself.(10) What appears on the tape is a kind of phantom: an electromagnetic double.

The Institute team was able to conduct a feedback experiment with a group of secondary schoolchildren from Fribourg. It was evident that the type of awareness that dawns on someone who sees himself on film for the first time resembles 'Paradise Lost'.(11) Seeing oneself from 'outside', as others see us, is tough. One feels disarmed, deprived of defences. But it is also highly exciting: intensely positive or intensely negative reactions, love or hate, tend to be aroused.

The extraordinary flare-up of aggression in the people involved in our backfeed conflict was undoubtedly of maximal intensity. Such an extremity is only reached in a situation of rape - in which, moreover, the victim is conscious of colluding, to some extent.

It is utterly essential (i) to anticipate situations in which control might be exercised over the use of videotapes (involving people of different social categories appearing in the film or institutionally associated with it, for example), and (ii) to devise modes of expression that allow them to make a presentation of themselves before, during, or after the showing of tapes to other people - particularly in an oral form and ultimately in a written form (especially in the case of research). Suppression of the opportunity of regulating the impression made on other people is felt as a serious assault, which should subsequently be redressed by the right of reply, an apologia for oneself. And it is advisable to change objective situations that give rise to anxiety.(12) Progress on the individual level as on the institutional level consists mainly in passing pragmatically through stages of trial and error, without whose acceptance fundamental growth is arrested.

The stringent puritanism that leads to the rejection of any display of imperfection must be suppressed, even or above all in its most classic institutional manifestation: the examination. Seeing oneself or being seen on film is still too closely assimilated to the control of a finished product, although the image may simply be of an intermediate stage.

But let us return to some of the elements of the situation that explain the conflict surrounding backfeed, and, first of all, to the increasing rigidity of the monitors as the discussion progressed. Here is an extract from an interview with one of them before the first viewing of the tape:

Q: How did you feel inside?

A: A bit like Daniel in the lions' den.

Q: What were you afraid of?

A: The fooling around, the leg-pulling by the pupils that led to absolutely nothing, or the fact of being dragged into it and not being able ...

then after seeing the tape:

Q: You say that when watching the film you do not have the same impression as when you are inside

A: Yes, when you see it all afterwards, you notice that various small sounds take on much too much importance

In front of a class that was presented and experienced as dangerous, the adults had to control themselves:

- which was consonant with the fact of controlling (keeping in hand) the discussion (the pupils) and with a traditional style of instruction (neither wanted by the adults in question nor

predicted by the experiment, but in some way rediscovered(13))
- which was consonant neither with the central message of the
film nor with the objective of exploring the children's world.
Later the class of secondary schoolchildren watched and discussed
the videotapes (the programme and the discussion were taped). Most
significantly they contributed a number of points concerning the
elements forming the authoritarian - or to put it more temperately,
academic and adult - image of the monitors:

FIRST PUPIL: What strikes me is the voice, the pedantic tone ...
SECOND PUPIL: What struck me was that they talked quickly, as if
they absolutely had to fit in a certain number of things. The
pupils were losing patience, putting up their hands..

THE AUTHORITY OF COMMUNICATION

Lessons are given and taken; a lesson does not develop as a joint
enterprise. Traditionally, the lesson, and more specifically the
'master', ensure the transmission of authority. The experiment we
have analysed shows that the communication *of* authority, and *by* an
authority, can be replaced - and here the Trojan horse aspect of the
gadget comes in - by the combination of lesson and educational ex-
periment with a televised programme. It is not so much the medium,
in the immediate sense of the term, that imports something that can-
not otherwise be brought into the classroom nowadays, but the part-
icular relationship that the pupils have with this medium.(14)

Of course, we soon come across contradictions. There is a great
diversity of reactions from those pupils who had anything to say.
If we had to choose half a dozen quotations, these would be they:

It's sweet (the film).
Behind it all are Their Excellencies.
You should normally be aware of the people behind it.
History isn't something acquired.
Like this you don't get 36,000 viewpoints! There is only one:
the one given by the film.

There is obviously a contradiction between the pupil who found the
film about Davel simply 'sweet' and 'novelettish' and those who
attach importance to any film document, on the ground that every-
thing that passes through an objective lens is ipso facto objective.
Or again, between the immediate, peripheral apprehension of so much
detail (accent, and so on), the interest shown in the audiovisual
gadget (how would you go about making a film on such-and-such a
subject?), and a fundamental understanding (rarely expressed): the
relative presence in the film of the theme of the dominators (Their
Excellencies) and the relative absence of that of the dominated (the
people).

It seems to us that a programme's potential for getting across
should be understood not only in terms of the interaction between
film, monitors, and pupils - which we have just examined - but also,
and especially, by taking account of the experiment itself. Despite
the somewhat indifferent expressions of a whole series of pupils who
have collaborated several times in Suisse Romande TV programmes, in
interviews, and so on, and despite the 'naturalness' of their class-
room behaviour (laughter, conversation, relaxed posture, joking), an

awareness of being filmed and observed persisted and had signifi-
cance. Apart from occasional glances at the cameras, heads turning
round or even eyes trained on the lens as if on an observer, this
awareness was mainly expressed in a quite explicit tendency on the
part of the pupils to identify the student-monitors with the TV
team, and also to make frequent technical comments ('they ought to
have ...'). If the experimental conditions do not seem to have
blocked the section of the audience that did join in the discussion,
it is probable that the fact of being heard, of having the chance of
passing judgment on a programme, made an impression on the majority.
Of course, we are unable to measure any of these effects.(15) But
it all happens as if various parallel phenomena of commutation(16)
are reinforcing each other, or at least might reinforce each other;
this phenomenon is directly related to a free style of learning that
conditions receptivity and consequently the reception of the message:
 Flipping:
 - from the film into the inner world (the pupils attentive, day-
 dreaming, attentive)
 - from the film into the world of the class (the pupils attentive,
 laughing, attentive)
 - from the film into the consciousness of being the object of
 observation (the pupils attentive, glances towards the cameras or
 the observers)
 - from the topic under discussion into consciousness of being a
 subject in the experiment (what do you think, I think that ...)
 - from the film into discussion about its production without even
 going through the questions asked by the monitors or the history
 teacher.
Rather than its precise explicit content, it is the fact that the
film exists and that it can be discussed, that the audience is taken
seriously but nevertheless left free to commute in and out at will
and in various ways - and that this is even regarded as interesting -
this is what encourages receptivity. This receptivity, relative as
it may be and perhaps not taken very far, opened up the possibility
of a reception which must still be discussed in relation to a refer-
ence to 'real' television, a reference clearly stated by some pupils
and probably felt by many others.
 - the pupil tends to prefer 'real' TV because it 'works directly';
 he feels himself plugged in at the very moment of viewing to
 people and places; and the history of the moment has actuality
 because it is happening now. Unless it presents a documentary or
 film of very high technical and artistic quality, a 'historical'
 educational TV programme will tend to arouse relatively less
 receptivity, and the message will hardly be received as 'actual'.
 One might say there is a contradiction between actualization and
 the non-actuality attributed to the medium.
 - The pupil claims to believe a film more than a written or spo-
 ken analysis; as photography of reality, television and even an
 educational TV film would have strong credibility.
When the credence accorded to a film by a pupil approaches closely
enough to that accorded to the current style of TV and when, on top
of this, the subsequent discussion is free and conducted in such a
way as to give opportunities to identify with the production and to
criticize it without having to accept a viewpoint or even a style,

the whole process of communication ends by acquiring an authority
that conceivably surpasses any that one might wish to communicate
intentionally.

There is no question of denying that this authority includes an
element of the prestige that automatically attaches to a 'gadget',
but that should not make us lose sight of the importance of the
process. It is quite secondary that the 'Davel' programme only
partly succeeded in transmitting the fundamentals with adequate
directness. The content of the Trojan horse is already there in
the importation of the horse, and these explorations must undoubt-
edly be continued. Systematic studies could throw light princi-
pally on the conditions under which the freedom to commute in and
out that we have described(17) leads to a very strong or a very weak
involvement, and in what forms. Here, it seems to us, is the germ
of a subjectivated relation to learning and to the organization of
learning which, though it remains utopian on the institutional
level, is technically feasible right now.

Chapter 8

YOUNG PEOPLE
Hesitant migrations

They are like the immigrants who came as pioneers to a new land,
lacking all knowledge of what demands the new conditions of life
would make upon them.

 Margaret Mead, 'Culture and Commitment', p. 71
Although some of them are of Swiss origin, the researchers working
on the present study have lived too long in Paris not to feel like
strangers in their new territory, Switzerland. All the same, with
the young, they found themselves immigrants among immigrants. And
Margaret Mead's observation gave expression to what struck us as
soon as the question of audio-visual aids, or new teaching methods,
arose. To take the anthropologist's formulation to its logical con-
clusion, the generation gap is also the generation grave. Either
the generations must completely disown themselves as such or they
will soon find themselves in the condition of corpses.

Over the past thirty years Switzerland has undergone fewer social
and cultural upheavals than the other European countries. According
to the elite and to a large number of parents, the best way of pre-
serving the current economic prosperity would be to transmit(1) to
the young well-tried recipes for good management within an unchang-
ing structure.

By using video - itself on trial and therefore able to reveal a
new world in the cultural, not the geographical, sense - in differ-
ent types of intervention, we were able to explore in three situa-
tions the difficulties of migration among adults and the problems of
young people of different ages in their attempts at migration.
Still influenced by tradition, and rejecting in a timid or a doctri-
naire way a world that has been relentlessly sold to them as the
best and indeed the only possible one, the young people hesitate on
the threshold of the promised land.

THE UNIVERSITY: VIDEO AS PROVOCATION

In Switzerland, university teaching is rarely discussed, except by
specialists. It seems unchangeable. Academic freedom in matters
of instruction and the dignity of a status regarded as 'magis-
terial' are the impregnable accompaniment of lectures delivered ex

cathedra, and are all the more sheltered from criticism behind the alibi of an increasing percentage of seminar time (supposedly open to general discussion, though often professorial monologues continue to predominate).

Now, a private association in the region concerned with 'further training of managers and executives', 'offered, on the occasion of its tenth anniversary, two days of discussion' to university tea- chers; 'the large amount of research devoted to "the difficult pro- fession of teaching" has often neglected the special character of the university sector'.(2) The two days were to be dedicated to the topic of 'the communication of knowledge'.(3) They fulfilled a public relations function, since the association was trying to legi- timate itself as a 'foundation for co-operation between the univer- sity and the economy'.

When our team was invited, very shortly before the meeting, to present 'the point of view of the students', we had no hope of con- ducting an inquiry and reporting the results. We therefore under- took to make a stimulus-film, since video would enable us to intro- duce a medium and a message capable of provoking awareness, or at least launching a discussion at a level normally suppressed in pol- ite conversation, that of oppositions that can only be described as impassioned. We thought that the need to make available empirical studies of the viewpoints of several types of student, at least in terms of social origin and faculty, would perhaps be felt in the course of the discussion; in any case, we made a point of saying so on numerous occasions.

Students are immigrants, both in the university and in society; the teachers are also immigrants in a world in the making. The film was conceived around these two themes - the background primarily illustrating the first, and the form the second - and we entitled it 'The Immigrants'.

The 'Russian doll' build-up

We had four days, in fact, in which to make a twenty-five-minute film. Although our brief was to produce a 'stimulus' and not a documentary, it was very little time. So it is obvious that we would have to use a collage technique to some extent, drawing on material already available. And various earlier ideas on similar subjects would be incorporated, so that production would in every way be carried out 'in action', with the researchers and the stud- ents collaborating in different stages of the process.

It was clear from the start that parallels would have to be drawn between the university situation and the overall society. After a short period of thinking around the subject generally, the stage of pre-articulation began: tossing around ideas that might illustrate different sides of an argument, and suggestions about producing a particular sequence or about the use of existing mater- ial. Next came the preliminary shooting, the assembly of picture and sound sequences, guided by the synopsis (which remained very rough), but also guided by concrete details that turned up on the spot during the actual shooting. This stage proved to be rich in suggestions from all quarters; for example, we were trying to give

visual expression to the parallel between preselection on the high-
way and in education. This led us to follow a particular route
through the town in order to film the streets. On this occasion
other parallels between the university and society suggested them-
selves (a substantial old house with two modern storeys added to
ancient foundations: reforms, plastering over ...). This stage gave
everyone present during the shooting the chance of intervening at
any point. In view of the speed with which decisions had to be
taken, the lens was obviously going to be focused on images that
lent themselves to identification (someone with a dog on a lead) or
to individual projections.

Then the montage - by means of simple electronic copies - brought
together materials of diverse origin that clearly illustrated some
of the possibilities offered by video: direct reportage (for exam-
ple, a passage describing a shop in a steelworks, used here to
underline a point); videographic scenes from everyday life, filmed
live, supplied context and illustration for an argument; a girl
student reading an actual document in an arranged setting; the film
of a discussion, with the students giving their opinions on the
subject-matter of a film of which they had just seen the rushes; a
print of a televised discussion dealing with some of the themes in
the film.
 Although at first sight heterogeneous, all these elements are on
the same wavelength: that of open reflection on the situation of
students confronted with a teaching institution, with teachers, and
with a society that pre-exist them. The choice of elements can take
account of the simultaneous presence of interacting realities (a
mother bottle-feeding her baby, urban 'order', symbols of authority
and formal lectures at the university, industrial work, and so
forth).
 The implementation of all this shooting, editing, and finally
screening is certainly more important in this context than the fin-
ished product. The first phase of shooting generates a second; the
first montage acts as a stimulus to a discussion, which will be
taped to form part of a second montage, which will in turn provoke
debate..... Like Russian dolls nesting inside each other, this type
of implementation is a dynamics of growth.

The gap between images and concepts

The dynamic process of producing the film was imprinted on its
'finished' form, which remained simply in the state of a sketch.
 The first procedure, analogy, was of a patently discussable
nature; it could be taken further, reinterpreted, or, conversely,
questioned and withdrawn. The second procedure, which might be
called dialectical, brought the interlocutors, or even the televised
debate and the students' discussion, into opposition. We thought
that making the contradictions inherent in reality appear in the
film itself would stimulate the audience to seek to clarify the
contradictions. So the schema of the two types of immigration sug-
gested a logical process of comprehension. The approach therefore
involved both the senses and the intellect.

As the students in the video debate were implying(4) the teachers
seeing the film were also immigrants, and furthermore these teachers
proceeded to demonstrate this fact themselves in their reaction to
the video stimulus.

The congress on 'the communication of knowledge' hardly discussed
this stimulus, which was perceived as highly provocative. This was
partly due to the way the days were organized, with oral communica-
tions predominating and with the periods allocated to small discus-
sion groups reserved for considering specific questions formulated
in advance and dealing with material covered in a number of presen-
tations. It is typical, however, that during a plenary session the
only contributions in which speakers flew off the handle were those
concerning this film.

Nevertheless, the physical arrangement, the institution, and the
conditions generated by a congress of this kind clearly demonstrated
the gap that was created between this audio-visual provocation and
the rationalized speeches that were the normal currency; indeed, the
gap was so great that no bridges could be built between the images
presented and the conceptual rationality of the congress.

In contrast, a subsequent showing of the videotape to an aud-
ience composed of students, teachers, and university officials gave
rise to more explicit reactions. Certain intellectuals launching on
a critique of the film could not help revealing their repulsion
(opposite but related pole to attraction) at the shock-images.

A TEACHER: Do you really think you are defending your thesis by
 showing a person holding a dog on a lead?
In this way new debating ground was broken; people openly took up
personal positions, emotive or passionate, which are hardly allowed
in normal debates structured by the written word; there was a decla-
ration and differentiation of subjective situations.

ANOTHER: In the discussion you formulate your own position to
 yourself, and it often precedes the formulation. This enables
 feelings and contradictions to come out in the open and ultimately
 to be transcended through the film.

The stultification and also the relative freezing of discussion can only be explained by the appearance of new conditions that do not allow the immediate reproduction of the traditional academic style of debate. In this case the blocks and resistances may be signs of a destructuring that precedes restructuring, a silent transition to an intelligibility based on sensibility.

SCHOOL: A VIDEO READING OF TV

Under the heading of an 'optional course' on the media, two groups of about fifteen high-school students (aged between fourteen and fifteen years) had three sessions of viewing and criticizing with their teachers a series of advertising spots recorded by French TV and by Suisse Romande TV, and then a series of three newscasts recorded on the same day by the three networks.

At the time of the first session each of the two discussion groups was taped and watched itself immediately; abundant use was made of the opportunity of stopping and re-running the tapes. There was no intention of analysing the content of the messages systematically, but rather of suggesting the dynamics of successive playbacks and re-playbacks.

What, then, is the specific discrepancy produced by video?

The re-playback of messages normally received in the family setting while waiting for something else (films, serials and so on) creates new conditions. There is no longer a 'gratifying' escapism; one is centred on the group. This kind of message is very rarely received by a peer group in an appropriate setting.

The creativity of the group is structured around certain themes, which are a function of the greater or lesser directiveness of the teacher who 'guides' the discussion; passivity, reasoned opinions, spontaneous reactions, interactions, leaders and so on. The relation between the sampled messages and the students could not in any case be assimilated by injection, but through a series of questions and answers mediatized by the adolescent subculture. A 'subcutaneous' injection nevertheless persists in the region where certain screening effects are operative. The important thing remains the spontaneity and liveliness of the reaction and, despite the apparently all-powerful force of prescribed models, the rejection they encounter and the decoding they undergo.

The first impression is that these young people are much less illiterate audio-visually than adults suppose them to be, and indeed than adults themselves continue to be. They spontaneously discuss the messages put out by advertising, though perhaps less willingly than they do television news programmes. They are at ease with anything that happens quickly (the spots are very short and, if one doesn't see them several times, it is often quite difficult to appreciate all the elements of information encoded in them), but equally they experience relative boredom and difficulty in plugging in to something slower or more discursive and linear (information).

This observation points to a paradox: how would they be capable, as the 'flood of images' flows more quickly, of grasping, understanding, and deciphering the very complicated codes without ever undergoing any 'education' directed to this end?

The school and the media: mediation through advertising

The combined viewing and discussion brought to light mechanisms and
metabolisms that are specific to immersion in the flood of images.
An awareness of the influence of publicity was evident:
> When they tell you in a toothpaste advertisement that this tooth-
> paste is the best, it really isn't the ideal way of influencing
> the masses.

and also of its subconscious influence:
> If you buy Dato, is it because you have thought about it?

Advertising is evaluated in terms of its own technical criteria:
> I hadn't realized it was Gillette; I was concentrating on the
> images; that's bad; you don't notice the product. The way in
> which it's presented is more striking than what is being demon-
> strated.

It is through its techniques that advertising gets home to them and
that they get inside it and, up to a point, appropriate its meaning.

Comprehension of advertising comes about through an overall app-
rehension of its specific style of procedure, of its greater or
lesser adequacy to the desired goals. Critical appreciation cannot
therefore develop through the usual instructional channels. In this
connection, when the teacher asks them: 'Are there people who might
say that this advertisement contains something reprehensible?' they
do not react. On the contrary, the criteria of originality and
atmosphere, which condition a possible identification in relation to
their own universe, seem to them essential:
> You feel they are looking for something striking, not as regards
> décor but for the viewer.
> A good ad., I think, you've got to take in a certain way, not
> holding back from it.

Dato washing powder uses an animated cartoon in which the Dato
packet fights against dirt with the dwarf Jaunard against the sounds
of a boxing match. This is the spot they enjoyed most. Why?
> The characters are attractive.
> Jaunard is pleased with the harm he's doing.
> The ad. is so well done that you sympathize with Jaunard; but
> this is only an impression.
> If you think it out properly you wouldn't come to the same con-
> clusions, because you feel Jaunard is nice and Dato is nasty.

They like the pace and the characters in 'Dato' and identify with
it. 'Dato' models their representation of the world; first of all
they decipher the techniques aimed at producing a particular atmos-
phere. Whether this corresponds to their own or not, they never
explain advertising on the basis of one or other view of the world.

Their understanding is therefore situated on the level of their
personal experience. What is this? It belongs to a world where
'everything happens at speed': images, sounds, displacements.
Animated cartoons, comic strips, westerns, detective stories, cars,
astronauts, pop music, motor-bikes ... form its backcloth, and
these socio-cultural mediations are certainly not the more bookish,
conceptual, and moral ones of their teachers.

On the other hand, their images of the social mechanisms that
underpin advertising activities are stereotyped:
> They would need a hell of a lot of good-will to test all the
> packets they sell.

> People in advertising are paid for just that ... they've got to
> sell the product.

Advertising, TV news, and the school: two worlds

Advertising provides the testing-ground where a televisual language
is developed that conditions the other programmes. Very far from
framing televised news programmes in a neutral way, the spots rub
off on them: the advertising atmosphere unifies the programmes, the
newscasts; it plays on sensation, impact, the unexpected, and rapid
linkages: 'You follow the pictures without thinking.'
 Many of them talked of TV news in terms of the sensational or
impressive. No links are forged between the news flashes and a
socio-historical understanding. Lack of interest in current events
on TV goes hand in hand with lack of interest in history as con-
ceived by the school. Nevertheless, bringing an event to notice
through the media could foster the emergence of an awareness of
history-in-the-making, producing a reading of the images of the
event, which is possible and realizable by video; this obviously
runs counter to established wisdom, which tends to present history
as finished, past, over-and-done-with. Comprehension of reality
comes with apprehending it; a culture grows from living experience;
progress on these lines is congruent with the genesis of social and
mental structures, but it is opposed to that imposed by the school.
 It is more on apprehension related to personal experience that
these students base their evaluation of the message; in claiming that
the young must be protected from the mass media, is not the school
primarily concerned with ensuring its own survival?
 Their reactions cannot be understood without recognizing that they
belong to a tactile, audible, visible universe-in-the-making. Given
this, the images of society they can develop will not be those im-
posed by the media, nor those disposed by the school, but those
which can be created on the basis of combining these multiple media-
tions.

OUT-OF-SCHOOL ACTIVITY: A GAME WITH VIDEO

> Provocation must also be conceived of in a wider, less dangerous
> sense: a sense in which the investigators of humanity, or the
> seekers after truth (armed with microphones and cameras) try to
> stir up a significant event on the peaceful surface of everyday
> life, even by their own intrusion into it.
>
> Edgar Morin, 'Le Vif du sujet'

Four high-school students equipped with video carried out an inquiry
in the streets on the theme 'What would be your ideal world?' The
astonished citizens were mostly completely thrown by this question.
However, it was such an encounter that gave birth to another experi-
ment, which the group itself christened 'gagophony'. In this video
intervention, four young people expressed in words and gestures
their reluctance to become integrated with the established world, or
even to migrate towards a world-in-the-making.

After this spontaneous exercise, which gave concrete form to the
common interests that united them, we provided them with the means
of self-expression: a video camera and microphone, with complete
freedom to use them as they wished. It very soon appeared that
their motivation was sufficiently flexible and powerful to enable
them to work out a shooting script with due attention to the tech-
nical difficulties inherent in video.

Since the method of using this instrument is not so well defined
as in the case of the taperecorder (traditionally used for recording
interviews), they were in a field much richer in possibilities, and
also much 'cooler'.

Having decided on a project that would allow them to explore the
medium itself as much as the everyday themes they were in any case
keen on, they chose a technique that would throw light on everyday
life: 'the invisible camera'.(5) It must be mentioned here that
this programme is unusual among those produced by official TV in
taking account, albeit in a negative way, of the modification effec-
ted by the presence of a film crew. Since everything that is filmed
is recorded as though there were no camera, the supposition is that
life is being captured 'live'.

Of course, the project, which was changed as shooting progressed,
did not exclude either intervention or provocation, since the scenes
filmed 'on the sly' depended on gags worked out and presented by the
'gagophonists' themselves, before and during shooting. Being unable
to take advantage, as with the real 'invisible camera', of the unac-
customed fact that it is adults who are playing, the children had to
turn the situation on its head and simulate or play at adult behav-
iour. The subjects of the gags were chosen to show:
 - superstitions regarding ladders (having left a ladder standing
 on the pavement, they asked passers-by to explain their behaviour:
 why they walked under it or round it)
 - telephone games (letting the phone ring in a public call-box
 and telling the person in the booby trap that he has won ten
 pounds in the Grand Prix)
 - property speculation with a building-plot one yard square
 (arbitrarily staked out on the pavement in one of the main squares
 of the city)
or else to create ludic situations:
 - selling and giving away coins laid out on the pavement
 - staging a collision between a rowing boat and a pedal-craft
 with a girl on board
 - playing music in the open street by means of a taperecorder
 hidden in a dustbin outside a supermarket
Apart from the fact that the gags had to be adapted to the recording
technique (only being able to take localized events and near-to
dialogue), it seemed at first sight that we would have the familiar
pattern: when there is suddenly an opportunity to be creative,
people in fact resort to imitation and to reproduction of previous
situations, in this case to imitation of a well-known programme and
of stereotyped behaviour. But this would be to leave out of account
the game that was introduced here into the phenomenon of reproduc-
tion. Because shooting was organized as a game in which they had to
'hide' the cameraman and his camera, to manoeuvre with a microphone
inside someone's coat, and to invervene in order to provoke a

situation in which a videotape was 'prefabricated'; and because the gagophonists simulated adult games while poking fun at them, or played at being adults while caricaturing the stereotype of their behaviour, ludic imitation led them to critical invention. As shooting progressed, the gagophonists tended to vary the technical and cinematic tasks in order to be able to intervene in the film of the events by accosting or badgering or yelling at the passers-by and so putting them in a flat spin.

Impelled by normally repressed desires to provoke, to unmask, and to communicate, but without being wholly aware of what they were doing, they set up situations in which automatic mechanisms, stereotypes, and roles were revealed, tested, and corroded. In this way they were exploring the everyday, repetitive, automatic aspects of life by questioning, in the game, social reality.

In all the gags the situation they constructed created what they were banking on: the unexpected, the encounter, the moment of truth. No one was more surprised than the gagophonists themselves when passers-by joined in the game or curtly refused:

 - A gagophonist approaches and questions a pedestrian of dignified appearance who walks round the ladder; he says arrogantly, 'Would you mind ... it's nothing to do with you.'
'But sir, why has it nothing to do with me?'
'Go and play with someone your own age.'
 - On the other hand there was another pedestrian who had forgotten which way he went and in answer to the same question retraced his steps and repeated his itinerary, to the astonishment of the team.

By their choice of themes - money, violence, the telephone, superstition, speculation, advertising - the gagophonists showed the importance they attributed to the facts and actions of everyday life filtered through the media. They never approached them in an academic, moralistic, or deliberate way; they wanted to put these themes to the test and to gain understanding of them in and through their actions. They were not interested in representing these themes in an imaginary scene superimposed on a street, they wanted rather to present them by setting them in motion. Experimentation took on a very positive meaning, near to invention. It triggered off a process of participation in which the behaviour and attitudes of passers-by were seized, questioned, and criticized; it carried the participants to the stage at which stereotyped models ceased to function and inventive processes should, or at any rate could, be generated. It was plain to see that exploring everyday life no longer satisfied them; they wanted to change it by turning the searchlight on its extreme banality.

Obviously the presence of a camera and a microphone in this experimentation had a variety of effects. What mattered most was that these instruments were manipulated and controlled by the group itself, which both did the filming and filmed itself. Gradually a ludic relationship developed to the technique; when they were not hiding the camera and the microphone, they fitted them into the situation like toys that could be displayed and used to stimulate the self-expression of other people.

Everyone took turns at being actor, collaborator, author, observer, and film-maker. The game involved everyone, while at the same

time sustaining a critical distance between each individual and his roles. Recording the game compelled them to express opinions about the future editing of the videotape, and introduced the distantiation that is indispensable to the organization of shooting. They were sometimes distantiated while filming, sometimes involved in the situation being filmed, and a commutation between disengagement and engagement was set in motion and supported by the constant permutation of tasks.

In a similar way, a subtle dialectic develops during the playback of the videotape; while watching it, one is simultaneously implicated in the images of social situations and explicated oneself by these same situations, within which a dismemberment of social images is taking place.

In this way, through the intermediary of a videotape, adults are helped by children to explicate their stereotypes, the elders learn from their juniors. Adults see how children see them ... and surpass them in inventiveness.

Of course, the (erasable) record of these experiments was not presented as a finished film. The gagophonists became aware of considerable difficulties of communication when they showed the tape to their schoolfellows. They were compelled to go into long explanations and to describe the entire process of producing the film. The operation takes such priority over the finished product that the latter ultimately becomes incommunicable without a commentary, that is to say apart from the active presence of the group who filmed and were filmed.

What was important then, as we have seen, was the spontaneous, non-professional use of a medium of communication, the fully experienced process of creation, the style of working, and not the product.

Through various experiments of this type, the need for, but also the technical difficulty of, the reappropriation of the communications media can be apprehended. Beyond an element of imitation emerges invention. 'Wildcat' utilization is immediately capable of realization and communication as long as the medium remains in the hands of a group; its future lies there. Distribution, even if restricted, outside the group demands a minimum of development in techniques of communication, which must be gradually acquired.

MARGINAL PEOPLE
Emigration by immersion

... on 13 February 1971, at three o'clock in the afternoon, the
abandoning centre carried out the first immersion of property in
the waters of Lac Léman; henceforth, the senders of these objects
are their owners by 'deliberate loss'.

In these words a pamphlet summarizes the kind of cultural animation
we shall be talking about in this chapter. 'Intermaginaire', the
Lausanne group we shall be concerned with here, saw the light of day
in 1967.

In fact, we are not a group at all, but a nexus of relations
between individuals, interests, and events of a particular kind,
a shared marginality, a parallel culture; there are other group-
ings in France, in Belgium, and in Italy with whom our links are
all the stronger because our integration in 'society' is so
weak.(1)

In very many ways the central preoccupations of this group link up
with communication, and more generally with this participative cul-
ture that is in process of emerging, primarily around a praxis such
as the video work we are discussing here.

That it is once more a question of property, in the action under-
taken under the heading 'abandoning centre', is certainly not a
matter of chance. When the high-school students who featured in the
previous chapter suggested their 'gags' about money and the square
yard of real estate, our team could not help exchanging amused
glances; the surrounding society had generated an analogous way of
treating the subject of property - that of the high-school students
and that of Intermaginaire.

How was the Intermaginaire group formed?

When I met Alain Croquelois, Lucilla Bordin, and some others,
we were all students; we shared a passionate interest in the dis-
covery and practice of surrealism. It was expressed in games, in
playing 'consequences', in collective paintings, in experiments
in automatic theatre, and so forth. In May 1968, we relived - a
month later - the sense of engagement and fascination experienced
in Paris. The events in France confirmed what we had anticipated:
that a society in process of exploding develops an intense crea-
tivity.... Art can be found directly embedded in everyday life
and can be transformed into the art of living....

As a result of their interest in space (which is connected with the fact that some of them are architectural students), with public places, and with new modes of communication that are both 'urban' and 'human', which is related to the desire to break down the barriers between cultural production and consumption, the group was drawn to the exploration of various media.

> At first we were satisfied with exploring new techniques on paper, on canvas, in sculpture, and so on; later we tried to carry out our own distribution in an informal way through 'secondary' media: photocopied collages, linocuts, and suchlike. Then we discovered that video is a revealer, sometimes even a catalyser, and that at the very least it crystallizes things that are otherwise barely visible; it is therefore remarkably well adapted to our projects, which consist essentially in bringing poetry to everyday life and transforming the compartmentalized banalities of urban existence.

FROM VOYEURS TO 'VIVEURS'

In the first issue of their review, the International Situationists launched a radical critique of the theatre. Going beyond this critique, the situation must be lived out by its architects, with no separation between authors, actors, and audience.

> The role of the public, which is, if not passive, at least merely supernumerary, should continually be reduced, while there should be an increase in the proportion of those who cannot be called actors, but, in a new sense of the term, 'viveurs'.(2)

Picked up by the marginal group we are discussing here, this theme was obviously to find direct resonances with their untiring interest in the imaginary, without which it is impossible to go beyond 'realities',(3) and more generally in social and cultural creativity.

It was only a step to pass on to the social image that, as it were, leaves an ephemeral electronic impression on a plastic tape. The praxis of the erasable magnetic image should, so it seems, have the effect of lending greater flexibility to the mental image, provided that some interaction has occurred.

The relations experienced between these two sorts of image and between different interpretations would have to be constructed. Instead of trying to reproduce reality, as was the case in Renaissance painting, for example, that is to say to represent it in a framework that necessarily separates it from its origins, the question will be to produce and present realities; the difference is not therefore purely in a change in the apprehension of 'reality'. The nature and definition of reality are modified, as is the centre of attention, which shifts from the work to the process whereby it is produced, itself in fact becoming not so much a product as the thing experienced. The role of video will therefore be to bring about a transition from the mental image or the exceptional, liberated action to a materialized image that presents the imaginary.

One sees how the insistence on process, on the 'in-action' aspect, or, to put it another way, on growth, finds its place between utopia, in the accustomed sense of a particular mental image, and fiction, in a film conceived by an author to 'realize' his mental

image. Utopia-as-something-experienced is situated halfway between these two poles: the tape, which is recorded while the experimenters are actually experiencing this utopia and actively constructing it (experiment-action), will be shown before the same people who are no less actively constructing their interpretations of what has happened, with the intention of going further into utopia and its concretization (interpret-action).(4)

The philosophical approach that involves acceptance of multiple points of view is often criticized for leading to an absolute relativism that is totally disintegrative. This is still to make judgments in far too universal terms, and on the basis of a belief that a culture or any other integrated system that embraces the entire population would be practicable or even desirable. Now, if it is true that the attempt to relativize, for example, points of view that are officially established or simply ground in by the monotony of the daily treadmill can fortunately have a disintegrating effect, relativization comes up against a boundary. The word 'intermaginary' suggests an important idea in this connection: the imaginary will be constituted by interaction; it isn't necessarily solipsistic, in so far as the modifications of established social images are really effected by a common effort, particularly when the parallel culture that is most often involved avoids atomization as a result of using group methods of communication.(5) The proximity of a medium directly controlled through different stages of the process by the people employing it (cultural self-management) would prevent both implicit chaos, as in programmes or films addressed to everyone and to no one, and explicit chaos, that is to say unlimited diversification. It is a question, what is more, says Alex Ganty, one of the animators of this group, of 'combating entropy by means of anthropy'.

VIDEO AND THE 'ABANDONING CENTRE': SUPPORT AND WITNESS

We shall now see how two projects launched by this marginal group were developed to the point of achieving concrete expression.
 Where did the idea of this 'abandoning centre' come from?
 ALAIN CROQUELOIS: Every system of social reconstruction tackles
the idea of property. For me, the point was to try an experiment
of living with other people in a different relationship to objects.
I therefore proposed, not the abolition of property, but an
extremely new and exciting mode of appropriation: abandonment by
immersion.
 Is the idea to move towards a sort of symbolic level of
 appropriation?
Only to a certain extent, since you know where the object is and
you can find it and touch it again when you want. Besides,
common knowledge about the place where the objects have been
abandoned creates collective property, at least potentially; it's
even possible to revert to conventional property.
Some time before the experiment was carried out, a pamphlet was
issued explaining the idea of the 'abandoning centre'.
 If you are racked by an irrepressible desire for possession,
 become proprietors by deliberate loss. Chose an object to which
 you are particularly attached. Decide to become its owner and

abandon it in a post office, dispatching it to my address. On an
auspicious day, weighed down by my precious burden, I shall go to
the shore, I shall face either the unruffled calm of the waters
or the fury of the elements, and I shall hurl your valuables into
the depths.

The pamphlet, which invited readers to contact Alain Croquelois at
his home address and to spread the news of this new form of owner-
ship, also proposed the idea of establishing 'planetary anthropoetic
days', which would punctuate the yearly calendar by offering cele-
brations at the full moon in order to promote communication. This
second invitation, designed to 'create a night of hope', proposed
'scattering the world with words, drawings, and other forms of
message'.

Distribution of the pamphlet had the effect of persuading people
to dispatch various objects; furthermore, Alain Truttat and François
Chevallier of ORTF made it known that they would be reporting these
events. We therefore followed the Intermaginaire team and the accom-
panying reporter with our video equipment. So there would be a
double reportage: radiophonic,(6) on the one hand, and videophonic,
on the other, which would make it possible to compare the difference.

It was apparent from the outset that radio reportage, again like
written description, despite attempts at illustration, hardly ever
manages to invest the event with as much solidity as the video film
achieves. In order to ground their incongruous experiment in real-
ity, the animators nevertheless have recourse to a quantity of
empirical facts. Having set out from the shore of the lake in a
fishing boat, the group announce the exact geographical co-ordinates
of the spot where the immersion will take place, the exact depth of
the lake, the exact weight and dimensions of the objects (a wooden
cross fitted to a bicycle crank, an inflatable cushion, and so on)
and even go so far as to give the exact etymology of certain words,
for example the origin of the word 'candle'.

The VTR authenticated the action during the immersions; from the
moment when the journalist interviewed a selection of passers-by
after the team had returned to dry land, and asked them to comment
on the new form of appropriation, the presence of video contributed
to establishing an atmosphere of credibility. Once it is recorded,
the tape videologizes what has happened; it produces a phenomenon
that is analogous but opposite to the spectacularization of everyday
life:(7) there is a 'familiarization' of the unfamiliar and utopian,
which consequently gains in verisimilitude and plausibility.

Furthermore, in a case like the present, the picture is even more
seriously missed from an oral or written report than it is in normal
circumstances, for it has much more than an illustrative function.
However well done, a radio commentary can hardly manage to establish
so utopian a reality, even though it has been well and truly exper-
ienced by the immediate participants. Without pictures, the audience
has difficulty in situating the reportage; words alone can only evoke
aspects of reality, they cannot really assemble them, and they leave
them in the weightless state of something that is not objectivated.
The tape and the pictures, on the other hand, tend to give substance
even to a highly improbable story;(8) there is a material and inter-
pretative difference here in the support given by the audible and
the audio-visible.

The video cameraman also contributed directly and intentionally
to forming this link between the imaginary and the commonplace.
For example, by a close-up of placards against a news-stand:
 KEY TO MYSTERY INSIDE HANDBAG
 THE LITTLE RED BOOK - ONCE AGAIN
 PIRATES RETURN TO NORTH SEA
 In a general way, focusing with close-ups or medium shots defines
the particular reality of the person making the film; everyday life
is thereby redefined.
 In other words, we are caught in a dialectic between the real and
the imaginary. Video 'familiarizes' an experience that has taken
place, but in the social domain of the imaginary; aspects of the
everyday environment appear in a different light; for example,
people reply quite seriously to questions they are asked in spite of
their incongruous nature - because of the authority of the ORTF
label and the presence of gadgets such as the professional taperecor-
der and the video camera - and this scene, once filmed, further in-
creases the credibility of the immersion and the whole project.
Utopia appears as topia, topia as utopia, and the combination of the
two movements - whose proportions still remain one of the secrets of
the modern alchemy of the audio-visual - succeeds, or not, in making
the whole thing hold together.
 The extent to which the imagination and the action of this group
of marginal people from a parallel culture are related to a pre-
occupation with communication is also to be read in another idea:
the France-Culture programme that featured the 'abandoning centre'
was cut into by several silences, announced slightly differently
each time, but always in the style of 'advertisement pages', with a
musical background theme.
 FEMALE ANNOUNCER: And here is a radiophonic silence of fourteen
 seconds;(9) listen to the voice of night.(10)
then, at the end:
 That silence came to you by courtesy of Intermaginaire.

LOUDSPEAKERS IN THE CITY

After 'nourishing the lake with potentialities', the team returns to
the town to carry out an experiment in urban communication. Armed
with loudspeakers, two animators talk to each other from opposite
pavements, while being taped by the video operator, with the jour-
nalist ready to take down their exchanges. 'The city is a savanna;
the transformation of the city will occur through words and ges-
tures.'(11)
 This time the point is to bring out the importance of interpret-
ing the situation. This 'urban communication' contains first and
foremost a link between two elements that are rarely juxtaposed: the
presence of 'inter-mediaries' and the birth of a whole series of
'inter-pretations'.
 GANTY: We didn't explain very much what we wanted to do; we
 simply did it, and what is surprising is the extent to which all
 this brought out different ways of seeing things, and, even more,
 released floods of words.
 CROQUELOIS: ... it's action as interpretation.

The video operator was integrated with the crowd of passers-by and integrated even more than previously with the team: when he came to the end of a tape, he grabbed a loudspeaker himself. In the video film this time, the animators hardly appear as stars; they are submerged in the everyday environment of the street, at least to start with. It can therefore be seen how the selection of shots and camera angles contributes to the emergence of action. The camera moves from the first to the second loudspeaker, follows the reactions of the public or shows their apparent imperturbability. The first interpretation of the logic of this action must be given by the operator, who has become the editor-recorder(12) of events.

The a priori conceptions of the various actors were quite divergent. According to one animator: 'Divide the world in two, put a loudspeaker at each corner of the street, and arrange things so that one part of the world is decanted into the other and vice versa.' Another animator: 'Get the urban words and gestures going by means of a snowballing process.' In fact, the definitions of the constructed situation could be very different but nevertheless react on one another, even cumulatively, owing to the setting-up of circuits or loops of communication.

As for the passers-by: smiles, set lips, disconcerted silences. A common, though surreptitious, diversion of urban life is being brought to light,(13) observation of other people. There is embarrassed avoidance behaviour; people turn round; a void is created in the field of communication like that surrounding a dog believed to be ill tempered, and people try not to get involved. On the other hand, some grab hold of a loudspeaker; others, more hurried and aware of the symbolic nature of the loudspeakers (made of cardboard and without amplification) raise their voices and say their piece directly. The movements of these people towards public involvement or frightened withdrawal are probably indicative of stereotyped or routinized social behaviours.(14) There are two poles: *stupor,* order is disturbed, and in spite of the extreme triviality of the acts proposed, the collapse of the whole socio-cultural universe seems imminent: 'where are we going?' taken negatively; *eruption,* let us seize immediately the all too rare opportunity for action, for bringing to life a situation felt as deadly dull, even - and particularly - if you don't know what it's all about: 'where are we going?' taken positively. These reactions are collected by the animators, who comment on them through the loudspeakers, and this enhances the dawning awareness of some of the passers-by, who reinterpret their original definition of the situation.

Even if it had been stopped at that point, the action could certainly have had some consequences: the loop could have been made videographically by a subsequent video playback of the film or even by a simultaneous showing in a shop or café window. Feedback of this kind would undoubtedly have produced more than a preliminary shock of awareness, since a social happening was involved. And it is easy to imagine various actions, resulting, for example, from the provocation of an interracial conflict in the street, that might be set in motion and pursued to their conclusion, with the presentation of the tape leading to group discussions, to public debate in the press and elsewhere, and even to concrete changes (in legislation, material arrangements, salaries, education, and so on).

The extremes meet: those who overestimate and those who under-
estimate the danger or the value of such attempts to upset the
orderly running of everyday affairs. Only the mass of 'don't knows'
is realistic in the trivial sense; by avoiding the experience of the
unexpected, one can be sure of continuing to experience routine
existence, at least for a time.

Apart from providing the mise-en-scène in the course of shooting,
the contribution of video is once again in giving material form to
a process, which this time includes sequences demonstrating the
evolution through a varying number of stages of interpretations of
the situation. Far from leading yet again to the conclusion that
there are 'facts' (the objective world), on the one hand, and illu-
sions (the subjective world), on the other, this demonstration would
seem to us to bring the observer to an awareness of awareness; one
never stops moving from one definition (subjective) of the situation
(objective) to another. And the subjective is itself a part of ob-
jective reality. If it had not become necessary to assert that this
is the way things are, it would in any case seem that the speeding-
up of interpretation, which has received little attention, deserves
a more fundamental analysis. Another aspect of the contribution of
video is, in fact, that the imaginary made real and visible, and the
interpretation applied to the situation and concretized on film, can
and conceivably will tend to stimulate further imagination in view-
ers of the film, at least in cultures like our own that are so atta-
ched to the positivity and positivism of what can be touched with
the hand.

VEILING AND UNVEILING

Removing the barriers between producers and spectators is therefore
related, in a way still relatively unexplored, to the decompart-
mentalization of the real and the imaginary. Subtle relations exist
and are interwoven between the actors in the real world and the com-
municators of the imaginary. And it is undoubtedly in this direc-
tion - towards the discovery of a culture that is no longer either
'cultivated culture' or 'mass culture' - that the efforts we have
followed stage by stage are heading. We have been able to see how
the veil of irony cast over the idea of property and over communica-
tion (in fact, lack of communication) at the same time unveils that
potential part of reality that remains so well hidden in what are
called normal circumstances. It seems appropriate to dwell a little
longer on these two themes and to show how, when examined more
closely, their incongruity is simply a matter of the style in which
they are presented.

Everything is perpetually changing. This proposition, widely accep-
ted and taught by certain oriental philosophies that are gaining
increasing influence in the West, is on the way to becoming an axiom
for more than just a subculture. We are beginning to discover that
human societies, like all beings in the animal kingdom, pass through
successive stages of death and rebirth. But we must eject (and re-
ject) everything that attaches us to the past and above all to

objects. A number of authors have drawn attention to this type of
problem.(15) And the serio-comic nature of the two conceptions
underlying the actions we have just described is attested by the
following facts: one of the participants in these events, during a
visit to Eastern Europe some time later, cut off a lock of his hair,
submerged half of it in the Danube, and sent the rest to Switzerland
(for the lake) in order to establish a link between two worlds and
to become the possessor in a more real sense of his hair and of the
world; a profound act, if ever there was one. This was similar to
the act of another member of the group who proposed setting up alea-
tory telecommunication by throwing quantities of messages in bottles
into the sea (he wrote: 'to marinade').

Another act devised by one of the group's animators represented a
plea for all that is vital and durable, in the ironic style charac-
teristic of the 'abandoning centre': the invention of 'paninox'.
The idea has affinities with Marcel Duchamps's 'readymades', but its
basic meaning is more polemical; the intention was, by spraying
pieces of bread with metal and sending them to a public selected at
random from the telephone directory, to plead the case against reif-
ication. Making durable and unchangeable something that is living
and therefore perishable is absurd; it can only be done by denatur-
ing something that when solidified becomes imperishable. Unveiling
by veiling.

There is a logical and existential difficulty that should not be
suppressed in relation to these attempts at raising consciousness
and this use of video for clarification; some phenomena derive their
charm precisely from their clandestine nature; consequently, reveal-
ing their latent possibilities is not necessarily or always a desir-
able objective. A series of reflections about the 'cool' could be
developed around this point. Unveiling can lead to veiling.

A new culture generates a new mode of communication. These
'actions', which admittedly have more to do with imbuing everyday
life with poetry than they have with politics - at least in the
current sense - give concrete embodiment to intentions and intuitions
that are rarely expressed or even expressible. They integrate var-
ious cultural elements (poetic, scientific, existential, political,
urban) rather than inclining decisively towards one or other of the
'sectors' customarily connected with them. This integration comes
about in terms of experience and interpretation in action. The
seeds of individual and collective creation unfold their potential
in a 'group' or 'network' style of communication. It is not clear
just how far these centres radiate outwards and succeed in stimu-
lating others, nor how great is their power of resistance against
the redefinition of their proposals by the surrounding 'system'.
It goes without saying, here in any case, that the tendency is
towards a new appropriation of the means ... of communication.

TELEVIEWERS
Immersion in the flood of images

The fetishism of discourse is accompanied by a fetishism of com-
munication (which goes with the importance of the mass media).
This fetishism, as we know, reduces social and human facts to
communication in general; it ignores the concrete conditions of
communication, its effective modalities. Now, never has commun-
ication been less sure of its channels than it is today.
 H. Lefebvre, 'Le Langage et la société'
What goes on in the evening, in a particular town or region? For
many people the evening is programmed in advance, and in the same
way, by the predictable sequence of television programmes. How is
the programmed reception of television experienced by the tele-
viewers? What traces of it persist the following day? The study
that follows does not try to answer these questions, but rather to
define them, which also leads to raising others.

A VIDEO MODEL

The origins of this study followed a number of paths. The principal
idea sprang from seeing a series of photographs showing at speci-
fied intervals what appeared on the small screen over a period of
several hours. From this photographic record compiled by Martine
Lanini, who also took part in the present study, we borrowed the
notion of the 'accumulation of messages'; in it was given an indi-
cation, a qualitative measure, of the array or bric-à-brac of images
paraded before the eyes of the televiewer. However, as there was no
question of treating the flood of images by itself in isolation, and
even less of approaching television divorced from the conditions in
which it is received, we decided to carry out this idea by situating
it in context, by creating a sort of 'living model' of the condi-
tions in which televiewers watch a TV programme.
 And so, after a number of false starts, we reached a decision
about setting up these conditions: during peak viewing time, over
quite short periods, we would record extracts of the programme dir-
ectly onto videotape, and, at the same time, we would indirectly
record the reception of the programme by viewers seated around the
small screen in an ordinary living-room. The video camera would

focus on the TV set and the viewers either simultaneously or alter-
nately. The video montage carried out later alternated extracts
from the programme with sequences of its reception as it was being
experienced; the second part of the montage contained sequences
filmed the following day in which people interviewed in the street
gave their opinions on the previous evening's programme. The two
together constituted a video sketch outlining a longitudinal pro-
file of the reception and retention of televised material.

The main objective of this experiment was to apprehend a com-
plete televisual environment at a given moment in a given place.
Like all sketches, it was intended to be exploratory, suggestive,
and multidimensional. Far from being a study in depth, this experi-
ment, in which the audio-visual helps to explore the audio-visual,
is an example of a preliminary model for more systemtic researches.
It also exhibits the advantages and disadvantages of integrating
several facets of a phenomenon from the outset, these different
aspects often being conveyed here by the various authors of the
experiment.

The observers to whom the video montage was shown had to appre-
hend a complex phenomenon; they saw at the same time direct excerpts
from the programme, televiewers in process of watching these ex-
cerpts, and, lastly, people talking about the programme in question;
but they, in their turn, were immersed in a flood of images, or
perhaps we should rather say, involved in a video phenomenon.
Videoviewers were observing televiewers, video was applying a steth-
oscope to television, David was trying to clinch with Goliath. An
encompassing phenomenon should thus permit comprehension of the
televisual phenomenon. In this respect the sketch was a kind of
simulation, in which the involvement and the distantiation of the
observers were to play an essential role.

Here are some details of the passages that were recalled and the
comments expressed at the time by the viewers who were recorded by
video.

1 TV news (succession of sequences)
- a black ghetto
- an announcer
- Scottish scenes
- Spanish throne: the Carlists
- inflation in Switzerland
- new issue of postage stamps
- resignation of Herr Ulbricht
- Kart racing

> *la Watching the news*
> - 'She's quite nice-looking' (of a
> princess)
> - 'The picture's fuzzy'
> - 'It's all right for five
> minutes.'

2 Advertisements, 'Carrefour'(1) (succession of sequences)
- washing powder: 'a world of tender softness' (soft music,
caresses)
- polaroid glasses (crabs emerging from the water)
- Kléber-Colombes tyres (accident narrowly avoided)
- Crème 21 (face cream)

- Winterthur Assurances (shot of a tent - in the style of American TV serial - with fragment of text: 'protection against men and animals as Winterthur advises')
- 'Carrefour' credits
- journalist
- 'The mystery of the haunted house' (which mysteriously filled with water near Fribourg); fault in the picture: the photo of the house appears too late.

> 2a *Watching the advertisements*
> *and 'Carrefour'*
> - 'Advertising's bloody stupid'
> - 'Carrefour' journalist address-
> ing the viewers: 'You know the
> facts...' Answer: 'No!'

3 *Female announcer, serial 'The Hamburg Mail' (succession of sequences)*
- Announcer introduces the serial and the interview with the leader of the POP (Swiss Communist) party
- serial: résumé of preceding episodes (combination of photos, commentaries 'off', and live sequences). The instalment begins: a family, some shady characters, some unsuccessful stooges, weird shots backstage in a theatre; the opening of a police investigation of a disappearance.

> 3a *Watching the serial*
> - sighs, stretching of limbs, rub-
> bing of eyes, lolling about
> - adjusting the picture
> - 'How frustrating TV is!'
> - switch to other channel, with
> general consensus

THE EXTERIORIZED TV PHENOMENON

This sketch, by attempting to bring to light the actual conditions in which reception takes place, has helped to reveal several facets of the phenomenon.

One of the first aspects, and by no means the least, became immediately apparent during the video-reading of excerpts from the programme: the irregular juxtaposition of messages. The rapid and uninterrupted sequence of images, the diversity of messages (advertising spots, news, serial), and the multiplicity of styles of presentation successively throw into relief the plurality of heterogeneous messages contained in a programme which seems to have no ordering principle other than a quantitative one. Faced with this abundance of helter-skelter shock-images, the viewers seem submerged by a continuous tide, an inundation of images. This submerged atmosphere is given physical expression in the blue glow emanating from the screen, which bathes the viewers in a continuous flux of luminous waves. The sepulchral sound and this fluorescence very faithfully evoke the humid, twilit atmosphere of a cave. In antithesis to the darkened auditorium of the cinema, the field of reception of television is in semi-daylight; objects, armchairs, ashtrays play a significant role; the everyday décor persists and cannot be dislodged from overall perception.

The uninterrupted output from the TV set creates a diffuse and fluid attention in the viewer, who is importuned by images, words, and sounds, but also by what is going on outside the screen: shifting of objects, whispers, exclamations, quick comments, snatches of conversation, all of which distract him. His concentration cannot be sustained because what is going on around forces him constantly to mobilize several fields of consciousness: his subconscious and his imaginative and perceptual consciousness will be engaged simultaneously.

A multiplicity of minute interactions is revealed among the viewers; diverse manoeuvres create a diversion: adjusting the set, switching to another channel, talking; trivial actions (lighting a cigarette, talking about something else ...) are intercalated in behaviour that is primarily influenced by tension in relation to the flow of picture-messages; this tension fluctuates, and is sometimes active at several points; it often attaches to the picture, and almost constantly to the sound, which the spectator is unable to escape.

The flux on the screen structures a whole region of everyday life. The phantom presence of the medium creates a televisual milieu in which reception is not experienced by direct injection, but rather by diffuse attention, fluctuating concentration, tension, distraction, and interjection.

In order to interpret the phenomenon, it is not enough to draw attention to this flood of images and this submersion of the viewers. Why do they let themselves be submerged? To some extent the viewer immerses himself in this flood because essentially it has been scheduled, structured, and programmed. If the submersion is in a daily programme, immersion occurs even more easily.

However, it is during the interviews that a new dimension appears. Of course, it is hardly surprising that in a particular district, on a particular evening, a good proportion of the inhabitants will have been watching television. All the same, when you realize that the majority of a series of people interviewed have, in fact, switched on their sets at approximately the same moment, and that they have thus all more or less submitted to the same tide, then you may say not only that this submersion is programmed, but that it is generalized to an entire population that has lived through an evening in some way homogenized by the programme. On the other hand, this programme may perhaps not achieve its end: its 'reception' is highly diversified.(2)

The people interviewed about this evening of TV most often recalled it in relation to what they were doing and relocated it in the context of their everyday lives; appended to the daily routine, television was experienced as an automatic rite, since most people had retained only a few scraps of everything they had seen and heard. It is of course essential to point out here how difficult it is in an interview to elicit any memories other than those which can be verbalized and rationalized; difficulties of this kind have hardly been overcome in the present case. But if there is amnesia or almost total blockage regarding the content of programmes, the styles and varieties of programme are appreciated or criticized, the

titles and the atmosphere are often mentioned, and affective judg-
ments are certainly expressed about the programmes, the actors, or
the announcers. Naturally, it is often hard to express in words
what has been experienced in a 'state of immersion'; here again, it
is this immersion which creates a problem:

> MARTINE LANINI: I've found that if people don't retain anything
> it's because they watch TV as if they were watching the world go
> by.

By creating a 'there-here', television offers every day the pro-
grammed opportunity of living outside oneself, and this 'strangeness
to oneself' is experienced in the triviality of everyday life as a
reinforcement. So here returns in full force the alienation exper-
ienced in the daily round. Immersion in the flood of images must be
understood as one of the aspects of the invasion of everyday life
that transforms the viewer into the spectator of his own survival.

ON THE INSIDE OF A VIDEO PHENOMENON

It must be remembered that the observer who is confronted with this
audio-visual sketch finds himself involved in a phenomenon analogous
to that represented by the videotape. He in his turn becomes a
televiewer of a video programme showing him other televiewers in
front of their screens.

This imbrication of phenomena is rich in potentialities. Himself
put in the position of a spectator, the observer can at every moment
implicate himself by referring to his own situation in order to
explicate to himself the phenomenon of reception. When implicated,
the observer becomes a participant. Distantiated, he once more
becomes an observer. Implication and distantiation will provide the
basis for his comprehension, for his explication of the phenomenon.

Here we have a kind of 'video phenomenology' that is fertile in
critical possibilities.

> A TEACHER: Video fosters analytical attention, because the speed
> of perception is modified. The first time you see a programme
> it is synchronous with a particular perception. On the other
> hand, a second viewing permits the eye to attend, to inspect, to
> explore. This shift in the conditions of reception is by no
> means the least effect of video; the 'private' framework is not
> well adapted to learning behaviour.

From this accumulation or flood of images there soon emerges a con-
stant: the spectacular. Messages are imbricated according to a pro-
gramme that presents above all a mosaic, a hotchpotch of images,
stories, news, serials, in response to the attraction they are supp-
osed to have for the viewer; this is the phenomenon of 'seduction by
spectacle'.

> It's a new form of bourgeois comedy, but more complex; a new
> triangle is set up, with TV as one of the partners. This is due
> to the fact that one hardly ever watches TV alone. As one watch-
> es, one feels the other person watching or reacting.

In that absence of the unexpected which is our daily experience,
television seems to be a predictable presence, and insidiously takes
on the quality of the expected 'being':

> When we turn the set on in the evening, there is expectancy, but
> of a relatively predictable kind; isn't it rather like waiting
> for someone...?

At first sight the televisual situation seems like a dialogue: the
announcer addresses himself directly to the viewer; the private
lives of certain actors are exposed to him, and so on; one cannot
always abstract from this communication the fact that it is trans-
mitted through a screen and that this indicates to him the gap sep-
arating him from those who seem to be communicating, by suggesting
the eternal return of the expected masquerading as the unexpected.

> TV news will last from 19.40 to 20 hours; we wait for what they
> are going to tell us, we don't yet know the content, even if we
> can often impress a particular structure on it: political news,
> disasters, sporting results

The fact that this sketch condensed excerpts from a TV programme
and the comments of people who had watched it encouraged the synthe-
sizing perception of a particular televisual environment. Undoubt-
edly the revelatory effect of removal from context, of displacement,
was in operation here:

> Television creates a climate, an atmosphere, an imaginary field.
> It's very plain in relation to interviews. To take an example,
> 'Carrefour'; well, what someone said about that is that 'it's
> very national'; perhaps what is important is not its news content
> but that the programme helps to indicate and unify a 'Helvetic
> space'.

The homogenization of perceptions and representations is related to
long-term effects that cannot be dealt with here; but it also has a
corollary at the level of the programme: the legitimation of every-
thing that appears on the screen by virtue of the fact that it is
transmitted by an authorized television network:

> Any old serial becomes legitimated when it appears on the screen;
> and, what is more, the account of it this woman comes up with in
> an interview is also 'legitimate'; she is recreating 'her' plot
> on the basis of what she has seen!

The last remark, which reminds us of the affective and imaginative
faculties at work in audio-visual reception, also throws light on
the need felt by any viewer who is immersed in the flood of images
to emerge by some means or other by unveiling the links he maintains
between the images imposed on him from outside and his own images,
projections, and alterations. Here is a whole field of virtualities,
based on the impossibility of perceiving whatever it may be without
making implicit or explicit reference to experience and to subjec-
tivity.

MILITANTS AND TV
Censored emergence

One suspects that the nice fairy tale of David and Goliath is less
plausible than the story of the iron pot that defeats the earthen-
ware pot. It is none the less true that the Goliath of centralized
television(1) is in need of fresh contributions, even of a guerrilla
kind. In the long run, even for the real professionals, there
arises the question of active public participation, of finding new
forces in the production of programmes. But what can non-profes-
sionals be allowed to do? What would be acceptable from them?

 It seemed interesting for us to take a look at this problem in
view of the current (1971-2) unrest surrounding Télévision Suisse
Romande and the overhaul of programmes that had actually been attemp-
ted. Using video to track the emergence of a new force, even though
it ended by being eliminated (censorship and suppression of the pro-
gramme) in the confrontation with official television, was all the
more logical since video will be the preferred instrument of non-
professional ventures because it reflects their style.

ABORTED PARTICIPATION

Recourse to non-professionals

The need, for various reasons, to allow a place to outside produc-
tion interests seems already to have been felt for some time. At
the beginning of 1971, the producers of the programme 'Regards' de-
cided to try out a new programme format. Previously, 'Regards' had
tackled 'delicate' subjects: sexual freedom, the young, foreign
workers, and so on. Essentially, the innovation consisted in hand-
ing over complete responsibility for producing a ten-minute film to
members of the public. The TV studio put at their disposal a tech-
nical unit and the necessary resources for producing a scenario
written by themselves. They would work 'in whatever way they wished'
(provided there was no contravention of the SSR(2) charter) on an
agreed topic: three people of different views and background would
be chosen for each programme; there would ultimately be three films,
followed by a direct confrontation between their authors, with a
journalist summing up the programme.

The first venture was a success and hopes were consequently raised. A teacher, a student, and an apprentice confronted each other on the subject of work. The film, produced in a highly personal style by the apprentice, delivered a violent critique of society, but it was not censored because it was presented as being 'subjective', and the discussion gave scope for what was regarded as a balanced exchange of opinion.

Things did not turn out the same way with the second venture, which brought an army lieutenant and a conscientious objector face to face on the subject of 'young people and conscientious objection'. The lieutenant's film was intended to defend the army's point of view, but it was judged to be inadequate as to both argument and presentation; the second film was deemed to be 'offensive' to the majority of citizens and to contain false allegations. During a university seminar on television, the programme director explained the reasons for censoring this feature.

The main stages of the third venture, on the subject of 'young people and democracy', were recorded by video, a process at the end of which not only was this particular programme censored but this formula for participation was suppressed.

It obviously carried more risks than did the French programme 'A Armes Egales' ('On equal terms'), which is open only to very well-known people. 'Regards' had the chance of encouraging the emergence of a deeper expression of reality as perceived by members of the so-called public.

The 'Jeunesses Progressistes', a leftwing group in Lausanne, was chosen by the 'Regards' team to represent the extra-parliamentary opposition. Through personal connections, one of us was able to follow and actively participate in the preparation of a scenario by this group. He began by making video recordings of incidents during their work, and was gradually drawn into covering the whole conflict, episode by episode.

Reformulation of the theme

Points of view on the subject of 'young people and democracy' had to be balanced. How were they to chose participants who would on this occasion express their socio-political orientations more directly than in the programme about work? The protagonists were spread along the left-right dimension, from parties to cells. A conservative, a representative of the centre, and a leftwinger would have the chance of giving their views on democracy - a 'Swiss' topic, if ever there was one; the majority of viewers would probably settle for an intermediate position, in the middle of the road.

The Jeunesses Progressistes began by getting advice from sympathizers in the film world about the technique of working on a scenario. The first idea emerged: a class in civics, with a teacher, some pupils, and a confrontation between the official formulations about democracy ('of the bourgeoisie') and the objections to them put forward by the pupils.

At that juncture the unrest that was fomenting in the television world took definite shape. For the first time a strike movement was bringing the hierarchy into conflict, primarily with the technicians.

There was talk, not without reference to the problem of state con-
trol, of parliamentary review of the statutes of SSR. The growth
crisis of a television just emerging from the 'craft' stage and
entering the stage of industrial organization had erupted into pub-
lic view.

Far from being unconnected with our problematic, this contin-
gency can only shed more light on the logic, and also the contra-
dictions, of the abortive attempt at participation we are consider-
ing. In our view, video enabled us to grasp the essentials of the
crisis; it enabled us to intervene quickly and at low cost. Its
sharpness as a style and instrument of observation enabled us to
capture instantly the significant moments in the development of a
crisis, which the finished tape would later give back for analysis
when their importance began to be apparent, or even strategic.

The stage during which the Jeunesses Progressistes reformulated
the theme and the initial scenario worked out in the following way.
In the event, instead of taking the theme of democracy in terms of
the constitution, parliament, parties, and so forth, the group deci-
ded, on reflection, to deal with democracy in relation to tele-
vision, which amounted to using the programme to turn television
against itself:

A MILITANT: In any case, there isn't time, in ten minutes, to
show that Switzerland isn't a really democratic country.

To avoid 'co-option' and the pitfalls of mere entertainment,
within the frame of reference of the programme, it was decided to
produce something more than a document, in fact a revolutionary
political 'act'; in order to transcend the question of formal demo-
cracy, the scenario dealt with democracy inside Télévision Suisse
Romande. When the project was referred to the programme directors,
their anxiety was not unnaturally aroused; certain modifications
would have to be made; it was decided to suppress scenes dealing
with work inside television and to retain the desired opposition
between actual living conditions (family life, housing, work) and
the spectacle of the everyday life of millionaires in the serials.
The target was the trend to insidious panegyrics of comfort, wealth,
and fame and their effect of reducing the sense of reality and in-
viting spurious compensations. The concluding question was: 'Are
you consulted about the content of programmes?' Is television
really democratic or is it simply an instrument serving the inter-
ests of the ruling class?

At the moment when the group of Jeunesses Progressistes and the
technical team are starting to shoot - shooting will take three
days - the previous 'Regards' programme on conscientious objection
has just been banned. For the local press the Director of Pro-
grammes becomes 'Mr Censorship'. He comes to the university to
lecture on a subject arranged some time beforehand. He knows that
he is liable to be interrogated about censorship by the audience.

Sensation! The Jeunesses Progressistes ask the TV team to film
the lecture by their own director in order to use parts of it in
their film.

This provocation is undoubtedly highly annoying to the director.
He eventually agrees that some extracts from the meeting can be
filmed. We duplicate the partial TV coverage with a complete video
recording. Soon after this incident the formula will be dropped and
the programme suppressed.

Formulation of suppression

The butt of press attacks, and peppered with questions by students,
intellectuals, and journalists, the Director of Programmes needs all
his debating skill to save his face. Filmed by the TV team and by
video, and again by the latter at the most awkward moments, he has
to summon all his elegant virtuosity to sidetrack his pursuers.
Apart from various mannerisms and clichés - to be found in any
speaker(3) - analysis of the videotape reveals aspects of behaviour
that are apparent only in the long term and get by at the time. In
due course his subacid ploys become completely recognizable: a judi-
cious blend of flattery and brilliant humour; incisive, but some-
times insidious, counterattacks at an abstract level (as for his
tone, playfulness alternates with irritation that is all the more
intense for being contained); constant reminders of technical errors
committed by his opponents (exploiting weaknesses in manner of ex-
pression); all this enables him to recover his wind and to evade
the basic issues.
 No doubt such tactics are the common currency of debate; analysis
of the tapes accentuates them with horrifying force. A formalistic
style of argument, which lends credibility to strategic passages the
first time round, exposes their weaknesses on a second showing.
 For example, a member of the audience points out the contra-
dictions in the speaker's position, to which he replies: 'I'm not
afraid of being caught in contradictions, I believe in an approach
that can perhaps be called'
 To say that you accept being 'caught' in contradictions is a
clever deception, and the notion of 'dialectic', all the more
strongly implied for not being put into words, provides a temporary
let-out; one agrees to being caught because in theory the dialectic
allows one to get out of contradictions. But this little trick
collapses when one watches the debate again away from the atmosphere
of instant contest and persuasion.
 The controversy over the previous transmissions made the death
sentence on the formula quite predictable.
 - The argument against the 'conscientious objection' programme
 concerns 'social technique'; the implicit, unwritten rules have
 been disregarded.
 - The film against the army 'went outside the subject'; it in-
 cluded criticisms of the overall social structure and of national
 investment policy (in Greece, South Africa, and elsewhere). The
 film contained some obvious historical errors. The discussion
 leader would have been compelled to turn himself into a prose-
 cuting counsel in order to 'redress' these errors. Furthermore,
 citizens who underwent military service in the normal way - and
 particularly those who did so during the war - would feel 'insul-
 ted' by a film that represented the army as an instrument of
 repression 'in the service of the bourgeoisie'.
It is precisely because these rules remain unwritten that the game
is impracticable in terms of the 'tables of the Law', the charter of
SSR.

ON PARTICIPANT-OBSERVATION

During the preparation of the programme with the Jeunesses Pro-
gressistes, and later during the semi-public discussion meeting with
the Director of Programmes, we practised two forms of video
participant-observation.

Preparing the programme with the Jeunesses Progressistes

The uncommitted sociologist, no less than the 'pirate' observer,
would not have had the opportunity of using video actually to follow
the working processes, the deep involvement, the hesitations, the
choice of group members, and so on.
 Although at the beginning the researcher was accepted on the
basis of friendship, and it was anticipated that video would be used
to visualize a written scenario, not to produce a reflexive piece,
the scenario was not in fact ready.
 The researcher, who was a sympathizer but not a member of the
group, soon realized that it would be inconceivable for him simply
to remain a 'film-maker'. The specific characteristics of video,
its simplicity of operation and capacity for immediate playback,
encourage the inclusion of the videologist and his equipment in the
work process, particularly because the development of the scenario
in a television film is carried out at this stage and there is scope
for testing out various ideas. It certainly took some time during
the discussion sessions to overcome resistance to the 'voyeurism' of
the camera. Indeed, it did not entirely disappear until the camera-
man continued the discussion while he was actually shooting the film.
 After a time this behaviour had become so natural that other mem-
bers of the group began to take over the camera. By an extraordi-
nary process of imitation, the cameraman of the moment (who had
possibly never done filming before) did not stop joining in the dis-
cussion while he held the camera.
 Once the weekend was over, the group was able to take a second
look at the essential phases of the discussions; then they discussed
the scenario of 'Democracy in Television' with the group of appren-
tices in the presence of Jean-Luc Godard, who happened to be passing
through Lausanne at the time. When the director, now a political
militant, described his conception of political cinema, and more
generally of sound and image, it was possible to appreciate the dis-
tance between his reflections on the media inspired by political
theory and the constraints of a scenario in the present situation.
 During these quite intense exchanges, videorecording was suspen-
ded in order not to disturb the rapport. On the other hand, the
small group had used the camera like a third eye, as if having the
feeling of being watched by someone whose face cannot be seen and
then becoming that eye themselves. The video process, thus inter-
mittently inserted in the work, stimulated creativity and the dev-
elopment of the group project, since the point was to find ideas, to
put them together, and to criticize them by constant reference to a
political project all within a very short time.
 'This instrument helps us to know more fully who we are', says
one of the members, 'and to know more fully who to become', adds

another, specifying, 'those of us who have been deprived of oppor-
tunities to find an identity'. The importance of this aid to self-
identification and to investment in the project by means of the
video-mirror certainly deserves to be studied more thoroughly. We
know that at some point, in a political organization for example,
the problem of a leader or leaders arises and of the behaviour of
the activists towards them and towards each other.

Censorship and collusion

From the moment when video is no longer utilized, and therefore
directly controlled from the inside, by the group in question, the
way is open for the development of a new ethic.(4)
 In a conflict situation, can the participant-observer stand aside
from the politics of the group? It was easy to suspect collusion.
 In a very explicit speech, the Director of Programmes sharply
contrasted the role of the critical sociologists ('You are the yeast
in the civic loaf of tomorrow') with that of the TV journalists,
'responsible' to the SSR charter, who have made it 'the standard for
their lives'. He developed the theme of 'responsibility' in a more
general way, implying that the sociologists were 'irresponsible'.
 QUESTION: Can TV take the risk of permitting the expression of
 extreme views in an 'open forum' type of programme?
Television should respect the convictions of all the groups that
make up the national collectivity. Television itself has no opinion.
If positions are stated, it is essential, on the one hand, that
their author should be clearly identifiable as such and, on the
other, that immediate opportunities should be made for countervail-
ing views, particularly in the format of a debate.
 This was in essence the reasoning of the Director of Programmes.
If there is responsibility on his side in relation to the general
contract (the charter) that seals the compact between his institu-
tion and the nation, it is in terms of this balance.
 In the limiting case, this represents not merely·a policy of
defending the 'consensus', but also a strategy very precisely dir-
ected towards maintaining the socio-political and cultural equilib-
rium of the moment. If one believes that, in its centres of power,
society depends on the generalized consent of the 'ordinary citizen',
as much as on the ownership of the means of production and the appro-
priation of control of the state, then this constant preoccupation
with equilibrium - neither too much criticism nor too much justifi-
cation of power - appears as a violent alignment with the status quo
in the guise of formal neutrality.
 If television is centripetal in this way, it is hardly surprising
that it finds it impossible to welcome 'quotation marks',(5) or that
it rejects a non-professional praxis oriented in a contrary direc-
tion; the centrifugal praxis of non-professionals will be directed
towards disrupting the equilibrium and towards a form of expression
that is particular rather than general, specific rather than average,
and it will contest attempts at reducing these distinctions in terms
of majority and minority interests.
 The following statement, contradicted by the subsequent censoring
of the programme, now appears oddly true and overtaken by events:

'Television is a monopoly, and is therefore open to all-comers.'
Expression of the views of a minority movement is in fact possible
provided it can be sterilized by the constraints of style of presen-
tation and by immediate antidotes (emphasis on the unrepresentative
nature(6) of the dissident group, and reference to 'realities' such
as laws, productivity, and percentages).

According to the Director, two conceptions of ethics confront
each other. The institutional one, imposed on television staff,
and the outside one shared by all those who intervene in television
- extra-institutionally.

We require, said the Director, in substance, that our journalists
shall carry out their duties according to a stringent professional
ethic that maintains a continuous reciprocity between freedom and
responsibility. And we have just seen the complexion of the latter.

This policy always favours the current general institutional and
socio-cultural framework as against the autonomy and aims of groups
whose right to exist cannot nevertheless be completely denied.
Opposed to it is a communal policy with the opposite options: all
the work carried out by a group, in video for instance, is control-
led by its members. They arrange for its eventual distribution and
give priority to the expression of their aims over all institutional
considerations, even over any examination of the framework in which
the distribution takes place - from a limited specific and critical
perspective.

This second panel of our participant-observation triptych, not sur-
prisingly, turns out to be more dangerous than the first, which re-
mained internal to the group. It was unthinkable, after the con-
tacts established during the preparatory phase, publicly to dissoc-
iate ourselves from the group at the meeting. In a conflict situa-
tion, one takes a definite stance, and, at this meeting, there was
not merely conflict but mounting tension. The Director of Programmes
was submitted to, and stood up against, a cumulative series of
pressures:
 - Bargaining by the group of militants who wanted the TV team put
 at their disposal to get the Director's agreement to their film-
 ing themselves.
 - Demands by the audience that the Director should give an ac-
 count of himself regarding the censorship measures he had imposed.
 (On the one hand, he did not intend to talk about it. On the
 other hand, he was being filmed by a TV team temporarily under
 the direction of an outside group, though subordinate to him, and
 the film would ultimately come under his control: a bizarre loop.)
 - The session was being recorded by video in its entirety, inclu-
 ding the awkward moments when the film unit was not shooting.
 - The whole affair was going on in the presence of journalists.
Question from the Director when leaving the meeting: 'What are you
going to do with this tape?'

The material was used only in a students' seminar for purposes of
the present analysis. The showings were restricted and the tapes
were wiped immediately. All the same, the conviction of collusion
between us and the group of Jeunesses Progressistes grew up during
the meeting and consequently fixed an 'image' of the observers.

Sociological realism leads, among other things, to confronting the authorities with the point of view of those who are subject to them; participant observation makes possible the collection of valuable data, but the price paid for this complicity is also the closing, at least temporarily, of the doors of the institution. The observers, like the participants in the group, should have been able to make judicious strategic calculations: 'How far is too far?'

Leaving aside the behaviour of the people involved in this particular case, we may speculate in a general way on the possibility of intervention in TV by militants.

On reflection, it seems that the latter inevitably fall into a trap. The militant group can only work with the team of technicians and producers that is put at their disposal. This team is sandwiched between its own administration and the group. Each side tries to outbid the other. The more critical the group becomes, the more the administration will resort to formal precautions, balancing measures, and the rest of it. The more the struggle hots up, the more pressure is brought by the officials of the dissident group. The more an atmosphere of conflict becomes apparent to the general public - because of previous acts of censorship - the more the pressure groups attack political power and television on the ground of repression. Thus, at a time of increasing challenge to the 'social consensus' in Switzerland as elsewhere, an inflammable atmosphere is generated, and irritation, anger, and anxiety are rife: should the mass media be more explicitly controlled by the powers-that-be or more truly open to opposing social and cultural currents? (And, on a broader scale, has this society the means of remaining 'pluralistic'?)

However that may be, if we return to the examination of the potential of video, the close and direct utilization of this simple equipment by groups outside the establishment, without full-time specialist teams, seems to be one of the only ways of getting out of the impasse for those who do not conform to the rules of the media. It would still be necessary to begin by accustoming at least a section of the public to judge the interest of a message by its stimulating quality rather than by its ease of assimilation.

What would an alternative television be like, in the context of a renewal of television? What role would video and the cable networks play? A great sense of insecurity can be read in the violence with which those 'responsible' for TV sometimes express their rejection of such ideas. The refusal - which cannot be maintained indefinitely but is still vigorous - of the potential contribution of new means and new forces reveals, among other things, the fear that equipment in the hands of small groups will alter the traditional relationship between a television that exercises (is) authority and its various publics (called 'the' public). Could video, in fact, in this case, become a sort of David with simpler resources (for outside groups representing critical or disruptive points of view) standing up to a Goliath with vast resources (His Master's Voice)?

STEELWORKERS
Emergence of a potential

Much of the immediate data that a sociological study normally takes account of is in the domain of what philosophers still refer to as appearances: they contribute very little to the understanding of reality. As we have said in various connexions, to go beyond this and above all to try to grasp a hidden social potential seems to us to be one of the most urgent tasks. In our view, a new means of investigation should be used to its fullest extent to reveal this element of virtuality, which is usually concealed by appearances.

Now, photographic or cinematic images have the characteristic of manifesting this virtuality to the highest degree, and they should in theory pilot us back towards these immediate data. On the other hand, an experiment such as the one we are about to describe runs into obstacles; in the event, it could not be carried out and got no further than the planning stage. Why then discuss it?

A series of elements in the specific situation examined below have so strong a bearing on the industrial and sociological problems raised by the video praxis described elsewhere in this book that it is appropriate to anatomize this relationship.

FROM TAYLORISM TO THE EXPLORATION OF POTENTIAL

Lunching with industrial 'practitioners' in the executives' canteen of a factory, and opening up an exchange of views on partly industrial, partly sociological topics, was for us an exercise whose ceremonial had become established over more than ten years of industrial sociology: delicately negotiated stages involving approaches and withdrawals, anecdotes and questions more or less skilfully introduced, and then some not too academic suggestions designed to provide a basis for description with finally even a little sociological reflection. This being so, during a five-day visit to Italy, a new kind of encounter launched our team on a Copernican revolution in our relations with such people. (1)

Our routine was knocked sideways: the 'practitioner' who had invited our collaboration did not separate description from reflection, nor 'praxis' from sociology, nor his work from our own, nor even 'reality' as defined by positive methods from the positivity of a definition of reality.

Just for once we did not have for dessert the custard pie of a
praxis that is supposed to be so remote from theory. The man we
were talking to was a man of action who was intellectually sophis-
ticated: he understood both worlds, and was both critical and
practical:
> The Taylorism that still dominates the thinking of so many engi-
> neers and managers is really finished. It will no longer do in
> regions of rapid industrial expansion or in modern industry. Do
> you know that remarkable passage in Marcuse's introduction to
> 'Reason and Revolution'?(2) Although it's no longer a new book,
> it's not at all well understood.

In 1970, Italian industry, particularly steel, had a large number of
strikes. Towards the end of the year, an agreement was concluded
between representatives of management and unions introducing a radi-
cal change in the wages structure. In spite of some resistance, the
system of job evaluation and the traditional distinctions between
wage-earners and salaried staff (i.e. between blue- and white-collar
workers) were to be broken down; the entire workforce would be divi-
ded into eight categories first and last. A new idea - 'profession-
ality' - would be discussed, and the task of our team was to help to
develop an instrument for measuring this (a grid for analysis and
synthesis).

Now, above all, it is important to understand how strongly the
emphasis here is on development: the steelmaking complex at Taranto
is scheduled to increase its workforce from 6,000 to 18,000 in less
than five years.

Although part of the labour will certainly be drawn from else-
where, and especially from northern Italy, many of the skilled jobs
will have to be filled by internal recruitment. In any case, the
need for a wide range of skills in the workforce presents a training
problem of fantastic proportions: whereas the normal industrial
attitude is obviously to discourage the upward mobility of workers,
here, for once, it will be necessary to plot the best and quickest
learning curve, and to take in both old and new workers. Instead of
minimizing potential, it will mean discovering the trajectories of a
hitherto latent method of learning by experience, since the essen-
tially local traditional routes (in workshops or even in teams, but
rarely in sectors) are just as likely to block candidates, who will
only aspire to posts that rarely fall vacant, as to help them pro-
gressively assimilate experience of the job.
> THE SOCIOLOGIST-PRACTITIONER: The point is to use the human pot-
> ential within the factory 100 per cent (and not 15 per cent, as
> is usual)! And it's got to be done quickly!
> A MEMBER OF THE ITALIAN RESEARCH TEAM: In three years' time, 3,000
> workers will have had less than two years' service in the factory,
> and, in the case of many, even in industry.

The task is therefore to find out which of the jobs have the great-
est training potential, for there can be no question of achieving
professionality except by actually doing things.

By professionality we understand the capacity of the worker to
achieve the set of objectives assigned to him, and above all to
solve problems that arise unexpectedly on the job, and this without
seeking outside aid.

By means of a series of transfers, the trainees would be promoted

at various levels, through teams, workshops, sectors, divisions, and
so on. Such, at least, is the theory - local customs and traditions
will set up resistances, or at any rate tend to inertia. Instead of
introducing illiterates into highly programmed systems or training
individuals in a school, the idea is to train them on the spot, but
not 'on the job' as in the past. The factory would become a school
'on site', socializing the individual not only into a job, but
rather into an understanding of industry from within a particular
'family' of jobs.

Here, as we see it, is the beginning of a transverse conception
which must be thoroughly justified in the face of scepticism on the
part of managers and of the workers themselves. This is a task one
could try to accomplish by means of lectures, graphics, discussion,
or better still, we thought, by means of a video process.

If it were only a matter of showing the importance of understand-
ing the production process, we might depart from the immediate, from
more or less tangible facts. But if it were a matter of defining
professionality more completely than had been done in the union-
management agreement, as well as these training trajectories, then
the task would be enormous.

UTOPIAS OF AN INDUSTRIAL VIDEO

What is to be understood by 'professionality'? An idea of this kind
invites psychological and sociological projections; it can, first of
all, be provisionally accepted by groups who do not understand it
exactly in one and the same way. It is, furthermore, a concept des-
igned to grasp what is potential; as such, it will have to be 'docu-
mented' in order to become acceptable, at least in essence, at the
theoretical level (by occupational psychologists, consultants, mana-
gers), at the trade union level (in negotiations regarding skills
and pay), and at the more directly practical level (between workers,
supervisors, and management on the shopfloor).

In a situation so clearly and classically conflictual as this, a
phase of explanation and illustration must precede attempts at imple-
menting the new idea, particularly among the workers concerned and
the partners in negotiations. However, since resistance cannot be
completely absorbed by techniques of information and training, a
more thoroughgoing intervention must be envisaged, in view of the
transformation of the organizational system and even of the basic
structures.

DESCRIPTIVE EXPLORATION WITH VIDEO

The psycho-technicians and psycho-sociologists of industry have not
waited for the arrival of video before describing the various as-
pects of industrial work; they mainly use dimensions of various
criteria in descriptive grids that are often exaggeratedly analy-
tical (atomizing groups into individuals, sectors into groups, and
so on), and sometimes questionnaires. Some of them, like some in-
dustrial sociologists as well, have tried to capture incidents,
critical moments, and even differences in work-style, outside the

everyday routine of normal functioning. They have come to use time-sampling techniques (Multi-Moment Aufnahme) or films in order to grasp what is beyond the reach of an observer who stays in contact with a job or a group for an hour or two.

Video reportage intended to uncover the side normally buried, the heart of the worker's contribution that lies outside routine, would necessarily start out by sharing or relinquishing control of this exploration. It would then move on, by means of discussion, to locating the people who are most aware of the problem. When they had defined their contribution at critical moments, it would be possible to attempt a joint description of professionality:
- repair, and above all prevention, of breakdowns
- an overall view, and an understanding of the way the job is slotted into the industrial process
- capacity for mobilizing theoretical knowledge and skills developed through experience in the job or previous industrial experience
- ability to improvise new, or partly new, behaviour

Video illustrations of the professionality of a few jobs would be shown and discussed in order to locate other jobs with a higher degree of professionality. In this way some measure of hierarchization would be introduced among the jobs, at the same time as a discriminative description of professionality.

At the second stage, the description would tackle the problem of transferring from one job to another in a learning trajectory. Some of them would, in fact, promote growth along some dimension of professionality,(3) even though, in relation to the whole, they were not necessarily at a very high level in their sector nor among the prestigeful appointments in the enterprise.

VIDEO-ACTION IN TRAINING

Collecting the basic information for a new and more accurate job classification is a considerable task, especially if it is intended to abandon systems established over many years by custom, disputes, and the intervention of management consultants (systems that are not more than half accepted by different generations of workers and managers). To gain acceptance for a new classification or a new training programme is equally difficult, even on the hypothesis that a video exercise would result in a description controlled by the personnel and therefore accepted by some, if not all, of them. In fact, one has to reckon with the compartmentalization of categories and with the parochialism of groups, workshops, and sectors. There are myths going around about the 'absolutely irreducible' time needed to train a rolling-mill operator, and the much shorter period for training a winder in the same sector, for example, although the professionality of the latter is nevertheless greater. Ideas on this matter are often dictated by tradition; when a sector passes from the craft stage to the mechanized stage, or even to the semi-automated stage, the former professional standards and the prestige attaching to them persist despite the realities of the new conditions, although other jobs, hitherto minor or nonexistent, have in fact become more difficult and more strategic.

Shopfloor meetings would give scope for discussing changes of this kind and getting familiarized with jobs that are unknown beyond the confines of the workshop and the sector: there would be deglamorization of the older jobs, and decompartmentalization of groups, workshops, sectors, and also of the industrial stages A, B, and C.(4)

The second phase of the training process carried out by means of video would illustrate those aspects of certain key formative jobs that would make good launching-pads, so that the worker-students, like managers at different levels, could become aware of their hitherto unused potential for learning and growth.

The struggle would therefore be waged on two fronts:

(i) against the false claims of certain jobs, and against the false requirement for learning on the job; by no means the least important task would be to expose the discrepancies, even the contradictions, between the reality of experience and that of organization charts, schemas, and regulations;

(ii) for the use of the higher abilities of people hitherto kept in subordinate positions or overorganized, since key examples demonstrate the possibility of either rapidly promoting them to better jobs or restructuring jobs that are too fragmented.

There remains the basic problem of organization and structure.

VIDEO-ACTION IN TRANSFORMATION

There would soon arise a wish on the part of the participants in the descriptive and developmental stages of the experiment to introduce something more than procedures for classification and training. The firm lines demarcating the division of labour would be questioned. The discussions would extend beyond the boundaries of the factory, and the illustrative material could be used more generally, for instance in confrontations between opposing social groups or even in certain stages of negotiations.

An interesting telescoping of distance, by means of mediatized presentations, would make it possible to take account of very specific local conditions, but in a context of general discussion that would confer on them a supra-local significance. Hopes of debureaucratization, concurrently with deparochialization! But let us get back to the factory.

It is evident that the speed of industrial development in certain countries leads to questioning of the old functionalist principles of stratification - hierarchy, compartments, the brake on mobility. This also encourages, when linked to the use of an instrument such as video, which can be both a solvent and an accelerator, a possible questioning of the structure itself. The definitions of functions and their particular 'competences' could come under scrutiny, and could perhaps no longer entirely escape it.

One can hardly fail to be struck by the quite recent emphasis on mobilization in an industrial sector as important as steel, and the mobilization of potentiality that is so obviously of first significance in videological praxis as we have described it. No doubt it is dangerous to jump to too optimistic conclusions at this point, but it does not seem impossible to us that the contradictions of capitalism are generating fundamental transformations, whose possi-

bilities it would be reactionary - in a 'renovated' sense of the
term - to underestimate. At any event, to the extent that the
mobilization of potentiality is also an act of dynamization - or, if
one must necessarily define the phenomenon in terms of the system,
of debureaucratization - a most multiform transcendence of the
originally intended movement can be produced.

Will this tendency move towards greater local autonomy for work
groups or for workers? Will there be new regroupings of new job
'families' (those that are high on communication, mobilization,
communication, and the rest)...? We shall have to watch industrial
changes, especially in Italy, to answer these questions.

The desacralization of established authority, whether it is called
hierarchy, organization, or even technology or technicity - as we
shall conclude - could and should be attempted by means of an exten-
ded and comprehensive video praxis, all the more because the task of
developing industrial and professional consciousness presupposes an
approach that is less conceptual, closer to action, and also more
active.

It is, of course, regrettable that hassles with the Customs
should have prevented our recovering our video equipment from the
clutches of an officialdom of a bygone age in time to put our pro-
jects to the test, with a view at least to embarking on the descrip-
tive phase.

PROCESS

It would be hazardous at this stage of our work to draw conclusions. We are in a period of audio-visual expansion but also, paradoxically, of centralism, of a full-blown cultural industry and even techno-cracy. There is this paradox of 'pluralism' and at the same time 'co-option'.

Furthermore, our experiments are exploratory, and necessarily local. Though few in number, they are nevertheless not isolated experiences, as the abundant literature and the existence of video globe-trotters attest.(1) And, above all, our conceptions of pro-jects and projections have been developed in symbiosis with the phenomenon of the 'third culture'.(2)

Rather than attempt conclusions, what we will do in Part III is to offer the fruit of our experience, still limited, but existential and therefore undergoing continuous transformation. We shall give the first word to our 'videologist' colleagues, whom we were able to interview and also to meet in and through their work. We shall next try to abstract from our videological praxis the basic conceptual, schematic, and sociological framework that this field seems to us to need, at the same time revealing, through the articulation of the process, the potential for transformation that can be liberated by video.

VIDEOLOGISTS
Some other practitioners

The areas of application of video become daily more diverse. Even
the underground current of video includes a range of practices(1)
that it would be difficult at the present time to reduce to a few
formulas. Our conversations with various practitioners, although
they cannot cover all this variety, will at least enable us to stake
out some guidelines for an eventual typology of videologists.

We shall provisionally define the videologist as the actor who,
in working with video, resituates his action, continuously or inter-
mittently, in response to existential, social, or cultural consider-
ations, that is to say in relation to a socio-logic. He depasses
not only technological instrumentalism but also simple description:
his praxis is a socio-technique which involves a clear awareness,
and more or less developed attempts at explanation and interpreta-
tion. He is both actor and researcher.

All the individuals and teams with whom we were able to talk work
with portapak. This apart, they differ in many aspects of practice
and individual style. Some, but not all, are professionals. Their
motivations vary. Our typology is, of course, more intuitive and
exploratory than rigorously descriptive.

Above all, it is a matter of understanding a potential. We are
in the inaugural phase. Much of the innovative potential of working
with video will be absorbed and used by commercial, advertising, and,
last but not least, police interests. But so far there's still time
for encounters with explorers, experimenters, prospectors.

How quickly will video become integrated? Will the contours of
actions of the kind described below soon be lost to view? What will
develop in the official circuits and networks? Will it be possible,
alongside the educational use of video (in schools, cultural affairs,
urban life, and so on), to muster sufficient forces in Europe to
create what in the United States and Canada is called the Alternative
Television Movement? These are a few of the questions surrounding
our concern to present some of the first beginnings of a video in-
volved in socio-cultural movements.

CONTACTS AND TAPING

From now on it will be increasingly accepted that one cannot under-
stand a film or a piece of research in the human sciences without
understanding the 'context of discovery'.(2) There is no longer a
kitchen behind closed doors, hermetically sealed from the dining-
room where a finished product is served up for consumption.
 This said, it is clear that viewpoints and methods of work vary
considerably from one videologist to another.

Reflexive rapport

Even though, in the course of this study, we are trying to elucidate
the potential of 'Video', and certain features that are specific to
it (the ephemeral nature of a tape, feedback, and so on), it is no
less true that this instrument can be used in a variety of ways.
All the practitioners we met were split between their insistence on
the specificity of the instrument and their awareness of being able
to use it in the tritest or most capricious manner as well as in
innumerable interesting ways. Now, one of the specific features of
video is its use in closed circuits. SD explains why he prefers
this:
 VT is an instrument you can use to break open the different lay-
 ers of make-believe; it makes it possible to reveal the truth of
 my relation to others, always on condition that video is operated
 in a certain climate.
Used within a group, video can become an important means towards
transforming persons as well as interpersonal relations, given
enough time and adequate preparation. It serves as a mirror. Pro-
vided that it is carefully introduced through a reflexive process,
· a very interesting series of events is set in motion: first, exper-
iencing the relationship with others, receiving the reflection
through the images, reflecting together. And the situation will
obviously be that much less artificial if the people 'inside' it
are members of a real group.
 The interest comes first and foremost from experiencing the
 relationship with those you are most involved with. Video should
 be used as a tool for living, rather than as a microscope.
SD warns against simplistic hopes. Video is not a cure-all; there
is little chance of achieving lasting results automatically.
 All this apparatus is useful only when the people mixing with it
 actually live with it, and when they really have something to
 say to each other.
A group discussion without video makes for lucid intellectual analy-
ses. It even happens that blocks are recognized and discussed, but
video provides an opportunity of going much further, because:
 When you look at the image you are pushed towards an emotional
 and sensual perceptiveness. Understanding where the conflicts
 and blocks are - that much you can cope with, but on top of this,
 you have to endure it all, including the styles of self-
 presentation of all the people there....
The importance of the reflexive process, but not in a mechanical
mirror-like sense, is stressed by SD in his critique of passive

recording and playback. We have this awful tendency simply to be-
come recorders and transmitters; to ingest and regurgitate pass-
ively. In other words, the conscious practice of video implies
consideration not so much of its mechanics as of those aspects of
contemporary urban and social life which are unfortunately so often
mechanistic. The sensitive use of video is conceivable only in
terms of a critique of our alienation.

> Alienation is living somewhere different from where you are; we
> must refuse the word that comes from somewhere else - it's terr-
> ible if the work of personal renewal done in our 'internal lab-
> oratory' is lacking; terrible if meaning is lacking.

Projecting an image on the screen tends to have a revelatory power.
In the picture, a person who exists only inside his role becomes
ludicrous. Ready-made discourse is no longer tolerable.

> The government minister who reads his speech can't be swallowed,
> neither can the priest who recites the catechism. Whereas the
> peasant who recreates each word of what he says inside himself
> (for example, in the film 'Le Chagrin et la Pitié'(3)), or the
> woman missionary from Chad who talked to us about the Wa-Konga
> priestess ... they shatter the screen.

If the picture does nothing more than invite dissection, you are
looking at something that is already dead. If, on the other hand,
you are confronted with a meaning, with someone who is visibly more
than just a role, you are offered a fragment of life, and trans-
formation becomes possible.

> Among the reasons that prompts SD to argue at this juncture for
closed-circuit video is the meaning that often cannot be read except
within a community by certain film-makers who are themselves members
of the group. There is then a risk that 'communication' of the
material produced to outside groups will become impossible. But the
examination of images in relation to the meaning we give to our own
actions, to our internal transactions, does not necessarily have to
be restricted to a community.

> In making and showing video films within the community, not only
> do you record your encounters with other people, but you are also
> inevitably thrown up against much wider conflicts than those which
> are specific to that group.

Indeed, reflexive video, which at this point can only be carried on
if it is existential - i.e. deliberate, and acceptable in terms of
helping to solve life's problems - is more a hope than a reality.
However, one must start by conceiving and doing it. And after the
closed-circuit stage, there may ultimately follow a stage of multiple
exchange.

Recording more freely

From cinema to video? This transition occurs at first among young
cinema enthusiasts who want to emancipate themselves from the finan-
cial constraints of the film production system, then to free them-
selves from 'technique', and finally to rediscover 'life'.(4)

> YN: Two sound recordists, two cameramen, can film nothing but
> corpses.

> Portapak can, in the extreme case, be operated by a single person,

but more easily by a basic team of cameraman/sound recordist; better
still by a small team of whom only the cameraman is really visible,
the sound being picked up by concealed microphones. In the practice
of video there are stylistic differences attributable as much to the
relative importance of the resources at the disposal of the video-
logists as to differences of temperament. It would be a misconcep-
tion to imagine that only film-makers who are uninterested in tech-
nique move over to video.

YN is an example of technical professionalism, an innovative
jack-of-all-trades, an eclectic virtuoso, who carries around a card-
index from which he retrieves, in the course of conversation, a
wealth of precise technical detail, information on various acces-
sories, and so on. On the other hand, this technical competence
does not exclude what could be called a craftsman's inventiveness,
especially in the work he does on his own.

You can do very good things on your own. For example, besides
the portable equipment - camera, mike, and VTR - I had some radio
mikes. I used to put a neck-microphone on the person I was re-
cording; I had a VTR on one shoulder and the camera on the other.
And for three days I followed him from morning till night; it was
at election time. In spite of everything, it didn't kill me.

On the whole, YN tried to free himself increasingly from this situa-
tion of being a one-man band. The sound recordists, with micro-
phones under their pullovers, approached the subjects to be recorded
unhampered by trailing cable. The implications of this mobility and
of their consequent inconspicuousness(5) are obviously substantial.
The content will be 'authentic' and its readability enhanced. In
YN's experience, it is desirable above all to give prominence to the
sound. It is possible to present a tape to an audience of two hun-
dred with a simple 50cm screen, provided it is raised and there are
sufficient loudspeakers, so long as the initial sound-recording was
clear and well differentiated.

In the present state of technology, videologists are compelled to
experiment with various brands of accessories. Without giving away
all the secrets of this new trade, they tend nevertheless to help
each other, to exchange know-how, to lend each other equipment. It
is a pioneering phase, as though a common struggle were being waged,
even if it is on the purely instrumental level(6) and before the
medium is fully recognized and its activities legitimated.

We asked a young American living in Europe how he had got into
video:

DS: In the US I worked in film units; I'd always wanted to make
a film, but the resources needed When I came to Europe YN
advised me to work with video instead. 'You'll see,' he told me,
'it will change your life.' And it did.

In all the people we met, taking up video brought about conversions,
through engagement with the immediate and transmission to a commun-
ity or group. Video creates involvement, and, in the present pion-
eering conditions at least, it impels people towards the social
sciences, or at any rate towards the social, and above all towards
social movements, if only because of their sensory - and sensational
- qualities.

First contacts and production

The events to be recorded, the circumstances and the times of re-
cording, were selected by our videologists in a variety of ways. We
have already noted the emergence of some characteristic approaches,
in which either observation or participation had greater salience.
The style seems to be set, in fact, from the first contacts.(7)
 One of the units began work with the intention of doing 'anthro-
pological', 'direct cinema', in order to understand and make under-
stood 'everyday life'. The two intending ethno-videographers were
at that time members of a political cell that had a subgroup con-
cerned with problems of homosexuality. For financial reasons, but
also because feedback promised to produce some effects of real deve-
lopment in people, video was chosen in preference to film. The
contacts were in existence before the idea of a video project arose.
In short, the two videologists were going to exchange the status of
simple participants for that of participant-observers.
 AE: For some of the others who do video in Europe it is a matter
 of getting to grips with things in a number of political groups
 in different countries - what we call extended work, horizontal
 work. For us, it is a matter of going as far as possible in
 depth, of seeing, for example, what is concealed behind a partic-
 ular discourse; asking questions stemming from things said pre-
 viously, or from things one has just heard: this is vertical work.
The strongly committed research in depth is here very close to the
preoccupations of what has come to be called 'antipsychiatry', which
involves active observation and therapeutic intention. This unit,
to whose work we shall be returning, carried out a project involving
close and sustained relations with the inmates - staff and 'patients'
- of a psychiatric hospital.
 In a tape about problems of homosexuality made by another unit,
contact with the people recorded was built on the basis of the ob-
server becoming more and more participant and involving himself
directly not only in the process set in train by the recording and
feedback, but also in the objectives of the group itself.
 ES: What one is recording in video is a situation, an event; in
 the case of the demonstrations by FHAR,(8) it is clear that we
 would never have been able to tape them if we hadn't campaigned
 with them; they would never have agreed to being recorded from
 the outside.
 It was the same with various other groups we recorded. Some-
 times such strong bonds were forged with the people that in the
 end we could not continue taping. In the case of the FHAR demon-
 stration, the situation itself enabled us to avoid falling too
 deeply into the problems of observer-observed, subject-object.
A process of fusion with the people being recorded seemed to be at
work in the two units, despite differences of style and procedure.
On the interplay in the encounter between those making the recording
and those being recorded depends the quality not only of the mater-
ial but also of the interaction between all concerned and this
material. There is no unalloyed technique any more. In the extreme
case it cannot be decided whether it is the aspect of observation or
of participation that is the more significant.
 At the time of playback, the impression of 'here is the event as

though I'd been present' is all the stronger the less the tape has
been processed (montage, cutting, etc.). This impression of 'real-
ity' will tend, on the one hand, to gain acceptance as a full record
for what, in spite of everything, cannot be other than a selection
of shots, because it is authentic and open to interpretation; on the
other hand, the perspective of the 'crude' shot(9) invites the spec-
tator to fusion with the event.

 ES (continuing with the example of FHAR): At certain times, when
 people are militant, particularly during a demonstration, they
 completely forget the camera, which itself becomes militant,
 totally participating in the action.

The relations between those recording and those being recorded are
in fact diametrically opposite to the relations between an actor/
director and the actors working to a scenario. It is the video unit
that is 'available'; often the only introduction into the settings
to be recorded is the promise that the tape will really be made for
that group, that they themselves will have control: times, places,
and conditions of recording will not often be decided by the produc-
tion unit.(10)

 Another videologist, DS, recorded certain episodes during a
strike of women workers in a factory in provincial France. Although
he left Paris in the company of some MLF(11) militants and a person
with wide local contacts, he ran into obstacles. CGT(12) supporters
tried to prevent him from talking with the women workers who had
played an important role in this unofficial strike. At first DS was
able to record these confrontations only from a distance, using a
zoom lens and a hidden radio-microphone; on the second day he had to
content himself with recording voices on a mini-cassette; then, only
on the following day, the last day of the strike, was he able to
record a very long statement which one of the women who had been
most active during the strike made for video, near the factory gate,
in the presence of some other workers. The end-product was three
live, unedited, but readable tapes.

 The fact of videotaping events that the media have passed over
further enhances the feeling of authenticity generated in every res-
pect by a 'raw' production. Even if the distribution of such tapes
is restricted, there is a kind of recoil of the technique upon it-
self; TV is challenged by a technically similar medium - VT - which
justifies the notion, in the Anglo-Saxon case, of an alternative TV.

 The focus on the phenomenon, on the local meaning of the event,
which is so rare in official TV, is here the primary consideration.
Everything occurs as though technical imperfections (hazy picture,
shaky camera, monotonous angles, inadequate lighting) would enhance,
or at least ratify, the authenticity of the material, at the same
time suggesting that a unit with poor resources is nearer the opp-
ressed, the ordinary people,(13) and that technical simplicity rules
out manipulation.

 A potential, therefore, for counter-propaganda.(14) Manipulation
is so widespread in the official media that it eventually becomes
more apparent than is readily admitted; an 'authentic'-seeming tape
can make a significant impact by a kind of boomerang effect, the
habitual manipulation by the mass-media recoils against them. With-
out doubt, producing this effect demands a new quality of relation-
ship between those recording and those recorded.

Edited recording/editing the recording

In most settings, the presence of a camera raises problems; the videologist tries to solve them without changing the 'scenario' that people would perform of their own accord away from this witness.
 If you do not appear at the outset with the camera, its subsequent introduction becomes a big problem. You must manage to do things in such a way that the camera becomes simply an appendage of the cameraman, just like his watch or his spectacles.
In favourable circumstances the recording logic will then be that of the actors' own discourse, their own way of presenting the situation. There is here a manifest opposition between a preconceived plan - scenario - and the recording-in-action - 'scenario' - the difficulty arising from the need to produce a usable tape, a communicable recorded discourse. Because of the need to end up with a readable tape, recording techniques are of relatively much greater importance in video than in film, taking into account the difficulties of editing.(15)
 One method consists of recording on the spot a series of sequences selected at once with a view to adequate communicability. The director has a particular idea of what it would be suitable to show; he follows the events taking place; he builds up as things go along.
 When you make an edited recording, the guy behind the camera knows that it is the sound that will really reproduce the logic; you can only intervene with the picture to reveal contradictions (for example, recording something that makes a contrast with the spoken word); or else you follow the speech and find pictures that reinforce it.
Whateven the style of 'edited recording' - and obviously there are others than the one just described - the principle lies in non-intervention. The situation to be recorded is in no way manipulated, except, if absolutely necessary, by questions asked at the 'right' moment in order to help someone come out with part of what he was going to say in any case, perhaps getting him to repeat something said out of range of the microphone, or filling a gap, effecting a transition and so on.
 Closer to the idea of the 'innocent eye' of the 'candid camera', or to methods of the 'direct cinema' kind, than to film montage, while at the same time distinguishable from them, the method of edited recording requires great patience during the period of introduction into the field and, most certainly, a developed capacity for immediate action comparable to that of a news reporter.
 The opposite method, close to a mise-en-scène, but nevertheless different from that employed in the cinema, is a kind of manipulative process of revelation, which we shall call 'editing the recording'.
 YN, from Quebec, intends, to use his own words, to 'excavate' a situation, to decipher reality, without hesitating sometimes to manipulate situations in order to go beyond the apparently real. He is not satisfied with filming people 'as if they were ants', as if they were incapable of explaining themselves. He is not satisfied with recording what one finds in a situation at the beginning. YN has a team at his disposal; he walks about and his cameraman follows; he gets into conversation with various people, and when he has found something interesting the recording is made.

If I were perpetually stuck behind my equipment, I would never manage to find any interesting people.

The videologist - or rather explorer - will follow one single individual, sometimes for a long time, until he knows enough about the course of events and the other people to be interviewed, and until he can intervene on the level of organizing time and space.

If someone wants to talk about something interesting and it is impossible to record it at the time, I discourage him from speaking, without his being aware of it, until the camera is ready. Sometimes I make an appointment for another day, then I arrange to put this person in the presence of others, for example people whom I know to hold different opinions. It is manipulation, to enable us to get to the heart of things.

Work of this kind, done in situations 'from cold', motivated by the need for deep and living description, will obviously bear the imprint of its author, as is the case with all video work. The social setting is, however, subject to hidden conflicts. The image used by the Canadian Perrault is apposite here: 'When you find a fire breaking out, it's enough to pour oil on the flames.'

DISTRIBUTION AND FEEDBACK

The problems of processing tapes after recording need to be approached as much from the technical standpoint as from that of the relations between video and the view that various publics may have of a given type of tape. However, we must restrict ourselves to a few observations before moving on to a description of distribution and feedback situations.

Visibility, legibility

The videologists we interviewed edit (process) their tapes very little, and express opinions on that subject with all the more reticence.

The technical reason for processing the tape is above all to make the material legible. To the relatively simple problem of the visibility of the things recorded - a technical domain in the optical sense - it is necessary to add the domain that can properly be called videological: what is readable, that is to say comprehensible, indued with meaning, capable of transforming the spectators (and first of all the people who have been recorded), and capable of illuminating and transforming society and culture? Conceived in this way, the problem of legibility will doubtless elude all systematization. Readability will be a function of themes, of publics, and so on. One is directly involved in the problematics of dissemination, but in a new sense. What is needed to stress a tape? The devices that might eventually be developed would have conditional value. They would be of the order of techniques of rhythm, of suspense, of shock, and all these, taking support from the achievements of the cinema, would have to be used in a specific way. Sometimes 'something is happening in the picture', it has a lot of movement or is visually intense; sometimes people explain themselves, conduct

dialogues, attack each other, and then it is the sound, the units of
meaning, which guide the editing. To create this more rapid rhythm,
one plays one or other keynote, usually the shots in which action
predominates, the speech providing a link.

LS: The reels on the demonstrations - you could leave them as
they were, or almost; those on discussions, less easily. There
were hesitations, then some unbearable longueurs, and you had to
make choices.

Such treatments as cutting down the longueurs, contrasting certain
sequences with one another, while shortening several in order to
speed up the overall pace, could sometimes appreciably increase
readability, but these are relatively simple techniques. The most
important principle seems to lie in the choice of sequences of high
intensity, whose effects are achieved mainly at the time of record-
ing and in a single operation. Above all, it is the sheer power,
or more generally the relevance, of a sequence that will lead to a
true reading among the really involved audiences.

Distribution in a conflict situation

The tape about the women strikers who were recorded by DS outside
the factory was shown to groups that brought together some of these
women and some men who included members of the CGT, the union that
had been opposed to the strike; the CGT had even banned the showing
of the tapes; people who went to watch the videofilms would be
challenging the agreements that the unions had succeeded in conclud-
ing with management. Consequently no one turned up to the organ-
ized public showing. The women decided to invite a certain number
of people to view the tapes in the flat where one of them lived.
There were prolonged discussions, a general exchange of views, and
a showing of the unprocessed 'raw' tapes.

DS: The unedited tape made a lot of people furious; to endure a
document without any orientation, that did not present a pre-
determined, structured viewpoint, was intolerable to them.

Discussion was only the more vigorous; 'situations' developed; con-
frontations; explanations; questioning of interpretations and rou-
tine actions. In the space of two months, DS showed the tape to
about fifty audiences ranging from thirty to two hundred people.
This was a work of sensitization, of increasing awareness. The
schema of confrontations was most visible and most 'readable' on the
spot - between the strikers and the CGT, or the unionized men - but
it was reproduced in the high schools, the university faculties, and
the trade-union centres in various provincial areas. It was the
opposition between a conflictual reality, lived and presented in the
style of 'everyday life', and the 'bureaucratic' versions of the
occurrence of the past, present, or future situation.

The fact of seeing and hearing the women workers expressing their
personal experiences directly, touched very directly and personally
even audiences and individuals who were strangers to this event, or
to this type of event. On numerous occasions DS noticed the con-
trast between the effect of opening up the discussion produced by

this tape and the effect of closing it down produced by the inter-
ventions of the entrenched and formal political or union militants.
When the union people spoke, or when the various political groups
trotted out not only their terminology but also their ready-made
analyses, 'they threw up barriers'; discussion was blocked, some-
times irretrievably, or altercations developed, the raw document
having given some people the courage to make a stand against dog-
matic statements or to come out with what they were really feel-
ing.(16)

Feedback

All the videologists agreed in underlining the central importance of
feedback, but their ways of working involved taking more or fewer
precautions, led to a variable amount of analysis, and aimed at
producing more or less lasting effects.

SD spoke of 'chemical reactions', the pictured image itself pro-
ducing subtle 'reactions' within people or interpersonal constel-
lations; he was referring primarily to instances of unblocking he
had observed. YN likewise (and we shall return to this) described
the unblocking that a prolonged experience with video produced in a
local community.

AE and KE described instances of feedback in psychiatric situa-
tions. Their first ventures, rather violent ones, were concerned
with 'wild' psychoanalysis. There were few safeguards, some violent
shocks, and some quite spectacular positive effects, but also nega-
tive ones. A sexually inhibited girl, who felt she was ugly, talked
about her life in front of the camera. The idea of treating the
subject of sexuality in this way, through an existential analysis,
as it were, arose from the dissatisfaction felt by a small political
group after a number of ordinary discussions on this theme. It is
easy enough to talk, but 'changing one's life' is far from easy.
After two months of confessions and feedbacks with the videologists,
the girl was positively transformed. She realized, for example, how
she had neglected her dress, betraying inadequate self-acceptance
and self-esteem. She began to take an interest in her clothes and
her hairstyle, and visited the dentist; then she liberated herself
from her sexual inhibitions for the first time in her life, at the
time of the May Day holiday! Certainly the difficulty of this un-
blocking was signalled by bouts of depression. Even if there is
some doubt about the overall success of the experiment - lasting
effects? - striking transformations took place at various points.

Unit E carried out an 'antipsychiatric' exploration with video
over several fairly long periods in a clinic near Paris. The tapes
were shown to the patients; sometimes they were violently disturbed,
sometimes a glimmer of awareness seemed to break through; in any
case, the videotapes and the unfolding of the process provided mat-
erial that could, and did, yield to deepening analysis. The doctors
also used the resultant documents as the basis for discussion with
their professional colleagues. Consequently several interested
groups were enabled to examine these experiments not simply as a
spectacle, with the projection relating to the playback, but as a
quasi-feedback, through unexpected identification. Indeed, these

'madmen' appeared as terribly normal and we, watching the tapes, saw ourselves as terribly similar to the 'madmen'. This antipsychiatric experiment raises, in the present context, the problem of unintended feedback: playing back a videofilm made in group A and viewed by group B can constitute the functional equivalent of an actual feedback. Let us say that there is a symbolic feedback when the showing of a tape made elsewhere than among the group that is viewing it triggers off a process of identification, which is combined, as is often the case, with projection (the identification partly deriving from the fact that those who are identifying are already objectively 'identical', or at least similar).

During extended experiments in a 'special' milieu of this kind, the personal involvement of a video team can be very considerable, especially when it is reinforced by entry into a nonconformist movement (here antipsychiatry) and when poverty of the available material resources demands significant personal effort. The total phenomenon that the videological experience thus becomes then leads to a multifunctional utilization of process and documents: to therapeutic feedback,(17) widespread distribution, generally of a militant kind or to sympathizers, psychological and sociological analyses and so on. One may wonder whether, ultimately when an element of division of labour has compartmentalized the various video activities, the enthusiasm of the pioneering period will survive, and whether that phase will not have produced the most productive research model.

Every milieu that has been recorded and introduced through feedback will generate its specific reactions, depassing the initial recognition ('Here is So-and-So') and the first shock. In some mentally ill people, the eye, symbolized by the camera, and 'positive' or 'negative' images of the self, can be invested with an extraordinary significance. One such person felt threatened with death if more than four or five photos of him were taken in a year. Most 'schizophrenics' are really fascinated by the feedback.(18) The videologist will observe some highly idiosyncratic codings in the world of the mentally ill, as, for instance, using the word 'man' instead of the word 'woman', and vice versa. If he manages to capture passages from an 'inverted' discourse of this kind, and to arrange a certain interplay of situations in which speech and picture are contrasted, the feedback will be effective. Without any need for verbal intervention from the staff, the tape makes it necessary in the discussion to 'put things back in place' (to call them by their true names or to allow the code to be broken).

YN reported some Canadian experiments with community video in which the feedback, far from being done crudely, or simply at random, was introduced as part of a long-term strategy of social reanimation. In a manner comparable with that long since advocated by anthropologists who wish to gain adequate confidence and understanding to carry out their descriptive work, the videologists penetrated very gradually into the situation. In this way they entered into this community which was blocked and torn apart by racial conflict. The community action project, financed by government,(19) was extended over two years of presence in the locality. The knowledge gained previously of its social structure, of its power relations, of its taboos, enabled them to calculate and control the exact place that a feedback should,(20) and probably could, assume.

The operational logic expounded by YN can be summarized in this way: in the introductory phases, record first of all innocuous scenes (children playing); then more sensitive situations (men at work), moving from one social group to another (first with whites, then with coloureds). The feedback took place separately, first of all with the people directly involved (the parents of the children, the families of the workers).

Once the introductory phase was over, the videologists and also their procedures had inspired sufficient confidence to allow them to think, cautiously, of recording conversations (at first with individuals, later with groups) bearing on the conflicts; taking social conflicts as the point of departure, in the end they were in a position to tackle the racial conflict. Here again, the feedback was done separately; interviews with whites were shown to whites, at first in direct feedback, later in indirect (to whites who had not themselves been recorded). In these discussions opinions on the opposing side were collected, but were not communicated to them until the end of the intervention process, and then to segregated audiences (whites were confronted with tapes on which coloureds expressed their feelings about whites, and vice versa). Right at the end, during an interracial meeting in the same hall, the two communities viewed together the tapes recorded with both groups.

This account, no doubt too schematic, gives an idea of what could be a true intervention strategy, with controlled feedbacks given at key moments co-ordinated with the transformations achieved.

It goes without saying that this work - of 'lubricating' or 'decoking', to use the terminology of this videologist - can be evaluated in various ways. Can the transformations achieved be deep and long-lasting? The least one can say is that such feedbacks revive exchanges that were previously blocked.

YN: Even a society as liberal as Canada obviously cannot continually stand work of this kind. If we work successfully, in a community for example, awkward political situations are provoked; it may make the mayor explode. If the machine starts working again, the weaker components may blow up, and so on.

Stimulating social communication in this way is certainly going to stimulate the emergence of latent conflict, which cannot happen without raising problems of relations with the authorities. And it can be imagined what kind of videologists will 'blow up' in their turn, in programmes financed by the government....

SOME VIDEOLOGIES

Anti-TV rather than mini-TV, group dynamite rather than group dynamics, and heir to direct cinema, the practice of our videologists cannot be encapsulated in formulas of the Lasswell type (who says what, to whom, when, on what channel, with what effect). It is praxis, ongoing activity, involvement, a total phenomenon.

Certainly, as a tool, video can be exploited in other ways. It is always possible to superimpose on a new technology the values and modes of behaviour established in an earlier phase. But the practitioners we have been describing seek to cultivate potentialities: to use the specific characteristics of the new medium in the pursuit of something that has hitherto remained unexpressed.

It is hardly in doubt that the thrust of such a movement carries with it intentions that are ultimately in total contradiction. There is, on the one hand, an absolute respect for the individual, at the expense of overlooking his social context, and, on the other, a no less absolute respect for 'the situation', at the expense of infringing the personal freedom of the individuals who are in it. Between these two extremes there are intermediate styles.

One way of classifying videological styles would certainly involve taking account of the degree of integration with the relevant society or subcultures: what might be regarded as the horizontal dimension. A second way would be to classify vertically in terms of the degree of local penetration in depth (particularly on the level of describing and understanding the phenomenon from the inside). Here one encounters the classic dilemma between intensive and extensive research.

We have sketched a typology distinguishing four kinds of video practice in a new style of 'action-research' (see Table 1). We must add that the videologists we have referred to follow one or another style, even one and another, according to circumstances.

TABLE 1 Video praxis: outline of a typology

	Reflexion	Reanimation	Sensitization	Agitation
Nature of the material	simple scenes, everyday life	complex scenes everyday life	crises, conflicts, social movements	happenings, marginal groups
Method of recording	free, 'raw'	systematic, elaborated	sensory, improvised	premeditated, directed
Processing of tapes	minimal treatment, unedited	edited	'raw' or edited reporting	'raw' or selective reporting
Distribution (a) public aimed at	closed groups	communities	militant audiences	provocation of micro-milieux
(b) place	on the spot	local	scattered	scattered
(c) timing	in stages	in stages	partial	partial
(d) style	distantiation	distantiation	identification	counter-identification
Feedback	self-analysis	unblocking between groups	support and revelation	triggering of crisis
Anticipated effect	long term	medium term	short term	very short term

VIDEOLOGY

In the sense in which we have tried to document them throughout this work, it would be of little interest to examine the technological basis or a particular style of video practice in isolation, or to consider a given style divorced from the social and cultural conditions in which it arises. Obviously, the phenomenon lies at the intersection of these factors.

FROM EMIGRATION TO EMERGENCE

The two faces of reality

In an exploratory work like the present study, we are precluded from going beyond the first attempts at completely grasping the phenomenon. Nevertheless, among other things, it is essential to suggest a paradigm for a global sociological approach. In our society the tendency towards unidimensionality remains powerful; it reflects the interests of authority. Developing the indications given by Margaret Mead, we might characterize the attitude of the person alienated by society and culture as the will or desire for emigration, or at least among the very young, a nostalgia for it.

In the literal sense, this term refers to tendencies such as 'blowing your mind', the drug scene, dropping out; but during the 'cold war' there was also an emphasis on the need for the intellectuals of Eastern Europe, for example, to undertake an 'internal emigration'.

Now, as the transformations and contradictions of our society accelerate and exacerbate, and understanding of past and present improves (in some people), the individual should increasingly wish to migrate from his roles (for example, in his work), to migrate from the alienation imposed by the material world, and it is becoming apparent to what extent immersion in the world of televised images is an escape similar to that sought by some people in drugs, including alcohol and tranquillizers.

The barriers raised against emancipation are such that only recourse to new technological means permits the importation of certain ideas, the imposition of certain practices, at least until defences

have been erected. Thus educational TV can on occasion be a Trojan
horse, running counter to respect for authority through the follow-
ing paradox: it can attempt this only thanks to the authority that
it in turn is tending to assume.

Certain social categories stand aside from established social
functioning: women, the young, and the very young. The moment has
come when they are invited to become integrated. This immigration,
desired or not, occurs in a hesitant manner. They would like to
play an important role, but without - entirely - accepting roles and
a game defined in advance.

Such are the contradictions of this world that the manipulation
ends by manipulating the manipulators. The means of production per-
petuate their own demands, and the media of communication propagate
a vision that is systematically sugary and 'average', that dereal-
izes people and things. Objective reality, imposed from outside on
the majority of people, sometimes escapes everyone, even those in
control.

The suppression of signs of emergence of new, direct, and aggres-
sive forces remains a reality. Then follows, perhaps, at least for
the spoken word, if not for action, the moment of 'breakthrough'.
Everything is in turmoil. There are complaints on the one hand of
provocation, on the other of co-option. At one and the same time,
the system will maintain itself and change itself. And the forms of
contestation, of repression, and of co-option will be transformed
accordingly.

The emergence of virtuality, which constitutes our theme, will
henceforth, and increasingly, be bound up with the phenomena of
mediation and mediatization.(1) The technologies of mass communi-
cation create factors of centralization that do not preclude some
significant breaking-down of compartments, through the mutual
acquaintance of social categories, cultures, and countries; this
is related to a world-wide simultaneity and intensive circulation
of messages. Such was the case with TV.

But a new technology, i.e. video, will secrete an antidote. Very
schematically, this is the global approach to the seizure of social
and cultural potential envisaged here. In this field, video -
catalyser, relay, mirror - generates a mediation between the inner
and the outer aspects of phenomena; it is indeed easier to locate on
the level of individuals and groups than on the level of communities,
classes and social strata, social and cultural movements, and socie-
ties, where it nonetheless exists.

The ancient positivist Mafia will delight in crying Rousseauism,
innatism, and so forth, unaware of Buckminster Fuller's dictum:
 The inside is the inside of the outside; the outside is the
 outside of the inside.(2)
These movements of emigration and immigration are defined against
the background of a social frame of reference; what one departs from
or approaches exists a priori; it is already there.

The emergent phenomena can be schematically related to the exist-
ing system in two ways: (a) as elements of the earlier system or of
a present or future system; (b) as a self-subsistent universe.
While conscious of the need to discuss and study perspective (a), it
will be understood that our inclination here is to align ourselves
with perspective (b).

Whatever may be the respective importance of these two approaches, migration is undeniably established. It would be impossible to conceive the emergent phenomena, or the hesitation to immigrate, or the desire and the effort to emigrate, solely on the basis of the characteristics of the existing system; equally, these hesitations, these wishes, these desires, could not be conceived without any reference at all to the system. 'Out' and 'in' are in a relation of inclusion and exclusion, at the intersection of an established system and an alternative system.

Videotopia

This research has chosen a field, some sites, some tools of exploration. Its project, its orientation in the field, are uncompromisingly u-topian, that is to say they belong to the realm of that which is not yet there, but could become concrete by taking support from latent motivations. It could make a constellation of potentialities emerge through praxis. It is meant to be yeast, enzyme, potential contagion. It is not intended to sow broadcast. Its orientation points expressly towards a progressive reappropriation of the means of communication, while clearly stating the need for the socialization of the use and control of the media.

If you trace out its 'topia', its real locus, you will not locate it through a definition of its domain. The locus of research is being sought while the research is being carried on; taking its point of departure from situations (of adolescents, women, students, workers, waiters, televiewers), it traces a series of possible migrations. By means of a succession of movements back and forth and adjustments, video practice tries to apprehend the macrosocial in the microsocial, close to the fabric of everyday life, while penetrating further than a cinematic ethnography and revealing what is latent and possible beyond what is visible and patent.

In this way video is at one and the same time both 'territory' and instrument of exploration; furthermore, the observers are also the objects of observation; the researchers are also actors, passing from a participation that is primarily observational to a participant-observation.

The video experience can go further than the audio-visual reporting of a situation. Through a series of documents and meetings that integrate various moments and feedbacks, it permits a redefinition both of the theme and of the situation and the actors.

Television and the cinema tend to bring near what is distant and to make distant what is near, as do all the 'mass' media, integrated as they are with a society which reduces creative works to products, and products to merchandise, and which generates around itself metalanguages either of 'high' culture or of mass culture.(3) These media increase the separation and alienation from experience. Conversely, video material, stored in the form of magnetic tapes, is comparable to a series of sketches or clay models: u-topias of images to be realized; u-topias of social situations to be made concrete, to be experimented with. This operation reveals a potentiality, and conceals it. It offers the possibility of learning, at the same time, both a language and a social praxis.

A group will tend to be 'hyper-reactive' to video images in which
it is directly involved (the multiplicative effect); it is then in a
position to distinguish what is normally obscured and repressed in
its experience, what is below the threshold of words but open to the
senses. It can offload the customary burden of the 'obvious' and
commonplace, the logical, the stereotyped. It attains to a stronger
awareness of one kind of reality that is 'sub-real' and of another
that is 'sur-real', something that practically never emerges from
the traditional methods of social investigation.

In a consumer society governed by the dominant models of the mass
media and advertising, centralized television is dependent in the
highest degree on the established technological and ideological
system. The endless dialectic between the ineluctable appearance of
new technical products (including video) and the multiple connota-
tions of such objects, linked to desires, practices, and changes in
society, at this point creates a breach: at a given moment video
becomes the medium for achieving liberation from subjection to TV;
it ends by encompassing TV in a combined praxis that is wider and
more complex; most videological processes offer reversible proposi-
tions, thus introducing a dimension that is almost nonexistent in
current televisual space.

The magic triangle of transmission-distribution-reception becomes
a series of trihedrons in space: in the case of the 'producers', the
conditions of production increasingly impinge on the message; in the
case of the 'receivers', the conditions of perception and of re-
creation acquire increasing importance; finally, in the case of
'distribution', this no longer corresponds to a linear schema, even
in a double sense, but rather to a series of loops and interactions,
leading to the establishment of a network branching out into auto-
nomous and/or co-ordinated regions.

A video operation proceeds like a Russian doll, each new stage
including the preceding ones. Dialectical relations are established
between one element and the whole and between the diachronic and the
synchronic dimensions.

The first 'topia' of this phenomenon is found in the relationship
between video (camera and VTR) and the general idea one is aiming to
develop (plan for a study, open scenario, or whatever); various ele-
ments of differing origins and fields of application are harmonized
and transformed.

Another locus of the video phenomenon is within an emergent cul-
tural current, for which it becomes, in the limiting case, an ampli-
fier or telescope.

The VT generation, following the TV generation, is in fact emerg-
ing towards new forms of creation and communication. Video can
depass its gadget status by becoming part of a cultural movement
that is essentially an action-culture.

A parallel can be found here with what is observable on the musi-
cal scene;(4) on the one hand, supersaturation of the market with
discs, pop idols, and so on; on the other the birth of new musical
and instrumental styles, of electronic-acoustic assemblages, seeking
liberation from the state of passive consumption. Video might come
to play the same role in relation to cinematic and televisual ex-
pression as is played by the guitar and electronic recording in
relation to musical forms that are experienced as external.

Processes or structures?

Observation of a social role by means of video has some unfamiliar features. You are thrown into a vortex of interaction; you start to make comparisons; your analysis grasps aspects that were not evident at the outset. This situation can be achieved by means of a varying number of tapings, of re-viewings, of feedbacks using the taped document as a stimulus to discussion, which is impossible with the classical interview or questionnaire. Through these distantiated viewings, several levels of interpretation of the observed social role emerge; you rapidly abandon 'detached' observation, behaviour-istic attitudes, and other unidimensional approaches: polyvision reveals polysemia. A social role is always embodied in a person in a situation.

Through the simple repetition of viewings, which one is admitted-ly tempted to present in slices (re-viewing brief passages), the taped sequence becomes analogous to a microscope slide. In looking more closely, a more complex analysis conduces to treating this material 'macroscopically' as well. Seeing not simply adjustment or maladjustment to the role, or even role-distance, but the submerged meaning of relative maladjustment; seeing the actor's adjustment to his role in relation to his experience, his emigration from the role or, at least, his intention, desire, or wish to leave it.

The decoding of sequences can certainly be carried out with re-peats of TV broadcasts, with the object of constructing a critical reading. But would this produce, by means of homeopathic doses, a detoxicating, antilethargic therapy? Would it be possible, through repeats, to benefit from broadcasts that are rich in sociographic data and research but are at present wasted in their single appear-ance on the screen, and whose critical appraisal still remains to be made?

Will familiarity with video produce televiewers who are more demanding and knowledgeable, better equipped to distinguish between the stage-set and the greenroom? One might think so; TV has already had the effect of enforcing a more direct and relaxed style of role-playing: whether in professional life or on TV, anyone who is noth-ing but his role is liable to be perceived as a marionnette, a puppet.

On the contrary, as in the case of Mme. Girard-Montet, (see Chapter 6) a subtle alternation between being in and out of role is now of great assistance to experienced political leaders (Pompidou, for example) in putting themselves across. In the case of a sig-nificant social transformation, for example the current change in the position and the image of women in western societies, this game with roles explored by video is the only one geared to the actual moment of change; it seduces the champions of 'culture' and evolu-tion; it confirms their belief in 'nature', tradition, and re-production. It undoubtedly enables some women - whether temporarily or permanently is uncertain - to play the role of real disrupters of the political machinery, since they are not yet sufficiently inte-grated to assume the sclerotic attitudes appropriate to the roles they endorse.

In recent years the impact of TV on public life has been studied primarily in terms of the influence of the TV image of leaders on

voting behaviour, in terms of broadcaster/viewer. Consequently each
leader has worked on his television impact. Video can restore to us
the possibility of unscrambling the elements of trickery and fabric-
ation from what is authentic in those who claim the right to broad-
cast. It presents masks and it tears them off. It is conceivable
that General de Gaulle would not have exercised such a rivetting
effect on TV had VT been as widely available during his régime as
were tape-recorders.

Introducing the message in the course of an analytical process that
constantly moves back and forth rapidly shatters its spell. A model
that can be played and replayed, and even cut up at will, loses some
of its 'structure'; whether it refers to a historical personage, to
'society', or to 'culture', they are perceived as less imposing,
less rigid, and less solid. To the extent that the structure in
question draws some of its strength from the belief in its strength,
a veil has indeed been lifted; since the structure draws its
strength only partly from so-called 'popular' support, this tendency
to demystify the structure can lead to remystification, this time in
terms of process, of underestimating the structure.
 Within an institution, video can play the role of 'analyser',
through the free expression of their experience by its members as
they observe each other, even without there being any verbal mani-
pulation. As a new educational technology, for example, video is
welcomed by those in authority; for some of them it represents the
march of progress, the 'industrial revolution' of education. They
imagine it can be introduced without any change in structure, not
suspecting that it conceals within itself, if not disruptive ele-
ments, at least disturbances of milieu and roles. It acts as a
leaven, and opens up new channels of communication. Teachers ex-
press their resistance - very understandably! - by prohibiting the
taping of conventional lessons, and only rarely are the pupils them-
selves permitted to join in the production process, since viewing
and discussing VT rob the Word of respect. The videofilm and its
language introduce hidden dimensions of uncontrolled feeling (a
penetration in parallel of the mass media and the school), which the
educational institution, whether school or university, represses,
and whose effects it manages very ineptly. Consequently these
institutions tend to avoid entering properly into the video process,
and limit their utilization simply to closed-circuit transmission or
to the provision of illustrative material for courses. Even outside
the hierarchical structures of administrators and teachers, teachers
and pupils, the structures of the programmes themselves are exposed
to challenge, as regards both facts and principles, by the freedom
of choice increasingly claimed by certain working groups.

Video reveals the variety of ways in which messages are perceived.
It faces education with the demand for a new codification if it is
to match the current levels of effectiveness achieved by the written
word in the transmission of technical knowledge. It offers the
human sciences, in relation to the flood of information, new possi-
bilities for investigating groups and categories - of age, sex,

profession, subculture and so on - by means of an audiovisual comm-
unication that forms part of the return to forms of oral culture,
though mediatized to the highest degree, cut in slices, divided into
segments.

It is highly significant that the adolescents described in Chap-
ter 8 chose the stereotype of the 'invisible camera' to unmask the
conformism, the norms, and the values internalized by adults. They
do more than that: 'playing' their videofilm, they continually im-
provise on the theme of the gag they have taken as a point of refer-
ence; they are not satisfied with producing something they have seen
elsewhere; they devise a way of manipulating adults capable of in-
creasingly revealing their stereotypes: the caricature becomes
generalized and spreads through the very movement of the film. What
they become aware of, through anticipation and discovery, is that
the whole of society has an artifical quality similar to a gag. The
place of a disturbing cacophony is taken by a gagophony that is at
first a game and then reappropriation. For how many hundreds of
hours have they already been subjected to lectures and broadcasts,
stretched out in front of the radio or TV set since infancy? In
contrast to this, video provides an itinerary: one navigates and
lights one's way along it in an ongoing process.

Likewise letting oneself be completely submerged by a typical
programme from the TV 'grid' reduces to absurdity if video can pro-
vide a second look at its reception. Breaking down a programme
into successive samples suggests at first sight a mechanical posit-
ivism. In fact it is soon apparent that the televiewer translates
the meaning that is transmitted into a meaning that is experienced.
The princess on the screen becomes a housewife; the image is de-
structured and restructured by a perception that is at the same time
an interpolation in a universe of pre-existing representations,
which can be modified or at least disturbed.

When it accompanies an operation like this immersion in objects,
video authenticates it for those to whom it transmits it, playing on
the illusion of reality much more than does the cinema. To follow
the development of such an operation (process) undoubtedly conduces
to greater credibility than does simply looking at a photograph
(structure); even one taken at the critical moment of immersion.

Roger Boussinot (1969) places the appearance of VT in the 1960s, a
period of prolific change, and compares it to the appearance of
Lumière's cinematograph, which for a century has represented a per-
fect utopia. What will be the precise future and scope of this new
invention, and what will be its effects?

It is already possible to envisage the advantages of using video
in sociological observation, in view of the emergence of a hidden
but already existing potential, or equally of the invention of new
ways of living and relating. This u-topian research leads us to
reformulate the analysis of communication and hence of society,
taking account of both the video potential and the sociocultural
potential.

MOMENTS OF THE PROCESS

In attempting now to develop a vocabulary and some abstract schemata,
we are fully aware of the fact that the capacity for reflexivity and
transformation of which we are speaking can remain hidden. And if
we are thinking in terms of its flowering, it is not because we ig-
nore the repressive and reductionist forces that oppose it, but be-
cause only hope itself can generate hope.

Assuming that conceptualization has some value, a theory cannot
really be established until the point at which various hypotheses
are advanced to explain the phenomena and to support predictions
that are properly susceptible to verification. In the second place,
our goal can only be to contrive an explanation of the 'active'
phenomenon that concerns us, which leads us to speak of a praxis in
terms of the dynamics of a process.

The inter-mediate domain

More and more it seems inadequate to represent the difficulties of
the relations between culture and the public as a problem of access-
ibility. In this context it seems misconceived to say that certain
things are 'in' - buy this cigarette and you are 'in', as the ad-
vertisements endlessly reiterate. Being 'in' or 'out' is no longer
a dilemma when cultural phenomena are in full and rapid transforma-
tion, with the collapse of ephemeral supports and the breakdown of
traditional dichotomies, between:
 professionals/amateurs
 artists/audience
 I/my product
 I/my environment
 theory/practice, and so on.
From now on, logic must be inter-mediate, and one can discern the
importance of the media interpolated in the process. The media are
the passively active third term, reflecting mirrors that invite ex-
pression; they are also actively passive, springboards for the leap
into reflexivity, because they give back the experience they have
registered. One is alternately 'in' and 'out'; often, and con-
sciously, one is in and out at the same time.

In this domain there are at least three moments, which are theor-
etically distinct though often confused in the actual phenomenon.
In the first place, one moves from the immediate to the mediate by
means of a mediation, which can occur in various forms, primarily
through the intervention of the media. These then impress their
imprint and the form of mediatization (movement to the mediate by
means of the media and under their influence), but this is not all.
One can pass into the essentially anti-dualistic domain of the
inter-mediate, the intervening space, the dynamic crossroads, to
which, from now on, the sociologist will have to give more atten-
tion.(5) To put it another way, there is a cultural schizoid state
(acceptable diversity), or rather, if one favours psychiatric
labels, a transition from sado-masochism (the sadistic component in
the broadcaster, the ravisher ravished by the ravishment of the
public; the masochistic component in the viewer, held in terrorized

enchantment by the spectacle) to a position of splitting: the producer-consumer is now subject and object, and consequently has various positions:

Versatility (positive)	Reversibility (neutral)	Lability (negative)
richer and capable of change	progressive involvement, progressive distantiation	more unstable

This schematic presentation is no more than one attempt, out of many possibilities, to organize an experience of 'life' as it can be 'realized' by means of video. It is no more than a reconnaissance; everyone must do it for himself or herself. What we are aiming at, however, is that grasp of which R.D. Laing (1967) writes:
The truth I am trying to grasp is the grasp that is trying to grasp it.
The phenomenon we are exploring is so constructed that the stages of exteriorization (objectivation) can be studied without springing the trap of reification that is always waiting in so many other situations. If a videofilm is indeed a materialization, a transcription into images of a living reality, the act of preserving is performed expressly to avoid preservation; if there is crystallization, it is normally(6) done in order not to last; it is ephemeral. And this materialization is usually interpolated in a complete process of activation and growing awareness, the third panel of a triptych - which we shall call transmediatization: the form of life surrounding the media, present not in fixity but in flux, neither localized nor localizable, except in so far as it is constantly bifurcating (an activity of connection, disconnection, and reconnection elsewhere, a ceaseless coming-and-going, one form of which is commutation).
A new type of sociology, which we may call transactional, seeks for objectivity through its relations with movements of objectification (materialization and crystallization). It is concerned with expression that has been made into an object, with what it can and cannot say, and, above all, with the interpretation that the observers-observed make of that object and of themselves, of other people, and of the situation. This interpretation (subjectivation) through encounters always related to the object can then become controllable, first subjectively, then intersubjectively (hence what we might call 'subjectification').
The question is to depass immediate descriptions of the mediate and to encompass the immediate contained in the mediate.

The immediate in mediation

The field of communication, as is understandable, is more cybernated than others, but the dichotomies that are useful in the industrial world - production and distribution, distribution and consumption - are still uncritically applied to it, although they are in many ways inappropriate.
It is true that these dichotomies have great force and rest on

the socio-economic reality of the connection between property and power. The ownership of the means of communication, as of all other means of production, implies control, most often, indeed, domination. From this point of view, it is not merely plausible but indispensable to speak of the producers and receivers of messages, since we wish to make apparent the asymmetry that is written into the structure.

There is likewise no question that 'Reality' ever enters directly into a given series of photographic images, since selection operates to punctuate the real from what is materially represented, whatever may be the reality one has in view. This act of selection applies as much to shooting as to editing.

Furthermore, the actor who is being recorded is playing a role for the camera, while at the same time, even in the videofilm, he is visibly something other than what he is playing. The dichotomy between self and role is just as much a constant in many private as well as public situations.

Nowadays one runs the risk of being misunderstood if one attempts to assert that there are possibilities of emancipation from these dichotomies, so if we assert that a potential for emancipation exists in a particular video praxis, it is because it is increasingly possible to verify it, and because this assertion tends in the direction of its appearance. We would not for a moment deny that there are massive structural barriers, nor that forms of co-option are already looming. All the same, the evolution of the media and comparisons between the media indicate that previous dichotomies were not themselves 100 per cent respected. And in order to comprehend the chances of emancipation, if only partial, it is necessary to reformulate the production-consumption relationship in completely new terms.

From ground to figure

In the audiovisual context production is a complex process that we shall call figuration. It is the formation of images through a series of acts of selecting, recording, and editing.

In relation to video, as we have seen above, editing can essentially be restricted to selection made while taping (edited recording). It is in every way very much reduced compared with what is done in cinema, hence a primary tendency to immediate expression.(7)

Whether or not there is a predominance of close-ups, the stage of fixing the images and ultimately projecting them on the screen means 'bringing to the fore' an extract from an essentially broader reality.

Reverting for a moment to the broader framework, the excerpt presented and present detaches itself like a figure from the ground. This figuration, as we shall call it in preference to 'production', is at one and the same time a voluntary act of selection and an activity dependent on external reality, and therefore one that partly eludes the will. It is true that the meaning of the message intended by the director can be very completely produced, but it is no

less true that the excerpt that figures on the screen retains its
'natural' and immediate character.

Not to lose sight of this immediate quality in what is certainly
also the beginning of a process of mediation seems to us even more
important when we turn from TV to VT, from the already cooked to the
still raw. It is no longer enough to echo the lamentations of those
intellectuals who are correct in deploring the loss of meaning im-
plied in this focus on the excerpt, with its possibilities for mani-
pulation, but who withdraw without noticing the quality of immediacy
contained in the figure.

To the extent that video recording owes very little to fabrica-
tion, this quality of immediacy has considerable interest. It is in
the tradition of 'direct cinema'; the event 'speaks for itself'. It
represents the introduction of a mediation into what is as immediate
as possible. A comparison between video and the written word, or
the spoken word in a lecture room, for instance, demonstrates forc-
ibly the degree to which this figuration lies outside the domain of
language. Of course, there is no question of denying the possibil-
ity of the development of a 'video language'; there is, after all a
'cinematic language'. A great part of the figuration stage contains
references to the frame within which the figure was placed, and some
directors have made interpretative commentaries explaining the mean-
ing of the figure in terms of their own universe of reference, and
occasionally in terms of their methods of carrying out the taping,
of making contact with the people being taped, and so on. Eventual-
ly, a language of images will undoubtedly emerge and be developed.

These are the mediate aspects of mediation. Apart from explana-
tions about the circumstances influencing the taping, they refer to
the meaning conferred on this figuration.

Mention must be made here of the idea of language: the choice of
images and sounds, of words and of commentaries, constitutes the
mode of expression; it is possible to distinguish grammars, styles,
and so on. But the raw, crude existence of the excerpt from reality
remains. (We shall turn next to the problems of its interpretation
by the viewer.)

And now, what of the human subject whom the process compels to
become an object?

From the subject to objectivation

On the level of language, in the first sense, a distinction is some-
times made between 'words' and 'discourse'. And the transition from
the abstract to the concrete in writing - reality having been trans-
formed first in my head and then through my hand - no longer pro-
vokes surprise. When the eye-and-ear video camera puts 'reality'
directly into pictures, since expression can no longer be given in
words but only by analogies more or less successfully transmitted
through the immediacy of images (figures of speech), this process of
concretization contains a strange paradox.

Although the act of expression, here carried out by means of
images, should give the person behind the camera the opportunity for
composing a discourse - retracing in the picture the image he has of
a particular reality - by using words he will achieve freedom while

imprisoning himself. Here, this image is at once expression and
screen, in both senses of the word: an object that both displays and
conceals.

This arises from the fact that the subject who intends to convey
a meaning, a message-discourse, is much more subordinated to exter-
nal reality, still more with video than with the cinema, and ends by
being objectivated by the medium of expression, to a far greater
extent than can occur with the simple written or spoken word.

The means of audio-visual expression are undoubtedly becoming
increasingly flexible, but they cannot provide a conceptual keyboard
(to use a term coined by R. Pagès) that is really complete and de-
ployable in a properly discriminating way. Above all, the subject
tends to appear in the film in his own person, in interviews, dis-
cussions and so on. If his intentions are then in some way objec-
tivated when they appear on the screen, enclosing the subject in
what he has succeeded in including in the picture-sound 'language' -
which often falls far short of his intentions - his person will
often be equally objectivated. The excerpt presented in pictures
and sounds is, however, supposed to express the subject, and,
whether he wants it or not, this expression oddly enough becomes his
double; it is him. At first reading every viewer will at once in-
cline to think so; hence the subject's desire to be present during
playback and to clarify, complete, and correct what is, on the screen,
his double.

In other words, the most subjective part of the figuration pro-
cess - the more or less declared purpose of the discourse - embodies
a not unnegligible appearance of the object, despite the obvious
contradiction this conceals.

This moment of the process brings us, conversely, back to mediatiza-
tion. The picture-sound should be a simple means of expression in a
phase of mediated communication: and there are already various as-
pects of the media that make their 'objectivating' nature felt. As
soon as the subject agrees to enter into a process of mediation, he
is already in the realm of mediatization.

It is appropriate now to see how the 'receiving' subjects can, in
fact, leave this realm, where in the present circumstances producers
and distributors would very much prefer them to remain confined.

For mediatization to transfiguration

Talking about the depassing of dichotomies, for example, of produc-
tion/distribution, and distribution/reception, in no way disposes of
the need to analyse them.

During what phase of a process does retotalization come about?
What alternating cycles occur: between ground and figure, between
taping-playback and feedback-re-taping, between playback and identi-
fication? Defining the different moments of these commutations
amounts to characterizing the transformation of the figure that has
been produced: this is the field of transfiguration.

From contained to container

It is important not to get hung up on the differences, but to grasp
the identity, persisting through the transitions, between: external
reality, the reality of the image on the screen, and the reality of
a mental image induced by the screen image; between: the latter and
the reality of an image produced by the addition of the induced
image and of a mental image existing from another source (a prior
image, imagination). As soon as we analyse the aspect called 're-
ception', we encounter paradoxes. Too much has been made of 'the
medium is the message'; if it is true that the container ends up by
becoming the contained, the converse in its turn is no less true.
And in any case, the essence of video lies in this curious alterna-
tion or transition, in the flux between one and the other. The con-
clusion to be drawn from this videological exploration is, in fact,
that two distinct worlds (inner and outer) do not exist.(8) If we
schematize figuration in the following way: a circle for the indiv-
iduals, a square for the environment that contains them $1a$, the
relationship between container and contained can be represented as
in 1 - a schema that will constantly recur, with the square signify-
ing the image and the circle the individual (see Figure 1 overleaf).
 Indeed, at the first showing of the videofilm, the individual can
be seen in the objectivated image (screen) that contains him 2; he
more or less completely fills the screen $2a$, that is to say his own
earlier environment remains to some degree visible - we will not
emphasize that.
 The moment of transfiguration begins as soon as the individual,
during feedback, is in process of interpolating the previous stage
into his own perceptual and representational world 3. It is then,
oddly enough, that he himself contains the earlier content that he
was $3a$; it is obvious that at this point he is simultaneously in-
gesting the medium $3a$. What is essential is that there is a permu-
tation of contained and container.
 This feedback situation, which is taped in turn, re-establishes
the earlier situation 4. If we wish to see it in depth, it can be
represented in all its complexity $4a$, but the actual movement of
alternation is probably as important as the complexification, if not
more so.
 Next - and this exploration in depth could be continued further -
the individual can re-view the feedback of the taped feedback (in
which he observes himself in process of seeing himself on the
screen). From this comes another turnaround 5, and a further
complexification $5a$.
 We are now involved in loops(10) - shot/playback/feedback/commen-
tary/shot, and so on indefinitely - and if we represent the loop, or
ultimately a loop of loops, we are immediately faced with the pro-
blem of making a preliminary formulation of exteriorization (object-
ification).

From the inside to the outside, and back

'The outside is the outside of the inside', runs Buckminster
Fuller's epigram; 'the inside is the inside of the outside.'

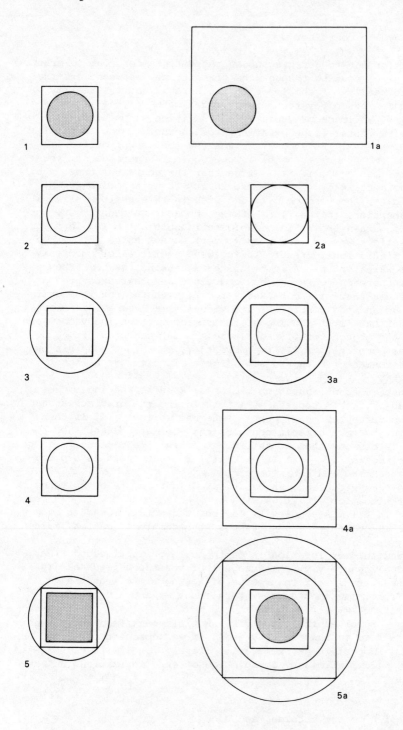

FIGURE 1 (see note 9)

Let us continue to consider the tapes, because this is where we have got to by another route.

FIGURE 2

Expression, as we have said, becomes embodied; the media inter-
vene, not only as transmitters, but also as incarnations. Exterior-
ization - the process whereby something internal becomes an external
object(11) - is a movement, but it depends on a materialization. It
is this material object - the tape (or, to be more precise, the mag-
netic recording and the electronic screen image) - which constitutes
this 'exterior'.

Everything takes place as though the exterior were actually docu-
menting part of the inner experience of the person being taped, but
only the part closest to expression (the most ex-ternal).

Conversely, all those images which constitute what we have called
the figure are an 'exterior' with a rich variety of facets. It can
be 'received' - read and interpreted - in many different ways. Who-
ever preserves the essence of this ('the inside of the outside...')
will be close to the inner reality of which this expression is part
('... is the outside of the inside'), bearing in mind that the
latter has been only partly translated into the object.

However, a second formulation is required. How, in fact, can we
represent the transition from the inside to the outside, and the
fact that, as we have already said, this occurs by means of feed-
backs in a continuing circuit?

In this connection the Moebius strip (see Figure 2) provides a
useful illustration,(12) although it does not take account of the
complexity of the person being taped.

We can proceed from this last fact, so perceptively expressed by
Fuller in the passage quoted above, to consider the sociological
concept of the role. Playing a social role is, like the tape in
this instance, to embody in concrete form (visible behaviour); one
has a mask that can be viewed from the outside, as it can be from
the inside; it expresses a part of the person (the outside of the
inside) but not the whole (the inside of the inside).

Just what is happening in the video process?

SELF: I imagine my mask from the inside

'THIRD': The outside of my mask is realized in pictures

'THIRD'/SELF: One presents the image of the outside of my mask to
the outside of the mask that I present

SELF: I realize inside me the outside of my mask (as if I were a
third but at the same time myself).

The two senses of the term 'realize' clearly indicate both the emergence into consciousness and the link with the materiality of exteriorization; indeed, without this entry into consciousness (interiorization of the external, and at the same time evaluation of it(13)), the materiality of the image is of very little interest, but the development of consciousness depends, in its turn, upon the existence of this concrete embodiment.

The media interpose themselves as third parties. The various degrees to which they are present could be examined in detail, but we will confine ourselves to the following examples:

- a lonely woman used to talk to her cat; since acquiring a TV she also talks to the set and to the person on the screen (a case of projection without modification of the third party)
- one talks to photos of oneself, or talks to a mirror when in front of it (projection onto an image of oneself, with modification); this approaches the video process
- talking, watching oneself talking, talking in a different way while one is being taped the second time round (one is distanced from the projection).

It is precisely because, in video, the 'third' is also the 'double' (the self in images, other members of the group in images, and so on) that at this point it becomes an intermediary: transformer/ transformed. You are mediatized in the sense that you are using a medium that is using you (you become for the time being the medium and the mediatization); on the other hand, but hand in hand, you are helped towards expression by the ephemeral nature of the taping; there is no need to bite your nails before launching into speech because you know that the videotape is reversible, wipeable. The reactions produced by feedback, however, run the risk of producing irreversible transformations (audio-visual self-defloration); the media, the mediate, have had us, immediately.

From identification to alterification

Through watching films and, above all, the TV 'stellariat', the spectator, when he can no longer really identify with them, even in spite of innumerable projective tricks, comes to fantasize a beautiful hand-sewn personal identity (the kind he might find in the bowling alley or the pub, measured up by someone against whom he can measure up).

He tries to modify the figures on TV. And, of course, a well-tried way is through projection. Selective hearing and seeing, redefinition of figures, with some references to their original context; redefinition of the commentary; inversion of meaning (serious/ comic, sad/absurd, and so on). There have surely been enough studies over a considerable period of time to provide evidence of the resources, not only of absolute projection (reading what is not written), but also of partial projection (reading a fragment and placing it in a context existing in one's own head). We will not dwell on those aspects of transfiguration which relate more specifically to the 'reception' - if you can call it that! - of TV or of other unalterable 'third terms'.

Returning to video, what is particularly inspiriting is the

alterophilism (sic) that usually develops in those who see them-
selves on tape in a feedback session. The possibility exists for
the transformation of oneself and others, through seeing and hearing
oneself, at the same time as the possibility of modifying the image
during the next stage of taping.

It is at this point that the idea of identification, so trendy
that, in our current state of supersaturated individualism, we no
longer have regard to its polar twin,(14) must be complemented -
indeed, depassed - by the idea of ALTERIFICATION.

EGO finds him- or herself in the presence of OTHERS (individuals,
groups, communities, classes) including the THIRD which is the med-
ium. According to the traditional viewpoint, EGO can eventually
transform himself through identification with OTHERS, or with the
THIRD; the possibility that EGO, OTHERS, and the THIRD may be found
in a process of reciprocal transformation is not foreseen.

We shall designate as ALTERIFICATION the process whereby EGO,
OTHERS, and THIRD reciprocally transform each other; by means of
criticism and redefinition, which include invention and even inno-
vation.

IDENTIFICATION ALTERIFICATION
imitation, adaptation invention, transformation
(mimesis) (poiesis)

FIGURE 3

Proceeding with the expression in terms of an ideal type of what con-
stitutes the originality of video, we arrive at this point at a
reversal of the idea of reflection. In other words, we leave the
field of subjectivation, which was the continuation of objectivation
and objectification introduced earlier.

1 - I am the figure, in a context; I figure in the image
2 - I see this image; I transfigure it
3 - in transfiguring the image, I am transfigured
4 - the subsequent image is transformed (I return to 2)
5 - I transfigure the context (external reality)

FIGURE 4

The others become extensions of me, no longer only through the dir-
ect relationship that I sustain with them, but in a mediate fashion;
the phenomenon of alterification sanctioned by video goes far beyond
McLuhan's assertion that 'the media are extensions of our senses';
a medium such as video can become an extension and a development of
sense (meaning).

When I see the reflection, a state of mingled reflexion and
reflexivity is induced, which I may either linger in to enjoy or
take action to leave, with the help of the others.

THE LIVING PROCESS

Naturally, it is hazardous to venture beyond conceptual exploration based on experience in order to proceed, if not actually towards explanation, at least towards the discussion of what gives life to the process, with its loops and reversals.

Transfiguration by means of discrepancies

The explanation of change is change, as my friend and colleague I. Neustadt remarked one day; indeed, it is enough for one element in a situation to be in motion to give the whole the chance of continuing to transform itself. At least, this will be so if the element that changes is in a sufficiently strategic position.

Without offering an explanation with any claims to finality, and therefore without tackling the question implied by 'strategic', we may say that confrontation with a videofilm in which the viewers recognize themselves, or in which they perceive a concrete situation that directly concerns them, provokes tension.

The mismatch between real time measured by the clock and real time experienced in a situation, and even more between that and time experienced during playback, is a source of discomfort; the presence of this duration cannot endure. The viewer intervenes. He tries first of all to self-regulate his perception by means of internal adjustments. If the mismatch is too great, he will talk: criticisms, explanations, suggestions for editing, proposals for a new angle on events. At first, transfiguration represents an attempt to make qualifications.

In favourable circumstances, the development of awareness depasses the loop of 'shot/playback/new shot'. The breaking of the circle at a more fundamental level than that of video practice can be perceived. We pass from this discrepancy between the interior (Innenwelt) and the exterior (Aussenwelt) to a discussion of the situation (Umwelt) - that is to say, to a form of action that will transcend video praxis - while the latter may, in certain cases and above all when it is a matter of social blockages of communication, bring the former to a resolution.

More generally, the life of the process may be understood in terms of the rupture of a logic of reciprocity (input-output) or of a logic of cumulation (ascending or descending spirals). The schema of alternations given above may be translated into terms of energy; not for nothing is this called the electronic age. This does not mean that information itself is equated with energy, but that it triggers or stimulates energy and its flow.(15)

- I am recorded; I provide energy, through information
- this is absorbed in the recording, which during playback, restores it by retransmitting it to me;
- I become the recipient of the energy I have transmitted, but I record a loss or a gain (the effect of the shooting and the editing = of the figuration realized by the communicators);
- I intervene in order to transfigure, in order to match.

FIGURE 5

This is undoubtedly a simplistic technomorphism, but nevertheless it seems necessary that we should follow this line in order to trace the source of the very powerful motivations seen to be in operation as soon as the mismatches between these centrifugal and centripetal stages are experienced.

We may add that objectivation is still more difficult to endure (i) when the mismatch between my potential self and my everyday self (or the self realized in the videofilm) is more extreme; (ii) when the presence of other people, in the film or at the time of playback, causes the differences to appear more clearly. This is what gives rise to the rejection of the tape, which may be rationalized in different ways but is often violent. It makes no difference that schizoid behaviour is increasingly recognized as natural; the self and its double find themselves confronted here in a simultaneous presence. (We shall return below to the successive presence of several selves - multiplicity rather than duality.)

If, as we believe, video 'reception' creates a creative milieu, we must not lose sight of the fact that those who participate most willingly in video experiments are often groups that are predisposed to do so.

This effect of self-selection aside, it remains to characterize what it is in the vitalizing process of video that derives from technology. This miniature, simplified gadget stimulates a game, a creative and immediate use directed towards a 'slice of life'. Side by side with this liberating aspect, a tendency towards fascination with technique may sometimes be observed when the instrument is used simply as a means, or at most a stimulus or a catalyser. The fact that one does not master all the resources of a device that, nevertheless, easily turns out a product,(16) leads to an element of fetishism. The same applies to research into this expertise, when it refers to the purely technical level. In that case alienation results from this instrumental utilization, whether it leads to perfecting technical quality for its own sake or simply to playing around with the gadget for the fun of it. Whatever else it may be, it is a form of mediatization.(17)

The other major technical features of the vitalization brought about by video undoubtedly relate to the speed with which the recorded experience is played back (feedback), to the extreme sensitivity to light of the tapes (unforeseen or unlikely shots), and to the reversibility of the process (recording and wiping, or re-recording). All these factors encourage mobility and action, and we know only too well how difficult it is to withstand the seductive appeal of instrumental capability - as is the case with the technological preparations for warfare.

On the technological side, mediatization contains another source of infuriating frustration, to which the present study has alluded with a number of illustrations: there is great ambiguity between, on the one hand, the pursuit of highly significant images (significant either in their own right or in the videological process, with a group or a community, for example) and, on the other, the pursuit of mastery of expression (through techniques of scenario, of camera-work, of editing, and so on). Regardless of whether the recording is made by a team of videologists or by a participating group, this ambiguity is as difficult to get rid of as to put up with. One

would certainly like to combine the meaning of an experience with
the know-how of video 'writing'; but success on both counts is ex-
tremely unusual, hence the imbalance between investment, on the one
hand, and achievement, on the other. The resulting frustration pro-
vokes discussion, new attempts, and even censure ('What you have
done is a pile of shit' a more or less well-intentioned colleague
once wrote to us).

Now, if it is true that, at present, the population most actively
involved in video is 'marginal', this suggests another line of ex-
planation to account for the vitality of the phenomenon. This
underground (representing various viewpoints) is interested in the
possible, which it opposes to established reality; in the producible,
rather than in what is actually produced, in the realm of objects,
urban life and so on; and finally in the communicable rather than in
what is communicated. When groups that are actively militant, or
simply in search of new solutions, see their manner of apprehending
one or the other - sometimes both - of these aspects of reality
being realized by video, the contradiction between the two acts like
a detonator. They can relate the 'virtual state' illustrated by the
videofilm to external reality and so on.

Transmediatization, or the dialectical bicycle

To see ourselves as we see others - to see others as we see our-
selves: to be in front of a TV-type screen that isn't a regular set;
to make a film that isn't exactly a film and so on. We have from
time to time taken up the theme of the antidote; it arises from a
phenomenon of the same nature as the phenomenon under attack. The
chance of success lies in what the two phenomena include, and at
the same time exclude: proximity (knowledge, understanding) and dis-
tance (detachment, incompatibility).

It seems that we must carry our argument further in terms of
loops and process. Although it is true that the greater part of the
dynamism of video practice derives from the direct involvement of
the self, of others, and of the environment, in a process that loops
back on itself, for all that the latter is not a closed circle, a
completed whole. One loop is followed by another, just as VT is a
form of post-TV; one loop conflicts with another, just as VT is an
anti-TV.

Our mathematician friend, Alain Croquelois, whose exploits were
described in Chapter 9, suggests visualizing the dialectical pro-
gression as an ascending and descending process on two loops or
wheels, in the following way:

Imagine a bicycle that rises and falls vertically in a 'chimney',
with one wheel on each side of its inside walls; the wheels will
move in opposite directions. This is a model for a real, ver-
tical, bi-cycle. What we usually call a bicycle, the horizontal
bicycle, is in fact a double monocycle.

In other words, you never enter one cycle except in so far as you
leave another, and conversely. If the same phenomenon is represen-
ted by a figure 8 lying on its side, you have a double cycle of a
loop and an anti-loop; more apposite still, an opposing Moebius
strip (with tension between the inside and the outside), or even a

sort of spiral of successive figure eights - and it is well known
how frequently the vicious circle(18) paradigm is invoked by the
various 'ologists', from psychologists to sociologists to political
economists. Making use of the two antagonistic cycles, the contra-
diction, according to Croquelois, is overcome on the vertical plane.
If we were previously speaking of the life of the process in terms
of rejection of ambiguity and of frustration provoked by mismatches,
we have now arrived at a complementary explanation.

From the moment when the participants in a video experiment be-
come aware either of a block, or of progressive unblockings due to
the contradiction between two polarities ('writing'/spontaneity,
self/others and so on), they have the opportunity to ascend or to
descend; and knowing this, they become involved in pursuing the
experiment. Blankly refusing the opposed polarity, just like re-
jecting the ambiguity, leads to blocking; accepting the ambiguity,
which varies in degree, leads to unblocking.

As we have said, materialization (objectivation) and exterior-
ization (objectification) are means that at one and the same time
permit and prevent expression. Likewise, the implication encouraged
by the looping process contains its antidote within itself: disim-
plication by means of mediatization. This expression, which is the
appearance on the screen of our situation, of ourselves, and of our
group, is in a double sense mediate; it is exteriorization, thereby
introducing a first kind of distance, and it is influenced by the
medium (mediatized). To the extent that this expression actually
reflects us, we 'take our distance' in relation to what we are; on
the other hand, the influence of the medium alters this reflection,
so we try to redress the error; the impetus to disimplication by
means of distantiation is followed by a new impetus to implication
in the struggle against mediatization.

Examination of a particular slice of the process thus discloses
a unity of opposites. A subtle exchange takes place between the
momentum of the process and its form.

What animates its form is what forms its animation.

The transaction from image to action

We would not attempt to deny that some of those involved in video
may remain fixated, if not on the gadget, which is outside our pre-
sent field of interest, but on instrumentalism; if not on individual
satisfaction at least on self-identification. But what concerns us
here is the fullest deployment of the potentialities of praxis.

One particular form of multiple reversible connections therefore
deserves more detailed discussion: we have called it commutation or,
alternatively, intermediatization. The structure of relations be-
tween the elements in this field is non-hierarchical: actors, com-
municators, audience, and medium - finding themselves within the
circuit, as a third among the others - are all on the same level.(19)
This structure authorizes and encourages a continuous movement back
and forth among these elements, which are, moreover, interchangeable.

At various moments of the process, except in the case of the re-
jection of ambiguities and of polar blockages mentioned above, a new
mode of inattentive attention, of disimplicated implication, may be

observed. This is the fact of non-localization. One is no longer
either within or without, but inter-mediate. And the articulation
of the image with its real external base, or with the imaginary and
imagination, generates far less of a problem than do some of the
other 'flips' whose nature we have examined above. However, we
would certainly not claim, at the present stage of our work, to have
examined them exhaustively.

Once the stages of transfiguration and transmediation have been
passed, the transition from image to action occurs, first of all at
the level of the project.

For the sake of simplicity, we will start with the videologist: he
imagines a video experiment, thinking about it over a long period;
he believes in this experiment, which will become a definite pro-
ject; he gives it practical shape, and the tape can be viewed; it is
the realization of his project. The image that has been realized is
thus the exteriorization of the reality of what has been imagined.

Conversely, the image of myself is, strangely enough, a stimulus
to virtualization. What I see of myself, or of others, or of a
situation makes concrete the distantiation between existence and
essence (the structure of a character, or of a group, or of a situ-
ation, if you prefer). The action proposed for attention can be
designated in two different ways as a return to virtuality: I may
consider either a reference back to the basic structures or the
possibility of changes in external appearances. In other words, I
perceive in the image on the screen the inside of the outside (the
person behind the role performance) and the outside of the outside
(role performance without regard to the individual characteristics
of the person). I can content myself with identifying more com-
pletely with one or other of these aspects (transformation by par-
tial self-identification). Or I can invent a new version of one of
these aspects (alterification).

Now, reality translated into image is the springboard for imagin-
ation. While not denying imagination its proper place, we must
recognize that it is a form of action, whether in relation to the
conception of projects or to the more pragmatic invention, in the
sense of putting in hand, of new solutions, which may be either
abstract or concrete. The loop of the process we are studying is
itself looped.

After figuration and transfiguration, we enter the domain of pre-
figuration. Whether one remains inside video praxis, and a new loop
is initiated; or whether one leaves it and a loop of the type 'pro-
ject/action/adjustment/new project' is begun - in either case the
importance of the conception must no more be underestimated than
that of action, in the sense of concrete, and usually aggressive,
implementation.

If the analysis of motives that lead to concrete action is the
domain of a specific sociology of action and goes beyond our present
purpose, the relation between image and action is very character-
istically a central preoccupation of videology.

We are very poorly equipped with a vocabulary for approaching the

domain of virtuality.(20) We must get used to distinguishing be-
neath the audio-visual (beneath the image made concrete by the
equipment termed audio-visual) a virtual image that is institutive
and audible-visible (possible).

The production of images in action during the practice of video
is certainly one of the fundamental results of the whole active and
activating process; likewise images produce action in the field of
video practice, and then depass it. Although we have laid greater
emphasis on the aspect of 'images inducing action' in the video
process, the aspect of 'action producing images' is no less con-
stantly present. It has the property of explaining the transition
from mimesis to poeisis that has been indicated above in the dis-
tinction made between identification (imitation) and alterification
(invention). In video practice, an active and implicated reading
results in disimplication - the abandonment of participation as a
spectator and of identification for practical participation. And
ultimately it leads on from a new presentation of self, of others,
and of the situation (representations) towards new prefigurations
(which we will cease calling representations).(21) Metamorphosis
through the image and the action, then within the (concrete) image
while one recreates it, leads towards new (abstract) images and new
actions.

So we have come back, either to the chain reaction set off by the
change that generates change (image through action, action through
image), or to that irremediable rupture of the old conventions
dividing knowledge from action, structure from process, project or
plan of action from action. We have come back to the foundation of
action in action, from action in the image to the image in action,(22)
or to give it its analog form:

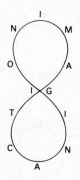

POSTFACE

Preface to new researches ...

NOTES

INTRODUCTION

1 The term 'virtuality', though not commonly used in English, has
 been retained to translate virtualité, in the third sense given
 by the 'Oxford English Dictionary': 'A virtual (as opposed to an
 actual) thing, capacity, etc.: a potentiality. "A Virtuality
 perfected into an Actuality". Thomas Carlyle, 'Past and Pre-
 sent', iv, i (1843).' The adjective 'virtual' has largely been
 avoided, since its normal acceptation: 'that is so in essence or
 effect, although not formally or actually' is misleading in the
 present context, although its special use in optics is suggest-
 ive. (Ed.)
2 He cited, among others, the following application of this idea:
 when confidence falls on Wall Street, share prices fall, and if
 share prices fall, confidence is further weakened; finally the
 shares collapse.
3 For an excellent account of the portapak and other video equip-
 ment, see 'CATS Video Training Manual' (Kirk, Hopkins and Evans,
 1973), and also 'Video in Community Development' (Hopkins, Evans,
 Herman and Kirk, 1972), which is both a handbook and a reference
 source on video practice in Britain and North America. Details
 of these titles and of other works referred to in the text
 appear in the Bibliography at the end of this volume. (Ed.)

PART ONE THE USE OF VIDEO IN CULTURAL ANIMATION

1 'Cultural animation', 'animator': following current usage (see
 Hopkins et al., 1972), these terms have been adopted to render
 action culturelle, animation culturelle, animateur, since they
 refer to a new type of revitalizing social action that has lit-
 tle in common with established and predominantly elitist forms
 of 'social work' or promotion of the arts in the community.
 Animation is meant to be a non-manipulative catalytic process
 that facilitates awareness, expression, and communication within
 and between individuals and groups, by providing human and
 material resources without seeking to impose external aims,
 standards, or content. (Ed.)

2 Subsidized community arts centres, introduced while André
 Malraux was Minister of Culture, to provide a focus for cultural
 life in the provinces. By 1973 nine regional Maisons had been
 established, with artistic policies ranging from the conven-
 tional to the experimental. (Ed.)
3 See the interview with him in Godard's film 'La Chinoise'.
4 'Co-option': Marcuse's term (see his 'One-Dimensional Man',1964)
 has been used throughout to render récupération, the process of
 containment whereby the 'system' blandly absorbs and detoxicates
 protesting and opposing tendencies in politics, the arts, educa-
 tion, and life-style, which, in their denatured and housetrained
 form, may be presented as evidence of its liberalism and toler-
 ance (Ed.).
5 In Part one of this study these all derive from interviews with
 Guy Milliard taperecorded by Alfred Willener.

CHAPTER 1 TOWARDS COLLECTIVE WRITING

1 We will return to this later in the chapter.
2 'To parachute someone: suddenly to appoint someone to a post for
 which his nomination was not expected', as 'Larousse' puts it,
 an expression unaccountably missing from the vocabulary, though
 not the practice, of Anglo-Saxon industrial management. (Ed.)
3 The analogue in reverse of what the Americans call the TV gener-
 ation. The Americans contrast TV to VT.
4 See Chapter 3.
5 It would be desirable to study more closely in what circum-
 stances and for what populations.
6 'Impression management', to use Erving Goffman's term. Here
 this management is preventive.
7 Who is accustomed to the idea of the transmission of a culture
 to the young: the 'postfigurative' system, to use Margaret
 Mead's terminology (Mead, 1970).
8 'Let us call *iso-topia* a place (topos) and what surrounds it
 ... what makes it *the same place*.' As for *u-topia*, it is 'the
 elsewhere, the non-place that has no place, yet nevertheless
 seeks its place' (Lefebvre, 1970, pp. 54-7).
9 There is the family (seen by the observer) and the 'family'
 (experienced by one of its members, for example), see R.D. Laing
 (1970).
10 This is an aspect too rarely brought to light even by those who
 so readily apply the language of the theatre to sociology:
 actors, roles, and so on; see, for example, Messinger (1968: 14).

CHAPTER 2 VT-TV IN A BLOCK OF FLATS

1 The controversial 'Montparnasse Tower' which crowns this enter-
 prise will probably assume a symbolic sociocultural character
 comparable to the Eiffel Tower; we are therefore involved in a
 pilot social phenomenon.
2 Office de Radiodiffusion et télévision française.
3 There were complicated tangles with the legal department of ORTF,
 which we will not go into here.

4 The journal 'Esprit' published a special issue on 'leisure'; in connection with the present discussion, see Touraine (1959).
5 Some other, one-inch, tapes had been made; we will not go into details here, but it is clear that various strategies underlie these 'norms', as the problems of standardization of equipment also reveal.
6 Manufacturers of 'software' and above all of 'hardware'; because of their economic superiority, the latter influence the former.
7 Notably by reducing the potential of this new medium to the status of a gadget for simply copying with, instead of offering it as a toy with which one can embark on new forms of growth.

CHAPTER 3 A LOCAL VIDEO NEWSREEL

1 The professional association of French school-teachers who support secular education.
2 What is artificial tends to be unmasked. The colloquial term 'claptrap' suggests an auditory connotation; something that sounds hollow.
3 For an account of subsequent research on the development of local TV, at Créteil and at Grenoble, see Beaud, Milliard, and Willener (1976).

CHAPTER 4 REGIONAL VIDEO

1 Father? Teacher?
2 The mysterious power of authority?
3 We shall see later (Part three) that the problem of bringing together distant, or even opposed, social categories has been approached by means of video.
4 The crowd attracted by a star is the barometer of popularity already achieved through the media themselves. We are therefore witnessing scenes of alienation provoked by the 'stellariat', with village people and visitors mingling in order to fight over pre-autographed photographs scattered on the ground.
5 In France there is a lack of studies on the consumption of TV, and also on the still latent possibilities of greater participation by various sections of the population in the production of programmes.
6 It should be recalled that Animation 70 is associated with the management company promoting the new resort.
7 The term is debatable; is there an overall culture somewhere?

CHAPTER 5 WAITERS

1 There were fifteen brief observations in various cafés in Lausanne by students and researchers; their sole objective was to study the relationship between waiters and customers.
2 Made by second-year students studying for their first degree (licence).
3 We shall return to this point in connection with experiments carried out in the street (see Chapter 9).

4 Just as any other methods and techniques could be used in a
 supplementary way.
5 We have classified our three cafés as A, B, and C following the
 schema devised by Alain Touraine in the context of the sociology
 of labour: Evolutionary stage A = manual-craft; B = mechanized;
 C = highly organized (semi-automated). See Touraine et al.(1965).
6 In the words of a girl student, 'like undulating fish'.
7 Admirable and eligible, like an air-hostess; there is an element
 of identification between this 'host' and his guest, which just-
 ifies his hauteur. 'I've the feeling,' commented a girl stu-
 dent, 'that in this place the waiters regard themselves as the
 cream of their profession.'
8 On the other hand, several customers were amused by this unex-
 pected happening and one of them would have liked to see the
 videofilm.
9 As did waiter C, but neither of them actually turned up.
10 Time, in the chronometrical sense; duration, in the phenomeno-
 logical sense (time-as-experienced).
11 Time as experienced by the waiter or by a customer in a hurry
 would be something quite different.
12 We define this as the equivalence, in the experience of the ob-
 servers, between time, duration in the situation, and duration
 during playback.
13 Here we are only beginning to explore a difficult territory; for
 the moment we are simply trying to state the problem.
14 The importance of speed in the logistics of service to the cust-
 omer was frequently pointed out in the students' reports.
15 Certain significant details were noticed only later; for example,
 waiter C put his left hand behind his back when pouring drinks
 (to show his expertise).
16 In which, from our present standpoint, we would give an import-
 ant place to work-cycles and to time, and would question the
 waiters during feedback about their personal experience of dura-
 tion.
17 On the other hand, the students' observations with the unaided
 eye often noted the waiter's socio-centrism: 'He makes a noise
 with the crockery without bothering about disturbing the custo-
 mers.'
18 The most frequently occurring behaviour is currently regarded as
 'modal', which would lead to the conclusion that if, for example,
 the majority of taxpayers with unearned income made false de-
 clarations to the Inland Revenue about their actual income, they
 would be acting in conformity with the role of taxpayer....

CHAPTER 6 WOMEN

1 Reported in this newspaper on 30 January 1971.
2 In this connection, see La libération des femmes in the journal
 'Partisans'.
3 'In order that each social class may take its destiny into its
 own hands, it is necessary for each to develop its position
 without constraints and independently of other classes. Class-
 consciousness, the ineluctable recognition of and preparation

for conflict, is called 'politics'. Whereas the negotiations between classes that each control some of the power in institutions are already in the realm of 'policy'.' Gérard Mendel, in 'Feuille d'Avis de Lausanne', 31 May 1972, p. 60.
4 See the article on the interview by Edgar Morin in 'Communications' (1966).

CHAPTER 7 SCHOOLCHILDREN

1 The name of a school in Geneva with about a thousand pupils aged between 12 and 15 years, one of whose aims is to facilitate their academic and professional choices.
2 From the Department of Education of the School of Social and Political Sciences in the University of Lausanne. The full report of the experiment can be obtained from: Institut de Sociologie des Communications de Masse, Université de Lausanne.
3 Whereas feedback, a relatively well-known phenomenon, is the playback, usually immediate, of a film to the people who have been filmed, backfeed is a phenomenon whose significance tends to escape those who are unprepared for it; we designate thus the showing of a film to someone who does not feature in it, in the absence of those who do and without their consent.
4 The Bernese conquest of the Vaud region took place in the middle of the sixteenth century. The patriciate (Their Excellencies of Berne, an aristocratic oligarchy) brought a unified administration to a country hitherto parcelled out among numerous feudal lords; freed the peasantry from serfdom; introduced the Reformation to the region; and developed its material resources. Though these measures increased prosperity and received widespread support, particularly among the country people and the Protestant clergy, they were resented by the remains of the feudal nobility and the burgesses of Lausanne, who wanted their former privileges restored. When Major Davel arrived with his troops in Lausanne on 31 March 1723, he had, however, omitted to prepare the ground by rallying those sections of the population opposed to Bernese domination, and he met betrayal and death. By the end of the eighteenth century, when revolutionary sentiment was fuelling a series of rebellions against the aristocratic regime, Davel had come to be regarded as a precursor in the struggle for liberty and a national hero. (See W. Martin, 'Histoire de la Suisse', 1966.) (Ed.)
5 The second war of Villmergen was the culmination of two centuries of religious conflict between the Catholic and Protestant cantons of the Swiss Confederation. On 25 July 1712 the Bernese troops, including a contingent from Vaud, routed the Catholic army and denominational parity was restored. (Ed.)
6 Having failed to relate the behaviour complained of to local norms rather than to the Parisian ones I had become accustomed to.
7 Not so much that it would have been impossible to obtain it, but because a group interview is too inaccessible to this, on account of a process to which we shall return later.
8 P = the leader of the pupils, whom we nicknamed 'the chief'; M = the girl student acting as monitor.

9 In his neo-Young-Marxist sociology, Touraine has always empha-
 sized the double principle of desire for creation and for con-
 trol (of the use of goods as a condition of their production).
10 'Man's main task in life is to give birth to himself, to become
 what he potentially is' (Fromm 1949:237).
11 'I don't want to look' *(covers his eyes with his hands).*
12 It's here that Goffman's notion of 'impression management' to
 which we are referring reaches its limits; something that inter-
 ests us transcends the order of adaptive responses.
13 Over and above the problem of controlling the situation, another
 element may have been at work: the need for an adult to 'save
 face'; the confrontation between generations who are differently
 situated in relation to TV (differing in degrees of familiarity
 and understanding) undoubtedly raises a problem that the dis-
 semination of schools programmes is likely to keep alive for a
 long time to come.
14 To emend the famous aphorism: the message is the massage.
15 For example, we do not know why the factual responses to the
 questionnaire concerned with acquiring understanding of detail,
 much of which had no real interest, should have produced such
 brilliant results; even if it is admitted that the more capable
 pupils inspired the responses of many of their classmates, and
 even if it is true that they could have obtained the information
 in advance of the programme, the result is still surprising.
16 The expression 'to flip' from the slang of one of the youth sub-
 cultures alludes to that trick of 'turning on', of switching
 from the outside world to the inner world, and vice versa, which
 R.D. Laing so well describes in 'Self and Others': 'When inside
 and outside have been flipped ...' (1969: 27).
17 And which, while it exists, remains much more hidden in the
 teaching relationship between teacher and pupils.

CHAPTER 8 YOUNG PEOPLE

1 This is still the stage of development that Margaret Mead calls
 'postfigurative', 'in which children learn primarily from their
 forebears', still a long way away from the 'cofigurative' stage,
 in which 'both children and adults learn from their peers', and
 insulated from even the idea of the 'prefigurative', in which
 the youngest generations define, or at least partly define, the
 future.
2 From the introductory statement to the conference in May 1971.
3 A baldly postfigurative formula; it's not very amusing to note
 this at the beginning.
4 'Whereas it ought to be a window open on the world, the univer-
 sity has become a kind of prison; the cultural world of the
 students is far richer.' (A student in the videotaped debate.)
5 A well-known ORTF programme.

CHAPTER 9 MARGINAL PEOPLE

1 The quotations and replies to our questions are from Alex Ganty,
one of the animators in the group and a member of the team res-
ponsible for the present book, who provided the basic material
for this chapter.
2 From the review 'Internationale situationniste' (1), 1958: 11.
3 'The imaginary is what tends to become real' (André Breton,
'Le Revolver à cheveux blancs', p. 11); 'The transformation of
the world will be related to the transformation of the image
that man has made of this world.' (Breton, quoted by Bédouin,
1970: 33.)
4 The telescoping of words draws attention to the simultaneity of
a number of things that are normally kept apart in the Western
world; this is the same syndrome that we dealt with earlier in
'The Action-Image of Society' (Willener, 1970).
5 In the example described below, we have radiophonic transmission
(mass communication) whose reception no doubt constitutes a
special case, since the programme was produced by a group that
practises and invites direct participation (and group communica-
tion).
6 France-Culture, Atelier de Création Radiophonique. The pro-
gramme about the experiment was broadcast on 7 March 1971.
7 Which we talked about in connection with the sequences recorded
during the ordinary everyday activities of a waiter who suddenly
became a star simply by appearing in pictures on a screen.
8 It goes without saying that this use of video as a support is
analogous to the use that 'land art' or other forms of action-
art makes of film; the norms of realism taken from television
play a subtle role here which, although it is becoming more and
more active, we are nowhere near adequately analysing.
9 Here again is the numerical precision we mentioned above.
10 Second version: 'Join in the discourse of the world.'
11 Statement by the animators of the group.
12 Reference to 'editing the recording', which will be discussed in
Part three.
13 Social vivisection, unspoken or otherwise, of passers-by, from a
seat in a café, for example.
14 Those who frequent conferences are very familiar with this
phenomenon; it is always the same people who speak, always the
same ones who say nothing, while others express their views in
the corridors.
15 See 'Amédée ou comment s'en débarrasser'. See also John Cage:
'Our nature is that of nature and man's unhappiness comes from
wanting at any price to preserve material things in a world
where nothing is fixed.' In Jotterand (1970).

CHAPTER 10 TELEVIEWERS

1 The regular regional news programme put out by Télévision Suisse
Romande (the French-speaking TV network in Switzerland).
2 No one would contest the need for undertaking - and financing -
extensive empirical studies of television viewing; the present
experiment only serves to underline this necessity.

CHAPTER 11 MILITANTS AND TV

1 Swiss television is not state-controlled, but a 'private corpor-
 ation, the concessionaire of a public service'; we shall have
 occasion to return to certain articles of the charter than con-
 stitutes this 'concession'.
2 Société Suisse de la Radiotélédiffusion, which controls Télé-
 vision Suisse Romande.
3 Although a sociopsychological analysis of them can be attempted
 for each case.
4 In the event, every group that has been filmed is likely to
 claim control of the tapes. It can happen in a conflict situa-
 tion, as it did for us, that one has to restrain the ardour of
 the militants who have been filmed, who intend to make public
 use of a tape without regard to the repercussions that might
 ensue (in this case affecting the people responsible for the
 programme, some of whom were sacked as the outcome of a conflict
 which some months later brought certain of the collaborators up
 against the administration; and also affecting us).
5 Criticisms, or so went one of the arguments, should be clearly
 attributable to their author; newspapers can use quotation
 marks, for television this is impossible.
6 This always being discussed in a reductionist way, in terms of
 the actual number of members in the group and not in terms of
 the potential identification - not measured - of an entire
 stratum of the population with a particular current of ideas.

CHAPTER 12 STEELWORKERS

1 It should be mentioned here that Pierre Tripier, as well as Guy
 Milliard, contributed to the work of the team.
2 Something is not true - in this case the importance of the
 workers' contribution, the level of their qualifications -
 until the moment at which all the objective possibilities that
 exist in it have been realized, in other words, when 'it is what
 it can be' (Marcuse, 'Reason and Revolution', 1954).
3 For example, the operator of a travelling crane with regard to
 the understanding of a sector.
4 See Chapter 5, note 5.

PART THREE PROCESS

1 Such as Werner Aellen of 'Inter-Media', from Vancouver, who has
 just circumnavigated the planet taking in more than 65 centres
 in a dozen countries.
2 This has been investigated on similar lines in a parallel study
 (see Beaud and Willener, 1973).

CHAPTER 13 VIDEOLOGISTS

1 Details of these may be found in, for example, the American
 journal 'Radical Software'.
2 Cf. books such as 'Sociologists at Work' (Hammond, 1964) and 'An
 Anthropologist at Work' (Mead, 1969), or, again, the emphasis
 placed on contacts by the 'ethnomethodologists'. We may recall
 that positivists insist on the uselessness of this kind of know-
 ledge.
3 The film about Occupied France by Marcel Ophuls shown on British
 TV under the title 'The Sorrow and the Pity', and for a long
 time banned in France. (Ed.)
4 We were able to discuss in depth a variety of problems of work-
 ing with video with YN, a Canadian, and with DS, an American
 living in Europe, who are both professionals, and also with LS
 a 'professional amateur'.
5 Indeed, one is even more discreet about taping when one wishes
 to be more indiscreet.
6 While the manufacturers are obstinately intent on preventing the
 standardization of equipment (tapes, heads, cable and so on),
 the pioneer users of it are collectively trying to surmount the
 barriers of technical incompatibility.
7 We cannot fail to note the remarkable affinity between the
 school of sociology known as 'ethnomethodology' and the militant
 'ethnovideography' encountered here, particularly in this res-
 pect (cf. Cicourel, 1970).
8 Front homosexuel d'action révolutionnaire, a Gay Liberation
 organization. (Ed.)
9 When the camera acts simply as the eye of the militant partici-
 pant, free of all the complex manipulations of a battery of
 cameras characteristic of the TV style.
10 The atmosphere of 'panic stations' compels the video team to
 operate in a style appropriate to the extreme pressure of 'hot'
 intervention in conditions of maximum uncertainty. It is clear
 from this that video teams with sociological objectives need to
 establish emergency squads of the type so rightly recommended,
 well before May 1968, by R. Pagès (1963).
11 Mouvement pour la Libération de la femme - Women's liberation
 movement. (Ed.)
12 Congrès général du travail - the Communist trade union. (Ed.)
13 Since TV is so obviously preoccupied with the constant presenta-
 tion of stars or of a stereotyped man-in-the-street.
14 Among the widely distributed underground texts, Jerry Rubin's
 book 'Do It!' speaks of the use to be made of audio-visual tech-
 niques by revolutionaries: 'A revolution is news; the status quo
 ain't. The media does not report "news", it creates it. An
 event happens when it goes on TV and becomes myth.' (p. 107).
 'You can't be a revolutionary today without a television set -
 it's as important as a gun!' (p. 108).
15 The electronic editing of tapes involves a lot of work; equip-
 ment is now becoming available to make it easier and to improve
 the quality of continuity.
16 We will not dwell on other forms of distribution that are at the
 moment in a very embryonic state in Europe. The mayor of a

certain spa engaged a video unit to tape some local events; the
distribution of the tapes will be made by means of a 'pirate'
bus which will tour the district: gipsy distribution. Tapes are
screened at exhibitions, or in shop windows: gadget-type distri-
bution, daytime parking. Some more or less underground groups
have work and recreation premises converted into a club: distri-
bution through a club, or even a videothèque open to the public.

17 To give an example:
>KE: For very dissociated people, seeing themselves in a
>group, on the tape, surrounded by several others, and watch-
>ing all this during playback, in the company of other people,
>this experience resituates them, puts them back into reality,
>and very often interrupts their madness in a non-repressive
>way.

18 DS, who has also worked in this setting says that certain dis-
turbed people have a 'love-relationship with their image ... and
with the video equipment'.

19 Within the framework of a now well-known programme called
'Challenge for Change'.

20 In this connection the entire problematic of technocracy could
obviously be explicated, but it is hardly the place to do so
here.

CHAPTER 14 VIDEOLOGY

1 See below: 'Moments of the process'.
2 We shall return to this point later.
3 See Walter Benjamin's essay The work of art in the age of mech-
anical reproduction (1936) and also John Berger (1972). (Ed.)
4 See also Beaud and Willener (1973).
5 We may recall that the number one article of epistemological
faith of many sociologists is still the rejection of the dialec-
tic and hence of ambiguity, even when it occurs in the pheno-
menon they are supposed to be studying.
6 We are trying to isolate the modal case, which seems to us the
essence of the phenomenon.
7 The technical developments that will make electronic editing
easier will reduce the immediate character of video practice.
8 Hence a renewed interest in the so-called Kleinian form and in
the Moebius strip (see, for example, 'Radical Software', no. 4,
1972).
9 The abstract topology of the enclosed areas does not imply any
physical space. Observe, however, how one is tempted, as wit-
ness the progression, to draw the containers larger and larger,
thus acknowledging the interesting notion of expansion of con-
sciousness; it is not just because of a taste for the drug cul-
ture that videologists say, adopting a psychedelic concept: 'It
gives you head space' (a suggestion made by W. Aellen).
10 We may note in passing the increasing importance of loops in
music (S. Reich, T. Riley, et al.).
11 Vergegenständlichung but also Entäusserung; we are rediscovering
concepts used by Marx, following Hegel, and recently taken up
by, for example, Berger and Luckmann (1966).

12 The Kleinian form, which is more difficult to follow because it
 is more complete, also solves the problem of the contained con-
 taining itself.
13 And, if possible, the embodiment of it.
14 In the sense in which Berger and Bendix (1959) speak of paired
 concepts.
15 On the distinction between energy and information, see Wilden
 (1972, p. 141 et seq.).
16 Whose good or bad technical quality, with all due respect to the
 perfectionists, does not entirely determine its interest.
17 The transition from a free utilization to fetishistic use, and
 conversely, is obviously possible.
18 Too strong a term, since it refers only to downward movement
 (the stronger the repression, the more violent the revolt and so
 on); would an upward movement be any less interesting?
19 This is in obvious contrast to the one-sided relationship be-
 tween communicators and actors, on the one hand, and communica-
 tors and audience, on the other, in the case of TV.
20 Taboo for positivists and 'objective' social scientists of all
 complexions.
21 There is a bad habit in sociology of emphasizing the reified,
 external nature of representations; they reach us from outside,
 like things, according to the followers of Durkheim; on the con-
 trary, this is the institutive phase; it isn't by accident that
 the German word for 'representations' is Vor-stellungen.
22 It is in this respect that the video praxis of which we have
 spoken is in the same stream of ideas as the utopia experienced
 in May 68 (cf. Willener, 1969).

BIBLIOGRAPHY

BEAUD, P. and WILLENER, A., 1973, 'Musique et vie quotidienne: essai de sociologie d'une nouvelle culture', Paris: Mame.

BEAUD, P., MILLIARD, G. and WILLENER, A., 1976, 'TV de quartier et animation urbaine', Paris: Tema.

BEDOUIN, J.-L., 1970, 'André Breton, Paris: Seghers.

BENJAMIN, W., 1936, The work of art in the age of mechanical reproduction, in 'Illuminations', London: Cape, 1970; Fontana, 1973.

BERGER, J., 1972, 'Ways of Seeing', London: BBC; Harmondsworth: Penguin.

BERGER, P. and BENDIX, R., 1959, Images of society and problems of concept formation, in Gross (ed.), 'Symposium on Sociological Theory', New York:

BERGER, P. and LUCKMANN, T., 1966, 'The Social Construction of Reality', New York: Doubleday; London: Allen Lane.

BOUSSINOT, R., 1969, 'Le Cinéma est mort, vive le cinéma', Paris: Pauvert.

BRETON, A., 1932, 'Le Revolver à cheveux blancs', Paris: Cahiers Libres.

CAGE, J., 1970, in F. Jotterand (ed.), 'Nouveau Théâtre américain', Paris: Seuil.

CICOUREL, A., 1970, The Ethnomethodological Paradigm, in 'Recent Sociology', vol. 2, New York and London: Collier-Macmillan.

FROMM, E., 1949, 'Man for Himself', London: Routledge & Kegan Paul.

GOFFMAN, E., 1961, Role distance, in 'Encounters', Indiana: Bobbs-Merrill.

HAMMOND, P.E., 1964, 'Sociologists at Work', New York: Basic Books.

HOPKINS, J., EVANS, C., HERMAN, S. and KIRK, J., 1972, 'Video in Community Development', London: Centre for Advanced Television Studies, 15 Prince of Wales Crescent, London NW1 8HA.

KIRK, J., HOPKINS, J. and EVANS, C., 1973, 'CATS Video Training Manual', London: Centre for Advanced Television Studies.

LAING, R.D., 1967, 'The Politics of Experience and the Bird of Paradist', Harmondsworth: Penguin; New York: Pantheon.

LAING, R.D., 1969, 'Self and Others', London: Tavistock; New York: Pantheon.

LAING, R.D., 1970, 'The Politics of the Family', London: Tavistock; New York: Pantheon.

LEFEBVRE, H., 1967, 'Le Langage et la société', Paris: Gallimard.
LEFEBVRE, H., 1970, 'La Révolution urbaine', Paris: Gallimard.
MANNHEIM, K., 1936, 'Ideology and Utopia', London: Routledge & Kegan Paul.
MARCORELLES, L., 1973, 'Living Cinema', London: Allen & Unwin.
MARCUSE, H., 1955, 'Reason and Revolution', London: Routledge & Kegan Paul.
MARCUSE, H., 1964, 'One-Dimensional Man', London: Routledge & Kegan Paul.
MARTIN, W., 1966, 'Switzerland from Roman Times to the Present'. Translated from the French by Jocasta Innes, London: Elek, 1971.
MEAD, M., 1969, 'An Anthropologist at Work', Boston: Houghton Mifflin.
MEAD, M., 1970, 'Culture and Commitment: a Study of the Generation Gap', London: Bodley Head.
MESSINGER, S.L., 1968, Life as theatre, in M. Truzzi (ed.), 'Sociology and Everyday Life', New Jersey: Prentice-Hall.
MORIN, E., 1966, L'interview, in 'Communications', vol. 7, Paris: Seuil.
MORIN, E., 1967, 'Le Vif du sujet', Paris: Seuil.
PAGES, R., 1963, De reportage psycho-sociologique et du racisme. 'Revue française de sociologie', no. 4.
RUBIN, J., 1970, 'Do It! Scenarios of the Revolution', London: Cape.
SARTRE, J.-P., 1943, 'L'Etre et le néant'. English translation by Hazel Barnes, 'Being and Nothingness', London: Methuen, 1957.
TOURAINE, A., 1959, Travail, loisirs, société, 'Esprit', June: 979-99.
TOURAINE, A., et al, 1965, 'Les Travailleurs et le changement technique', Paris: OCDE.
WILDEN, A., 1972, 'System and Structure: Essays in Communication and Exchange', London: Tavistock.
WILLENER, A., 1970, 'The Action-Image of Society', London: Tavistock; New York: Pantheon.

INDEX